THE J. PAUL GETTY MUSEUM

· HANDBOOK ·

OF THE PHOTOGRAPHS COLLECTION

THE J. PAUL GETTY MUSEUM
· HANDBOOK ·
OF THE PHOTOGRAPHS COLLECTION

Weston Naef

THE J. PAUL GETTY MUSEUM
LOS ANGELES

© 1995 The J. Paul Getty Museum
1200 Getty Center Drive
Suite 1000
Los Angeles, California 90049-1687

Second printing

Christopher Hudson, Publisher
Mark Greenberg, Managing Editor

John Harris, Editor
Patrick Dooley, Designer
Amy Armstrong, Production Coordinator
Ellen Rosenbery, Photographer

Typography by G & S Typesetters, Inc., Austin, Texas
Printed by Nissha Printing Co., Ltd., Kyoto, Japan

J. Paul Getty Museum.
 The J. Paul Getty Museum handbook of the photographs collection / Weston Naef.
 p. cm.
 Includes index.
 ISBN 0-89236-316-9
 1. J. Paul Getty Museum—Photograph collections—Catalogs.
 2. Photography, Artistic—Catalogs. 3. Photograph collections—California—
 Malibu—Catalogs. I. Naef, Weston J., 1942- . II. Title.
 TR6.U62M355 1995
 779′.074′79493—dc20 94-22516
 CIP

Cover: Lewis W. Hine. *Self-Portrait with Newsboy* (detail), 1908. (See pl. 103.)
Frontispiece: André Kertész. *Hands and Books* (detail), 1927. (See pl. 186.)

CONTENTS

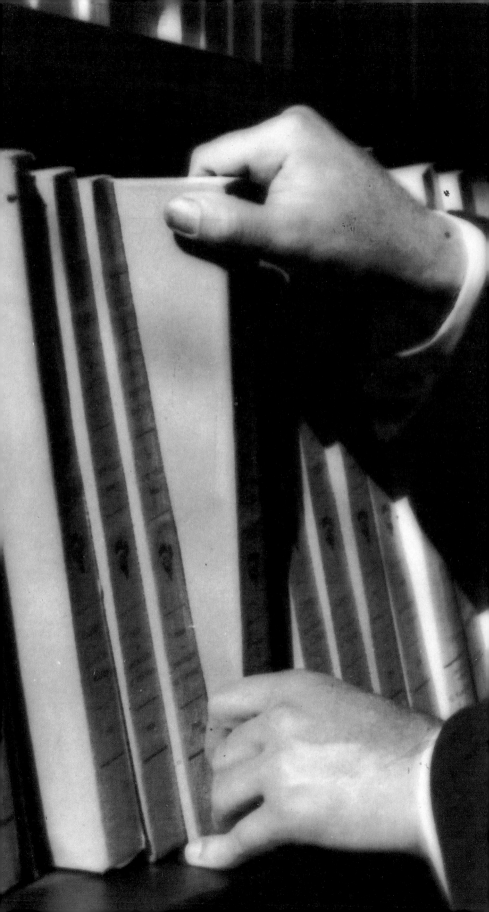

FOREWORD

Early in 1984, the Getty Museum had the opportunity to purchase a group of the largest and best private collections of photographs in the world—more than 25,000 photographs and hundreds of daguerreotypes, as well as books and albums with thousands of mounted prints, ranging in date from the late 1830s to the 1960s—and thus to establish one of the finest collections anywhere. The chance was too important to pass up, especially in view of the lack of any comprehensive collections of photographs in the western United States. The acquisitions were made, and a Department of Photographs formed as the Getty's seventh curatorial department (and the last for the foreseeable future). To Weston Naef, whom I named the first curator, fell the large responsibility of organizing the photographs, as well as housing, documenting, conserving, displaying, and publishing them. This work has taken almost a decade and was essential to preparing even a brief survey of the collection.

The approach here has been to organize the material chronologically into two parts, one devoted to the nineteenth century, the other to the twentieth. Within those two categories, the chapters are arranged according to the purposes for which the photographs were created. Photographs have been paired on facing pages so as to address each other in picture language, as Weston Naef says, and to allow for interesting social and historical juxtapositions. The extended captions are connected by a narrative thread with which the history of photography can be stitched together. At the end is a listing of the 1,700-odd photographers represented in the collection and the number of individual photographs by each.

Few things the Getty Museum has done during the past decade can rival the work of the Department of Photographs for solid achievement, creativity, or delight. This book is a tribute to Weston Naef and the devoted staff of his department, to whom I shall always be grateful.

John Walsh
Director

PREFACE AND
ACKNOWLEDGMENTS

Photographs became the seventh curatorial department of the Getty Museum in the summer of 1984, when the trustees of the newly established J. Paul Getty Trust purchased all or part of several of the most significant collections of photographs that had been formed since World War II. With the purchase in toto of the collections of Samuel Wagstaff (New York), Volker Kahmen/Georg Heusch (near Bonn, Germany), and Bruno Bischofberger (Zurich), Los Angeles immediately became a center for the study of rare and important photographs, and for the Getty Museum photography became the only curatorial department reaching into the twentieth century. At the same time, significant parts of the formidable collections formed by Arnold Crane (American and European photographs) and André and Marie-Thérèse Jammes (French photographs) were joined by all or part of twelve smaller and more specialized collections, including acquisitions from Seymour Adelman (Thomas Eakins), Michel Auer (Eynard-Lullin), Werner Bokelberg (daguerreotypes), the Estate of Ralston Crawford (Crawford), Krystyna Gmurzynska (Rodchenko), William Innes Homer (circle of Alfred Stieglitz), Gerd Sander (August Sander, Lisette Model), Wilhem Schürmann (Czech photography), and Jürgen and Ann Wilde (Renger-Patzsch). By the end of 1984, the Museum had acquired 25,500 individual prints, 1,500 daguerreotypes and other cased objects, 475 albums with almost 40,000 mounted photographs, and about 30,000 stereographs and cartes-de-visite. The transactions that made these acquisitions possible were skillfully negotiated beginning in early 1984 by Daniel Wolf (New York), whose personal collection was made available to complement and fill gaps in the core holdings and to achieve a respectable representation of the most important artists, periods, and styles in the history of photography.

The 1984 acquisitions have since been complemented by the purchase of individual photographs and groups of photographs, many acquired from the descendants or beneficiaries of photographers and pioneer collectors of photographs.

In addition to extensive suites of work by two dozen of the key nineteenth- and twentieth-century makers, our collection is a resource for understanding how photographs were gathered and preserved during the first one hundred and fifty years of the medium's existence. Just as we are indebted to the post-War collectors and dealers named at the end of this preface, so too their holdings would not have been possible without the

efforts of the true pioneers in the collecting of photographs in the century following its discovery, along with the descendants and heirs of notable photographers, who have been important sources for new acquisitions.

The first generation of photography collectors was composed largely of individuals who had participated in the medium's discovery and invention, such as William Henry Fox Talbot, Sir John Herschel, and David Brewster, along with their spouses and the friends and relatives who received photographs as gifts and by inheritance. The earliest systematic collector represented in depth in the Getty collection is David Brewster, a friend of Talbot's who gathered specimens of calotypes made by members of his circle in Edinburgh. He mounted the calotypes into a quarto-sized blank book, which eventually came into the possession of Bruno Bischofberger.

The Emperor Napoleon III was one of the most devoted collectors of photographs of his generation. Many important objects found their way into the art market rather than into national collections because of the humiliating circumstances of his removal from the throne of France and exile to England. The André and Marie-Thérèse Jammes collection provided several items that were formerly in the collection of the emperor, including one of the sets of Le Gray's photographs of the camp at Châlons that Napoleon III presented to his generals (see pl. 76).

The earliest American collector represented in the Getty collection is Alfred R. Waud, who was an artist-illustrator in the 1860s. He obsessively gathered photographs of Civil War subjects, which he used as reference materials for his own drawings. Waud's photographs were dispersed in the 1970s and reassembled from various sources by Arnold Crane and Samuel Wagstaff.

The scope of the existing collection can be appreciated through the exhibitions that have been drawn from it. From the fall of 1986 to the winter of 1994–95, they have been:

Whisper of the Muse:
The Work of Julia Margaret Cameron
September 10–November 16, 1986

Edward Weston:
The Home Spirit and Beyond
November 25, 1986–February l, 1987

Procession to the Fallen Gods:
Photography in Nineteenth-Century Egypt
February 10–April 19, 1987

The Flowering of Early French Photography,
1840–1870
April 28–June 28, 1987

Rare States and Unusual Subjects:
Photographs by Paul Strand, André Kertész, and Man Ray
July 7–September 6, 1987

". . . images that yet/Fresh images beget . . .":
Photographing Art
September 15–November 15, 1987

Alexander Rodchenko:
Modern Photography in Soviet Russia
November 24, 1987–January 31, 1988

Eternal Cities:
Photographs of Athens and Rome
February 9–April 17, 1988

Gustave Le Gray
May 3–August 28, 1988

After the Manner of Women:
Photographs by Käsebier, Cunningham, and Ulmann
September 6–December 31, 1988

Experimental Photography:
Discovery and Invention
January 17–April 2, 1989

Experimental Photography:
The First Golden Age, 1851–1889
April 11–June 25, 1989

Experimental Photography:
The Painter-Photographer
July 5–September 17, 1989

Experimental Photography:
The Machine Age
September 26–December 10, 1989

Experimental Photography:
The New Subjectivity
December 19, 1989–March 4, 1990

Carleton Watkins:
Western Landscape and the Classical Vision
March 13–May 27, 1990

Persistent Themes:
Notable Photography Acquisitions, 1985–1990
June 5–September 2, 1990

Paul Strand: People and Place
September 11–November 25, 1990

The Heart of the Storm:
Northern California Pictorialism
September 13–November 27, 1994

Frederick Sommer: Poetry and Logic
December 6, 1994–February 12, 1995

Since 1984, our pattern of collecting has been to focus on groups of photographs by individual master photographers active in the first half of this century. Notable among these are suites of photographs by Alfred Stieglitz, Gertrude Käsebier, Paul Strand, Doris Ulmann, Edward Weston, Imogen Cunningham, André Kertész, Aaron Siskind, Edmund Teske, Harry Callahan, and Frederick Sommer. Because time and place represent important components in the creation of a photograph, we feel it is important to preserve the context of the creation of a masterpiece as well as to collect the masterpiece itself, which has led to holdings in which quality and diversity are achieved in their correct proportions and authenticity is beyond doubt.

The acquisition procedure begins by examining the work in order to establish condition and authenticity. Since unauthentic photographs are becoming more prevalent as prices rise and the hunger for fresh-to-market items increases, vigilance is essential. Authenticity insofar as it applies to photographs starts with authorship: were the negative and print made by the artist who signed the print or whose name is associated with it because of circumstantial evidence? It is also essential to know whether the print was made from the original negative or from a copy negative and whether it was made about the same time as the negative or later. Museums chiefly collect prints that were made about the same time as the negatives—the rare states—and do not very often collect prints that were made later, unless for reference purposes. Authenticity is established by the look and feel of the photographic paper and by any marks or inscriptions on the front or back, including the photographer's signature, the date, and the title. Some photographers did not sign their works but rather marked prints with a wet stamp or embossed their name in the paper. Inscriptions and dedications by the photographer or an early owner are likewise desirable, as they help establish authenticity and provide useful information for scholars. Also fundamental is provenance, that is, the history of a photograph's ownership. Knowing when and how a print was acquired by a key former owner—a member of the photographer's family, a close friend or professional colleague, or a writer, curator, or collector whose taste is especially respected—is information that establishes the pedigree of the photograph.

Condition is an important aspect of all works of art, and highest priority is placed on photographs that are in excellent condition. However, a surprisingly large number of photographs survive in but one or two

examples. When such a photograph—even if damaged—is deemed to be a high priority because of its great relevance to the existing collection or its great importance to the history of art, then the acquisition of this work may be warranted.

Once authenticity and condition have been established, broader issues must be addressed. The photographs should not only be authentic and rare, but they must be beautiful and important to the history of art. Beauty is the most elusive ingredient of all, and gauging it requires an eye that has been trained by looking at photographs in other museums and private collections around the world. It is not sufficient for the eye to be guided exclusively by knowledge, however, since the soul of a work of art is measured by the heart in concert with the emotions. For example, connoisseurs must be sensitive to the subtle aesthetics of the nineteenth century, a period when the best photographers often expressed themselves in a quiet visual poetry that can be mistakenly thought to be timid or unemotional. Likewise we must comprehend the bold formalist abstraction and extreme romantic subjectivity of twentieth-century work. Each style and period in photography has an integrity that must be respected; to do so, our objectivity and subjectivity are both required, because they are the intertwined opposite forces from which photography's perpetual self-regeneration derives.

Our choices are guided by an understanding of the photographers who continuously exceed our expectations and who surprise and delight us by revealing unexpected facets that surface as forgotten work comes to light. In setting priorities, we look carefully at the biography of the photographer and the process by which an individual style evolved over time. We tend to value most those photographers who had long and productive careers over those with brief but meteoric ones, although it cannot be ignored that some of the greatest names in the pantheon of photography, especially in the last century, worked at their art for a decade or less.

The process of augmenting the collection is one of adding to strengths and selectively filling gaps. Thus, the character and content of the existing collection influence growth more than any other factors. We add to our strengths when items superior to comparable photographs in the existing collection are available, and we fill gaps when the opportunity to acquire the best in any category is presented.

We have sought to underscore the broad sweep of our collection, and of the history of photography itself, by organizing the material contained in this book into eight chapters divided in two parts. The first part, "Discovery and Invention," deals with the history of the new medium from 1835 to the end of the nineteenth century. The second part, "Matter and Spirit," describes the complex forms and aesthetics of photography in the twentieth century. The text and plates are followed by a roster of makers that lists the holdings in our collection by maker, and an index of the photographers whose work appears in this volume.

Many people have contributed to the creation of this book, and I would like to thank a number of them now. First and foremost I would like to acknowledge the important contributions made by the staff members of the Department of Photographs, whose advice and support have been invaluable. In particular I want to acknowledge Gordon Baldwin, Julian Cox, Joan Gallant Dooley, Judith Keller, and Katherine Ware, along with former staff members Victoria Blasco, Andrea Hales, and Louise Stover. Three individuals contributed in a special way: Peggy Hanssen, departmental senior secretary, patiently deciphered my handwriting and prepared the manuscript and diskettes for publication; Michael Hargraves, cataloguing assistant, prepared the roster of makers, pulled the photographs from storage, checked the catalogue descriptions, and coordinated new photography; and Ernie Mack, conservation assistant, prepared the photographs for the exhibitions listed above.

Within the Museum's Department of Publications, I would like to acknowledge the work of John Harris, who skillfully edited the manuscript. The fine reproduction photography in this book is the work of Ellen Rosenbery of the Museum's Photographic Services department. Designer Patrick Dooley is responsible for the elegant and functional design of the volume. The Getty's usual high standards of book production were maintained by Amy Armstrong at Getty Trust Publication Services, who managed to keep this project on its very tight schedule.

The book was read in manuscript by Gordon Baldwin, Judith Keller, Naomi Rosenblum, and David Travis, and their discerning comments enabled me to refine my text in valuable ways.

I would like to express my gratitude to Otto Wittmann, an emeritus trustee of the Getty Trust and a former chairman of the Getty Museum's Acquisitions Committee; Harold M. Williams, President of the Getty Trust; John Walsh, Director of the Getty Museum; and Deborah Gribbon, the Museum's Associate Director and Chief Curator. Their faithful support has made possible the acquisition of the photographs represented here.

Dozens of people have contributed ideas and information that have been incorporated into this book. I wish specifically to acknowledge the following individuals who in conversation or through their writing have added significantly to my own knowledge, and to the knowledge of all students of photography: Mary Alinder (Adams), Michel Auer (Eynard-Lullin), Gordon Baldwin (de Meyer, Reekie, Russell), Neil Baldwin (Man Ray), Victoria Blasco (Alvarez Bravo), Gail Buckland (Talbot), Peter Bunnell (Callahan, Weston), Carl Chiarenza (Siskind), Van Deren Coke (Schamberg, Sheeler, Strand), Amy Conger (Weston, Modotti), Mildred Constantine (Modotti), John Coplans (Watkins, Weegee), Malcolm Daniel (Baldus), Susan Danly (Weston), Keith Davis (Charnay, Gardner), Elaine Dines (Outerbridge), Joan Gallant Dooley (Model, Renger-Patzsch,

Sander), Gary Edwards (Margaritis and Perraud), Ann Erenkrantz (de Meyer), Anna Farova (Funke), David Featherstone (Ulmann), Thomas Fels (Russell, Watkins), Gilberto Ferrez (Ferrez), Merry Forresta (Man Ray), Peter Galassi (Cartier-Bresson), Helmut Gernsheim (Cameron, Daguerre, Fenton), Ralph Gibson (Man Ray, Outerbridge), Sander Gillman (Diamond), Elizabeth Glassman (Stieglitz), Vicki Goldberg (Bourke-White), Sarah Greenough (Stieglitz, Strand), Robert Haas (Muybridge), Peter Hales (Jackson), Maria Morris Hambourg (Atget), Anne Hammond (Emerson), Ellen Handy (Emerson, Robinson), John Hannavy (Fenton), Susan Harder (Kertész), Margaret Harker (Robinson), Mark Haworth-Booth (Silvy), Virginia Heckert (Becher, Renger-Patzsch), Françoise Heilbrun (Nègre), John Hill (Walker Evans), Michael Hoffman (Strand), William Homer (Eakins, Käsebier, Stieglitz), André Jammes (Devéria, Giroux, Regnault), Isabelle Jammes (Blanquart-Evrard), Eugenia Janis (Degas, Devéria, Le Gray), Ian Jeffrey (Emerson), William Johnson (Smith), Estelle Jussim (Day), Nancy Keeler (Bayard), Judith Keller (Evans, Rodchenko, Ulmann), Ulrich Keller (Sander), Richard Kostelanetz (Moholy-Nagy), Robert Lassam (Jones), Valerie Lloyd (Fenton), Bernd Lohse (Erfurth), Sue Davidson Lowe (Stieglitz), Bates and Isabel Lowry (Bemis; Southworth and Hawes), Barbara Lynes (Stieglitz), Anne McCauley (Disdéri), Ben Maddow (Weston), Margery Mann (Cunningham), Bernard Marbot (Collard, Durandelle, Marville), Grace Mayer (Steichen), David Mellor (Brandt), Barbara Michaels (Atget, Käsebier), Katherine Michaelson (Hill and Adamson), Hattula Moholy-Nagy (Moholy-Nagy), Philippe Néagu (Nadar), Molly Nesbit (Atget), Floris Neusüss (Moholy-Nagy, Schad), Beaumont Newhall (Frederick H. Evans, Maurisset, Talbot), Dorothy Norman (Stieglitz), Hank O'Neill (Abbott), Peter Palmquist (Watkins), Richard Pare (Fenton), Christian Peterson (Steichen), Sandra Phillips (Kertész), Terrence Pitts (Weston), Nicole Plett (Schlemmer), Jochen Poetter (Polke), Leland Rice (Moholy-Nagy, Sommer, Teske), Franklin Riehlman (Kuniyoshi), Naomi Rosenblum (Braun, Hine, Strand), Amy Rule (Weston), Gerd Sander (Model, Sander), Larry Schaaf (Atkins, Herschel, Talbot), Bettina Schad (Schad), Stephen Shore (Walker Evans), Graham Smith (Adamson, Brewster), Joel Snyder (O'Sullivan), Robert Sobieszek (Southworth and Hawes), Stephanie Spencer (Rejlander), Theodore Stebbins and Norman Keyes (Sheeler), Sarah Stevenson (Hill and Adamson), Louise Stover (Muybridge, O'Sullivan), John Szarkowski (Arbus, Atget, Winogrand), Ann Thomas (Model), Jerry Thompson (Walker Evans), Edith Tonelli (Crawford), David Travis (Kertész), Anne Tucker (Brassaï), Katherine Ware (Moholy-Nagy), Mike Weaver (Cameron, Talbot), Peter Weiermair (Kuehn), Robert Weinstein (Vroman), William Welling (Black, Meade, Plumbe), Ann and Juergen Wilde (Renger-Patzsch), Charis Wilson (Weston), and Michael Wilson (Beato, Muybridge).

Our collection could not have been built without the help of the following individuals, whose knowledge, good taste, diplomacy, perseverance, and even, sometimes, obsession caused the collections to be formed that constitute the heart of the Getty Museum's Department of Photographs. Each of them contributed at least one of the photographs reproduced in this book: Michel Auer, Bruno Bischofberger, Werner Bokelberg, Christian Bouqueret, Mr. and Mrs. William Cannon, Mr. and Mrs. William Dailey, Susan Ehrens, Gilberto Ferrez, Dr. and Mrs. William Fielder, Jeffrey Fraenkel, Krystyna Gmurzynska, Susan Harder, G. Ray Hawkins, Robert Hendrickson, Robert Hershkowitz, Neville Hickman, Georg Heusch, William Homer, Edwynn Houk, Volker Kahmen, Paul Kasmin, Hans P. Kraus, Jr., Janet Lehr, Gerard Levy, Peter MacGill, Robert McHugh, Lee Male, James Maroney, Mr. and Mrs. R. Joseph Monsen, Mr. and Mrs. Graham Nash, Mrs. John Jacob Niles, The Estate of Georgia O'Keeffe, Mr. and Mrs. Eugene Prakapas, Esther Robinson, Willem Schürmann, Etheleen Staley, Robert Stubbs, Joan Washburn, Cole Weston, Carol Williams, Michael Wilson, Virginia Zabriskie, and William Zewadski.

From the collections of the following individuals came ten or more of the photographs reproduced in this book. To these collectors our debt of appreciation is enormous: Arnold Crane, Mr. and Mrs. André Jammes, Samuel Wagstaff, and Daniel Wolf.

The collection of the Getty Museum could not have been formed without the discernment and dedication of these individuals, and others like them. They have earned our deepest respect.

<div align="right">

Weston Naef
Curator of Photographs

</div>

DISCOVERY
& INVENTION

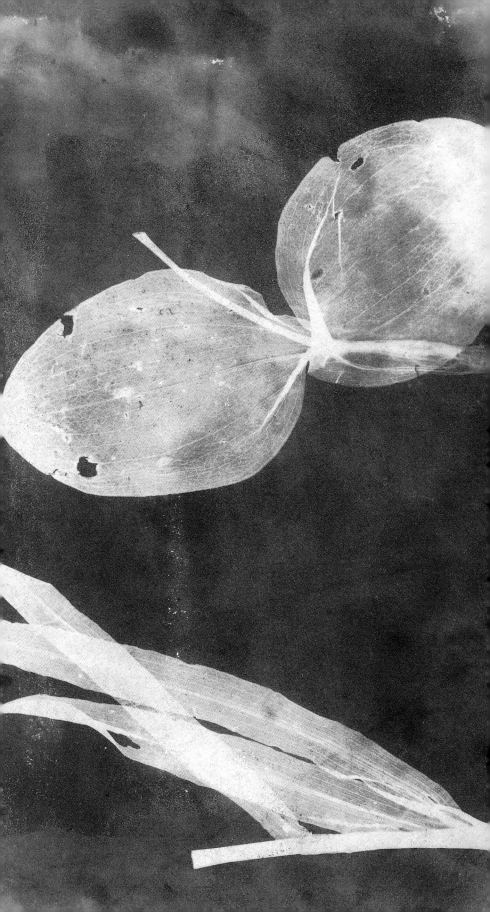

THE PENCIL OF NATURE

"For centuries a dreamy idea occupied the minds of romance writers and alchemists that Nature possessed the power of delineating her features far more faithfully than the hand of man could depict them, and all sorts of impossible and impracticable processes were imagined and described." Thus wrote John Werge, the daguerreian artist and early historian of photography, on the medium's fiftieth anniversary in 1889. The route by which these dreams became a reality involved, first, the discovery that silver can easily be made light sensitive and, second, the invention of an apparatus and photochemical formulas to take advantage of this phenomenon. History books chronicle the many times that the light-sensitive property of silver had been noted, even as far back as the sixteenth century, but it was only in the early 1800s that a series of experiments led to the creation of still-surviving images made by the action of light.

In January 1839, the world heard two nearly simultaneous public announcements that sunlight had been harnessed to make pictures: one from Louis-Jacques-Mandé Daguerre in Paris, the other three weeks later from William Henry Fox Talbot in London. Lacking other ways to make understandable their prodigious discovery, both inventors described their creations as types of drawing, and Talbot even bestowed the name *photogenic drawing* on his first pictures made with light.

Talbot's two-step process that starts with a negative from which a positive print is made became the root of later photography. Because Talbot and his circle left behind more documentation about the genesis of his discoveries—including pictures dating from 1835 (earlier than any surviving daguerreotype)—and because Talbot's invention led to more surviving experiments by other people, our story begins in England.

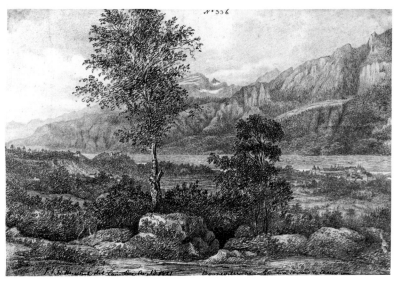

1–2 SIR JOHN HERSCHEL
British, 1792–1871
Bonneville near Geneva on the Road to Chamonix, August 13, 1821
Graphite drawing made with the aid of a camera lucida
19.2 × 29 cm (7%₆ × 11⅞₆ in.)
91.GG.98.59 [Gift of Mr. and Mrs. Graham Nash]

Before the discovery of photography, artists dreamed of ways to shorten the distance between the eye and the hand. "Why don't we paint directly with our eyes!" spoke the fictional artist created by the dramatist Gotthold Lessing in his play *Emilia Galotti* (1772). Before photography, drawing was the most quickly realized type of picture because it was the most precise and immediate way for artists to visualize their ideas. Herschel, who was the greatest general scientist of his generation, made a grand tour of the Continent in 1821, when he recorded his observations of geographical and geological formations with the aid of a drawing tool called the camera lucida. Long before the first surviving photograph was made, Herschel looked at nature through this device and drew what he saw in close-valued shades of gray that anticipate photographs in their composition and tonal scale. Like a photograph, Herschel's drawing made near Bonneville leaves the prime subject ambiguous. He gazes at the mountains near Geneva with the same attention to detail that he devotes to the tree in the foreground, thus achieving a uniform field of focus that is closer to camera vision than it is to the selective focus of the unaided eye.

Ravine in the Simplon Opposite Isella, September 1, 1821
Graphite drawing made with the aid of a camera lucida
29.6 × 20.5 cm (11⅝ × 8¹/₁₆ in.)
91.GG.98.48 [Gift of Mr. and Mrs. Graham Nash]

Herschel's camera lucida drawings form an important transition from the pre- to the post-photographic era. They define a category of visual thinking that we may call "documentary" as opposed to "creative." Herschel would surely have been disappointed if anyone had considered his drawings works of art, because, in his day, the words *art* and *fiction* were virtually synonymous, while his goal was to achieve highly objective records of his topographical sightings. Herschel believed that truth was to be valued more than beauty and that his drawings should be reports and not poetic evocations. The challenge for photographers in subsequent decades would be to establish a new visual language that reconciled truth and beauty, reporting and poetry, as the purely documentary began to overlap significantly with the purely creative.

3 LOUIS-JACQUES-MANDÉ DAGUERRE
French, 1787–1851
The Entrance to the Church of St.-Sépulcre, ca. 1820
Lithograph
26.8 × 21.5 cm (10⅚₆ × 8½in.)
84.XP.1450.7

Herschel's camera lucida drawings (pls. 1–2) were part art and part science, just as photography itself would prove to be. Art and science have in common the fact that they are in constant movement, and for both the engine of progress is experiment. In the manually crafted arts, the wish by artists to make direct replicas of their actual crayon or ink markings was satisfied when Alois Sennefelder invented lithography in 1796. By about 1815, when Louis-Jacques-Mandé Daguerre was completing his art studies, he was introduced to the relatively young process of lithography, which commanded his attention no doubt because of the fidelity with which a crayon sketch could be duplicated on paper. Unlike his contemporaries Gericault and Delacroix, Daguerre failed to distinguish himself in lithography. Yet prints like *The Entrance to the Church of St-Sépulcre* display a remarkable interest in geometry and perspective, as well as the specifics of how light falls on buildings. Light and geometry would become important to photography two decades later.

Lithography made it possible for artists to magnify the influence of their art through the potential for inexpensive autograph replicas of drawings to reach much wider audiences. The importance of a paying audience for Daguerre was proven by the diorama, a performance event without actors, where visual illusions were created in a theater-like space, with dramatic lighting effects and life-sized pictures displayed on three separate stages. Daguerre's diorama brought him his first taste of fame in 1822, about the same time that Herschel was making his first experiments with the camera lucida.

4 LOUIS-JACQUES-MANDÉ DAGUERRE
French, 1787–1851
Dessin-Fumée—Fantasie, ca. 1827
Graphite and vaporized ink on paper
7.9 × 6.1 cm (3⅛ × 2⅜ in.)
84.XM.905

Daguerre's diorama involved effects of light passing through life-sized translucent paintings. He also made a series of small drawings by a process he called the "dessin-fumée" in 1827, the same year he became aware of Nicéphore Niépce's experiments with light-sensitive materials and exchanged one of his dessin-fumée drawings for one of Niépce's engraved pewter plates. "Dessin-fumée" can be translated loosely as "drawing in smoke," a designation perhaps chosen because the drawings may have been created with the smoke from a lighted candle that was manipulated to create effects resembling light and shadow. The dessin-fumée process is notable for the way atmospheric and linear effects are unified homogenously.

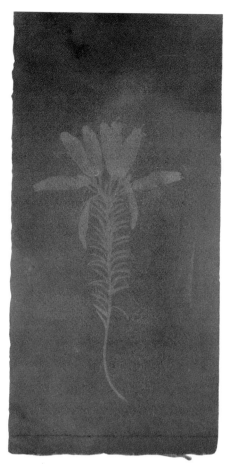

5–7 WILLIAM HENRY FOX TALBOT
British, 1800–1877
Botanical Specimen, probably March 1839
Salt-fixed photogenic drawing negative
14 × 6.9 cm (5½ × 2¹¹⁄₁₆ in.)
85.XM.150.13

Talbot began his experiments with light-sensitive materials in mid-1834 and in 1835 achieved results that we can still see today. His first pictures created with light are the shadows of plants (pl. 5) and of textiles (pl. 6) placed in contact with paper that was brushed with a solution of table salt, then sensitized by applying a solution of silver nitrate that, in contact with the salt, became light-sensitive silver chloride. Eventually he made pictures by exposing sensitized paper through a lens fitted to a wooden box (pl. 7). He called these images "photogenic drawings," thus associating them with the history of art rather than natural history. Until the spring of 1839, most of Talbot's pictures were negatives, that is, the tones of nature are reversed, with the light areas reading as dark and vice versa. Talbot was encouraged in his work by Herschel (pls. 1–2), whom he had met in 1824 in Munich. Herschel's studies of the properties of light were essential for Talbot's dream of photography to be fulfilled. Talbot's early photogenic drawings were unstable; some darkened and others lightened when exposed to light. The surviving examples are still light sensitive and should not be exhibited.

Linen, ca. 1835
Photogenic drawing negative
11.2 × 4.8 cm (4⅜ × 1⅞ in.)
85.XM.150.14

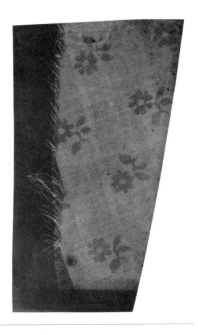

Lacock Abbey, November 4, 1839
Photogenic drawing negative
5.4 × 6.8 cm (2⅜ × 2¹¹⁄₁₆ in.)
85.XM.150.22

8–9 WILLIAM HENRY
FOX TALBOT
British, 1800–1877

Rooftop and Chimneys, Lacock Abbey, ca. 1835
Salt-fixed photogenic drawing negative
11.2 × 11.9 cm (4⅜ × 4⅜ in.)
84.XM.478.9

Leaves of Orchidea, April 1839
Photogenic drawing negative
17.2 × 20.9 cm (6¾ × 8¾₆ in.)
86.XM.621

By August 1835, Talbot had devised a way for buildings to "draw" their own pictures with light reflected from them into a lens that projected the image onto light-sensitive paper that had been pinned into the back of a camera obscura (a light-proof box fitted with a lens). The pictures were created by the direct chemical action of sunlight on the sensitized paper; no chemical development was performed, since no method had yet been discovered to chemically accelerate the development process. However, Talbot dropped his work with light-sensitive materials between the summer of 1835 and mid-January 1839, at which time Daguerre and Talbot learned of each other's parallel efforts to capture light and shadow with chemistry. Both men rushed to publish their work, each hoping to gain a place in history as the inventor of photography. Daguerre's pictures were made on sheets of opaque silver-plated copper (a fact which Talbot and Herschel learned in January 1839) and Talbot's were on translucent paper, which made them very different-looking artifacts.

The period of time between January 25, 1839, when Talbot organized the first public display of his photogenic drawings, and April, when he made this image, brought one epochal discovery after another. (The words *photography* and *photo-*

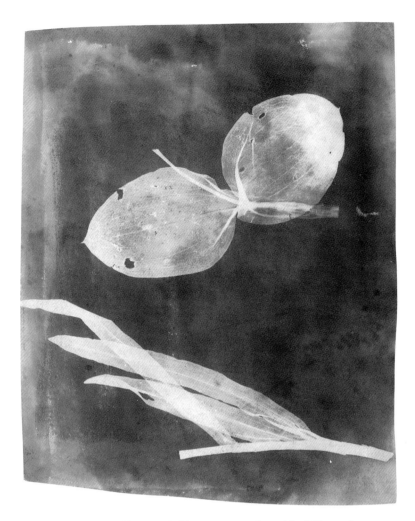

graphic were first used by Herschel but were not adopted by Talbot, who pre-ferred the word *photogenic*, an adjective used today to denote something that looks as if it might photograph well.) March and April were months of intensive simultaneous independent experimentation by Talbot and his mentor, Herschel, chronicled in letters, in laboratory notebooks, and in several dozen surviving sheets of light-sensitized paper, ranging from pale relics to dynamic, well-preserved compositions such as the *Leaves of Orchidea*.

The differences between the *Leaves of Orchidea* and *Rooftop and Chimneys* reveal the ambivalence about means and ends that persisted in Talbot's mind until late 1839. *Rooftop and Chimneys* was made by light reflected from the buildings pass-ing through a lens to record the scene; *Leaves of Orchidea* was created by placing the botanical specimens directly onto the sensitized paper, causing an image to be formed by light passing through and around the specimens. In the spring of 1839, Talbot was still pondering whether the genius of his process was to capture shadows in a one-to-one ratio of object to image (as with the *Leaves of Orchidea*) or to use the lens to change this ratio.

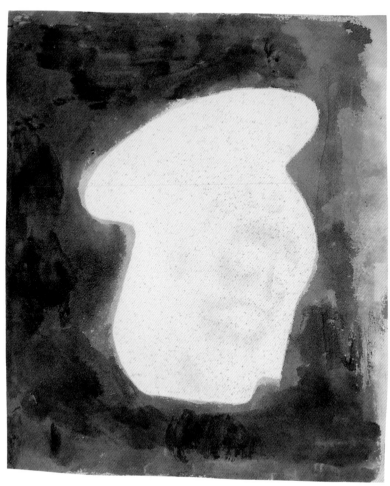

10–12 WILLIAM HENRY FOX TALBOT
British, 1800–1877
The Head of Christ from a Painting on Glass, 1839
Iodide-fixed photogenic drawing negative
21.8 × 17.5 cm (8⅝ × 6¹⁵⁄₁₆ in.)
84.XM.1002.44

In mid-1839, Talbot began the experiments that led in 1840 to his epochal dis-
covery of how to shorten the exposure time and increase the speed with which a
negative could be made by using chemistry to accelerate the development of a
latent image. This made it possible for him to harness the phenomenon of rever-
sal from negative to positive: exposures made on a transparent base reversed them-
selves from one generation of replicas to the next, a procedure that was not pos-
sible in the daguerreotype, which was a unique image. One starting point for
Talbot was a painting on glass by an unknown artist that he utilized to create
numerous negatives. They were of uniform density when first completed but
faded from the long exposure to sunlight necessary to create positives from them;
in order for his negative/positive process to succeed, Talbot had to devise ways to
prevent the negatives from fading by using improved fixatives and shorter expo-
sure times.

The Head of Christ from a Painting on Glass, July 30, 1839
Salt-fixed print from a photogenic drawing negative
20.8 × 17 cm (8¼ × 6¾ in.)
84.XM.1002.45

*The Head of Christ from a Painting on
Glass*, 1839
Iodide-fixed photogenic drawing
negative
20.8 × 17 cm (8¼ × 6¾ in.)
84.XM.1002.46

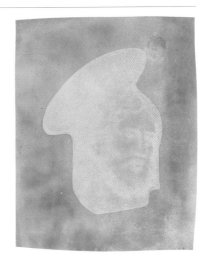

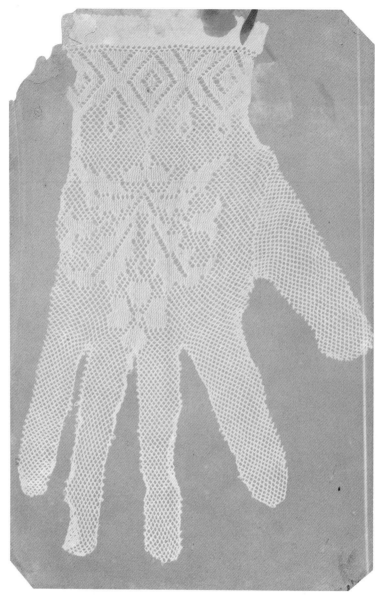

13–14 HIPPOLYTE BAYARD
French, 1801–1887

Lace Glove, ca. 1843–46	*Arrangement of Specimens,* ca. 1842
Cyanotype	Cyanotype
21.1 × 13.9 cm (8⅜₆ × 5½ in.)	27.7 × 21.6 cm (10¹⁵⁄₁₆ × 8½ in.)
84.XO.968.9	84.XO.968.5

Bayard occupies a position in the shadow of his fellow countryman, Daguerre, and also of Talbot, from whom he learned some important techniques. Neither an inventor nor a follower, he was a satellite in the sphere of invention. One mystery surrounding Bayard's role in the discovery of photography stems from the fact that he had progressed far enough by the summer of 1839 to precede Daguerre in

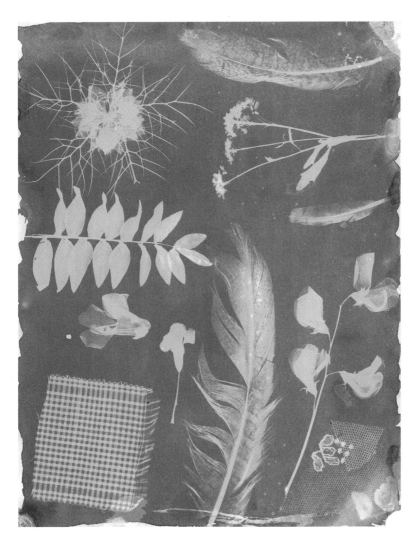

the public display of his discoveries. Bayard was introduced to the work of Herschel and Talbot by Calvert Jones (one of Talbot's friends), and he soon abandoned his own direct-positive-on-paper prints in favor of Herschel's cyanotype and Talbot's calotype. Comparing two of Bayard's cameraless photograms with Talbot's work of about the same type reveals significant differences. When Talbot made a photogenic drawing of linen (pl. 6), he chose a specimen made from a very fine gauge of thread, while Bayard selected a coarsely woven lace glove (pl. 13) that more strongly asserts the presence of man as *homo faber*. Talbot was fascinated with nature's power to give form, while Bayard's arrangement of specimens (pl. 14) seems to say that nature's design is elevated to a higher power by an organizing human intelligence. Both men proved that the choice of subject is fundamental to the art of photography.

15 ANNA ATKINS
AND ANNE DIXON
British, 1799–1871; 1799–1877
Uvena Novea Villiae, ca. 1854
Cyanotype
34.8 × 24.6 cm (13¾ × 9²³⁄₃₂ in.)
84.XM.797

16 ATTRIBUTED TO
ANNA ATKINS
British, 1799–1871
Confervae, 1843–45
Cyanotype
24.2 × 19.8 cm (9⁹⁄₁₆ × 7²⁵⁄₃₂ in.)
84.XZ.369

Sir John Herschel (pls. 1–2) may be credited as the sole inventor of one impor-
tant photographic process, the cyanotype, which he named after the Greek word
for "deep blue" (cyan). He first published the formula for a photographic method
that used iron salts in place of silver in 1842, and he sent a copy to George Chil-
dren, the father of Anna Atkins. George Children was a curator of natural history
at the British Museum and collaborated with his daughter on a translation of
Jean-Baptiste Lamarck's *Genera of Shells*. *Confervae* (pl. 16) dates from the first
years of Atkins's work in cyanotype, about the time she decided to create a visual
catalogue of underwater plants inspired by Lamarck's model devoted to specimens
of British algae. The hair-like fibrils of this alga are shown as though floating in
an azure sea and are represented with more detail than a drawing could record.

Atkins's father died in 1852, depriving her of a valued collaborator and interrupting her career. Anne Dixon, who was a close childhood friend, became Atkins's assistant, and together they explored the visual delights of commonplace flowers and plants (pl. 15).

Atkins was the first woman to create a significant body of work in the history of photography, and although other female pioneers in photography are recorded (and are well represented in the Getty collection), she occupies a special place for her intelligence and perseverance and for the scope of her work. Her studies in plant forms were the logical conclusion of Talbot's photogenic drawing idea. She was, moreover, the first to create a highly useful photographically illustrated book, *British Algae*, issued in October 1843, eight months before Talbot's *Pencil of Nature*. Although Atkins owned a camera, her entire body of work was produced without the use of one. With the assistance of Anne Dixon, she gathered botanical specimens, some of them highly perishable, and exposed them directly to sensitized paper, achieving poetic photograms that inspired Atkins's own verses about representation and reality. All subsequent advances in the early history of photography between 1842 and about 1880 would rely on the lens to change the scale of the subject.

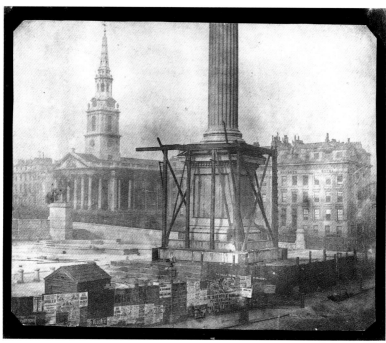

17–18 WILLIAM HENRY
FOX TALBOT
British, 1800–1877

The Nelson Column, 1843
Salt-fixed print from a paper negative
17 × 21 cm (6¾ × 8⁵⁄₁₆ in.)
84.XM.478.19

The Open Door, April 1844
Salt-fixed calotype from a paper negative
14 × 16.8 cm (5⁷⁄₁₆ × 6⅝ in.)
84.XO.968.167

In the very early history of photography, the transition from private experiments
to works that expressed content comprehensible to the non-scientific public was
slow in occurring. The key discovery enabling photographs to reach a larger
audience was a new process called by Talbot the calotype, a method he patented
in February 1841. Calotypes made visible ("developed") a latent, invisible image
that was produced on light-sensitive paper at the instant of exposure. This discov-
ery made possible accelerated production of negatives that could be printed and
mounted onto pages with typography to achieve photographically illustrated
books with commercial potential. Talbot proved how effective the combination
of words and photographs could be in his epochal publication *The Pencil of Na-
ture*, issued in parts beginning in June 1844.

Talbot's tightly composed study, which he titled *The Nelson Column in Trafal-
gar Square When Building* (pl. 17), displays his skill at selecting a personal view-
point. A refined visual intelligence has established the perimeter of the picture. It
is one of the few Talbot photographs that has political content. The transforma-
tion of Trafalgar Square by the addition of William Railton's monument was the
subject of bitter popular controversy. The monument was considered out of scale
to its surroundings, and many feared that it would destroy the view from the steps
of the National Gallery looking toward Whitehall. Talbot's calotype editorializes

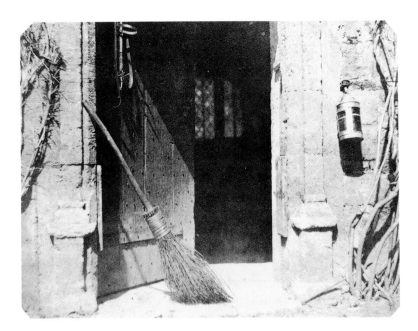

on the side of those who believed the colossal foundations were "an absolute deformity." It is an experiment in the storytelling power of photography.

In his intellectual makeup, Talbot was driven by the search for the essence of things, and one expression of this quest was his book *On English Etymologies* of 1847. Did Talbot connect the naming function of words with the power of the photograph to name objects in purely visual language? Certainly in 1843 and 1844, Talbot was directing his attention to ways of expressing literary content in calotypes, as is indicated by *The Open Door*, in which each carefully chosen object seems to have a symbolic value. Surprisingly, neither *The Nelson Column* nor *The Open Door* was included in *The Pencil of Nature*, yet visually and conceptually they are among the strongest of Talbot's early calotypes.

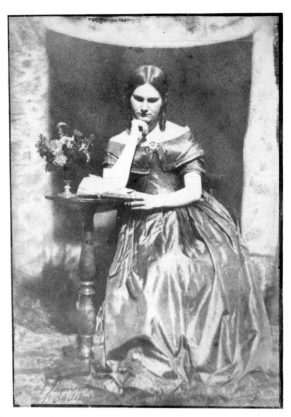

19 JOHN ADAMSON
British, 1810–1870
Miss Thomson of St. Andrews, ca. 1845
Salt-fixed print from a calotype negative
19.8 × 14.2 cm (7¹³⁄₁₆ × 5⅝ in.)
84.XZ.574.67

Although the chief discoveries that led to photography were made within a
hundred-mile radius of either London or Paris, the British and French capitals
were not the exclusive domains of significant innovation. Herschel (pls. 1–2)
introduced Talbot to David Brewster, who was Scotland's greatest scientist of the
early nineteenth century. Talbot and Brewster became fast friends. Talbot shared
details of his work that in turn were communicated by Brewster to his circle in
the St. Andrews Literary and Historical Society. Among them was John Adamson,
a physician with no apparent training in art who nonetheless created two master-
pieces of early photography. The first, *Miss Thomson of St. Andrews*, was made
before there was such a thing in Scotland as a studio designed specifically for
making photographs. To gain adequate light, Adamson posed the young woman
outdoors. She is wearing an elegant dress, seated in a chair, with her right elbow
resting on a stand and with one hand to her chin, while the other gracefully
touches the table's edge. On the table are a bouquet and an open book. Behind
her is a dark, tent-like cloth, and underfoot is a wrinkled oriental carpet. Her eye
sockets become broad almond shapes drawn by the deep shadows, adding a dis-
quieting element to the freshness of the improvised setting. Adamson achieves
here a psychological tension absent in most of Talbot's work.

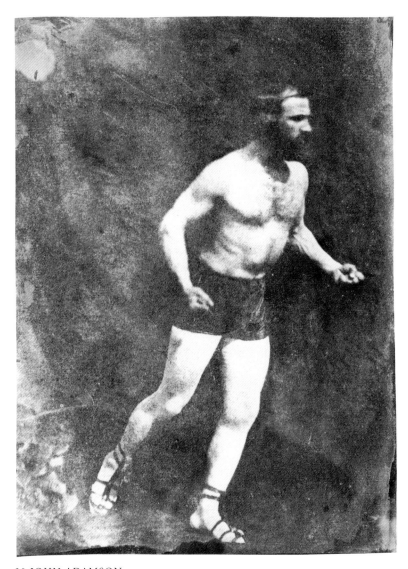

20 JOHN ADAMSON
British, 1810–1870
An Athlete, ca. 1845
Salt-fixed print from a calotype negative
17.3 × 12.8 cm (6¹³⁄₁₆ × 5 in.)
84.XZ.574.173

Adamson's second masterpiece is an untitled photograph now known as *An Athlete*. It shows a figure dressed in shorts and wearing Roman sandals who appears to be lunging or striding forward. Is he meant to be a boxer or a runner? His fists are tightly clenched, and the veins in his left forearm bulge from the tension. The anonymous model is the first person ever to be photographed in a way that expresses animation rather than the static immobility that the slow processes of early photography required. We are not seeing actual motion that has been arrested, but rather a cleverly staged illusion.

21 HIPPOLYTE BAYARD
French, 1801–1887
In the Studio of Bayard, ca. 1845
Salt-fixed print from a paper negative
23.5 × 17.4 cm (9¼ × 6⅞ in.)
84.XO.968.26

Photographers, like other artists, communicate meaning through their subjects. Talbot's *The Open Door* (pl. 18) employs universal symbols, such as the lantern that seems to recall Plato's Myth of the Cave. Bayard, on the other hand, chose to focus on things that direct our thinking away from generalities and toward specifics. Perhaps inspired by Daguerre's earlier works with still-life arrangements, Bayard juxtaposed casts of sculpture with a glass apparatus associated with the chemistry of photography, thus bringing high art and the processes of photography into association. Incidental details such as peeling paint and partially exposed brick remind us of the realities of everyday existence and the destructive forces of time.

22 HIPPOLYTE BAYARD
French, 1801–1887
Self-Portrait in the Garden, 1847
Salt-fixed print from a paper negative
16.5 × 12.3 cm (6⁹⁄₁₆ × 4¹³⁄₁₆ in.)
84.XO.968.166

Neither Talbot nor Daguerre made any self-portraits, and they rarely sat for other photographers (pl. 29). Bayard forever changed photography by opening it up to specifically autobiographical content. Bayard tells us about himself by letting us see how he dresses: he is neither bohemian nor aristocratic but rather solidly bourgeois. He associates himself not with artifacts of political power or symbols of material wealth, but with commonplace objects—flowerpots, a watering can, a trellis, a vase, a barrel, and a ladder. He is telling us, "I am a gardener as well as a photographer," and in doing so introduces the maker's private concerns into photography for the first time.

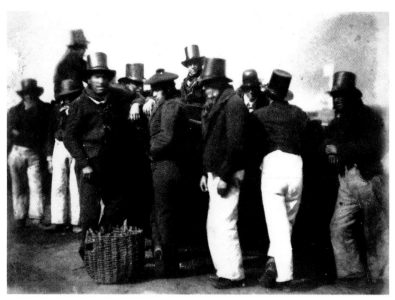

23–24 DAVID OCTAVIUS HILL
AND ROBERT ADAMSON
British, 1802–1870; 1821–1848
Newhaven Fishermen, 1844–48
Calotype
15 × 20.7 cm (5¹⁵⁄₁₆ × 8¹⁄₁₆ in.)
84.XM.445.12

*Marian Finlay, Margaret Dryburgh
Lyall, and Grace Finlay Ramsay:
"The Letter,"* ca. 1845
Salt-fixed print from a paper negative
(calotype)
20.3 × 14.3 cm (8 × 5⅝ in.)
84.XM.966.10

Talbot's invention of the calotype was brought to Scotland by David Brewster,
who was Talbot's best friend. As we have seen (pls. 19–20), Brewster in 1841–42
passed the information along to his friend John Adamson, who taught his
younger brother, Robert Adamson, the procedures that had been patented by
Talbot in England (but not in Scotland, where they lived and worked), thus
making Scotland one of the earliest centers of experimental photography. The
partnership between Hill, who was a painter, and Adamson, who was an engi-
neering student, was itself an experiment, for they were the first two individuals
to produce a body of photographs published under joint authorship. Much of
their work was devoted to portraying the men and women of Edinburgh's intel-
lectual aristocracy. However, in June 1845, Hill and Adamson took their equip-
ment to the fishing village of Newhaven near Edinburgh and commenced a series
of calotypes of the local people. Snapshots were not yet possible; cameras had to
be mounted on tripods, with an exposure that was no faster than the rate at which
a brass lens cap could be taken off and replaced. Subjects had to remain absolutely
still. Never before had photographers wandered through the streets prospecting
for subjects who were part of an unfolding situation and were not static objects. It
is unlikely that even one of the eleven top-hatted fishermen had ever seen a pho-
tograph before the day this picture was made. Their ignorance of being immortal-
ized is signaled by their poses and the lack of recognition on their faces. If art is
an eternal battle to make order out of chaos, then here we see the two photogra-
phers challenged to bring human behavior under artistic control. Because the

fishermen were totally uncorrupted in their idea as to how they should behave in front of a camera, the result is one of the first group of photographs that is, in a sense, candid.

By contrast, the three fisherwomen represented in a composition called *The Letter* could only have been enlisted by the photographers to establish the illusion of a spontaneous event that has been arrested by the camera. These two photographs teach us that, from the very beginning, photography showed a powerful capacity to merge truth and fiction.

25a–b CALVERT RICHARD JONES
British, 1804–1877
Two-Part Panoramic Study of Margam Hall with Figures, ca. 1845
Salt print from a calotype negative
Each: 22.5 × 18.6 cm (8⅞ × 7/₁₆ in.)
89.XM.75.1–.2

Calvert Jones was a skilled draftsman, having been trained by the most prominent drawing master in England, James Duffield Harding. Although he remained an amateur artist, he well understood the problems of visual representation. Jones imagined that the most fitting use of the camera was in the field, where the camera could be used to record landscape and architecture, as in this study of Margam Hall, the recently completed Gothic Revival mansion commissioned by Christopher Talbot, a cousin of Fox Talbot (pls. 5–12). Dissatisfied with the narrow field

of vision of the lenses then in use, Jones invented the segmented panorama format, which he called simply "double pictures," whereby a series of slightly overlapping exposures could be joined to encompass a field of vision closer to that of the human eye. We see here the Talbot and Jones families gracefully positioned across the grounds of Margam Hall.

In November of 1845, the Jones and Talbot families departed on Christopher Talbot's yacht to winter in the Mediterranean. Jones continued his field work, using Fox Talbot's three-year-old calotype process in hopes of earning revenues from the sale of prints of exotic landscapes and monuments. The prints were to be produced in commercial quantities at Fox Talbot's establishment, near Reading. However, profits from the sales did not meet expenses.

26 LOUIS-DÉSIRÉ BLANQUART-EVRARD
French, 1802–1872
Tree, 1860s
Salt print
21.2 × 17.3 cm (8⅜ × 6¹³⁄₁₆ in.)
84.XO.1279.12

The forward momentum of Talbot's calotype process, by which multiple prints could be made from a single negative, led to the potential for editions of photographs. Calvert Jones (pls. 25a–b) accumulated more than three hundred paper negatives that he hoped could be used for this purpose; however, Talbot's calotypes were unstable, and it was in France that the potential for uniform editions of photographs was first realized. Louis-Désiré Blanquart-Evrard created an establishment at Lille, France, similar to Talbot's workshop in Reading, England, where the all-too-fugitive prints bound into *The Pencil of Nature* (see pl. 18) had been made. The French improvements to Talbot's calotype must surely have been motivated by Blanquart-Evrard's desire to facilitate the presentation of his own photographs. His work consisted of family portraits in the manner of Hill and Adamson and landscapes such as this study of a tree, which is closely related in its Barbizon School origins to the work of Charles Marville (pl. 27).

27 CHARLES MARVILLE
French, 1816–1879
In the Garden of the École des Beaux-Arts, Paris, February 17, 1853
Salt print
35.6 × 25.8 cm (14 × 10⅛ in.)
84.XM.505.20

Charles Marville played a role for Blanquart-Evrard (pl. 26) comparable to that
of Calvert Jones for Talbot. Both supplied negatives destined for production in
editions that are estimated to have ranged in size from twenty-five to fifty prints
from each negative—mass production at this early stage in the history of photog-
raphy. While Jones had a career in photography that lasted less than a decade,
Marville eventually graduated from Blanquart-Evrard's employment and contin-
ued to be active in photography for over thirty years. Although we know few
details of his life, it can be deduced from his body of work that he was one of
the first professional photographers and not a gentleman amateur. According to
the journalist Charles Gaudin, Marville's study of the entrance to the École des
Beaux-Arts after a fresh snowfall was made on New Year's Eve. Gaudin went on to
analyze the picture, saying: "The effect of this snow is admirably reproduced, but
what is most striking is the effect of the perspective. The spatial planes recede and
diminish in a vaporous atmosphere, and the details in the distance are outlined
with charming delicacy." Gaudin deserves credit for being among the first critics
to write cogently about the purely aesthetic aspects of photographs at a time when
most others wrote about formulas and logistics.

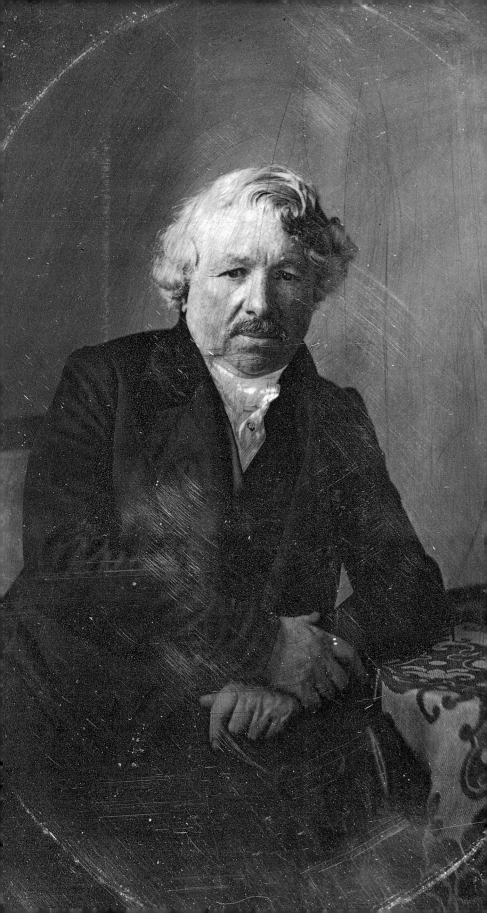

THE DAGUERREIAN EPOCH

Between 1835 and 1837, Daguerre working in France and Talbot working in England succeeded in capturing nature's shadows by using variations on a long-known phenomenon, namely, that silver salts are light sensitive. Their discoveries were made known to the public in independent announcements in January 1839. Between 1839 and 1841, their procedures were improved by other inventors. Thus, by early 1842, calotypes—the name Talbot finally settled on for his pictures—and daguerreotypes were being made by people other than their inventors, but the results were neither predictable nor reliable until after about 1848.

The British and French experiments differed in one fundamental respect. Niépce and Daguerre utilized opaque metal surfaces of the type that had for centuries been used for engravings, while the British preferred paper as the support for the negative and the positive print made from it. Photographs on paper could be handled like prints and drawings by mounting them in albums or onto larger sheets for presentation or display. The situation was very different with metal plates. The fragile, highly polished surface of daguerreotypes had to be protected from fingerprints and oxidation by sealed glass covers, which led to the commercial development of standardized protective cases. Since the unsensitized plates and the cases were mass-produced by stamping them from dies, photographers soon became tied to the standard sizes of these materials. The overall uniformity of the plate sizes and cases gave the public more reason to believe the images were the product of a machine and to ignore the fact that the daguerreotype (and its derivative processes the ambrotype and tintype) were one-of-a-kind pictures controlled by the hand, the eye, and human intuition. Because of the elaborate technical procedures involved, almost all daguerreotypes were made indoors in portrait studios designed for the purpose.

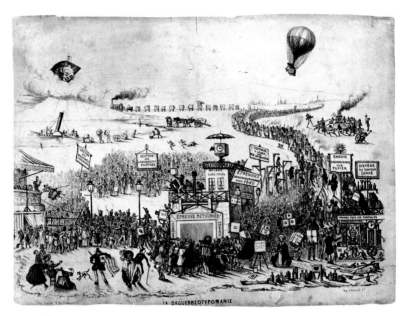

LA DAGUERREOTYPOMANIE.

28 THÉODORE MAURISSET

French, active 1835–1859

Daguerreotypomania (La Daguerréotypomanie), December 1839

Lithograph

26 × 35.7 cm (10¼ × 14¹⁄₁₆ in.)

84.XP.983.28

Daguerre began his romance with light in the early 1820s, became a partner with Nicéphore Niépce in 1829, and made the first successful daguerreotype in 1837, four years after his partner's death. The first public display of the results took place in the summer of 1839, after the French government bought Daguerre's patent rights and immediately transferred them to the public domain. Once the secret procedures and chemical formulas were made known, the need for users to pay royalties or license fees to Daguerre was eliminated, causing a great rush by opportunity seekers. (The situation was very different across the Channel, where licensing fees still had to be paid to Talbot.)

Théodore Maurisset's lithograph playfully presents a time when vast crowds would line up to have their likenesses made. It chronicles the many ways entrepreneurs hoped to cash in on the craze, from selling supplies and equipment to giving lessons in how to perform photographic procedures.

Maurisset imagines a world dominated by photography and where even time, in the form of a camera-like clock, is measured by it. Notice the engravers to the right of center, who are shown committing suicide because their jobs have been taken away by the advent of the camera. In a comically exaggerated way, Maurisset was expressing the fears of artists about a discovery that many believed posed a threat to their profession.

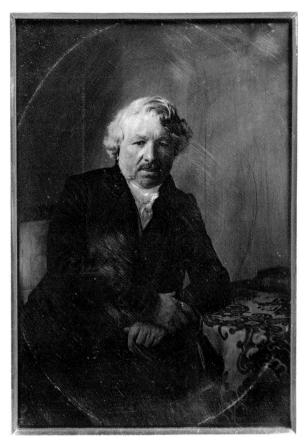

29 CHARLES R. MEADE
American, 1827–1858
Portrait of Louis-Jacques-Mandé Daguerre, 1848
Half-plate daguerreotype
16 × 12 cm (6⁵/₁₆ × 4¹³/₁₆ in.)
84.XT.953

One of the unresolved mysteries in the history of photography is why Daguerre, who was a painter, became interested in light-sensitive materials about 1824. He pursued his interest with such fervor that in 1829 he formed a partnership with Nicéphore Niépce, who had successfully worked with sensitized metal plates. By New Year's Day of 1840—little more than one year after Talbot had first displayed his photogenic drawings in London and just four months after the first daguerreotypes had been exhibited in Paris and a public demonstration of the process was held—Daguerre's instruction manual had been translated into at least four languages and printed in at least twenty-one editions. In this way, his well-kept secret formula and list of materials quickly spread to the Americas and to provincial locations all over Europe. Photography became a Gold Rush-like phenomenon, with as much fiction attached to it as fact.

Nowhere was the daguerreotype more enthusiastically accepted than in the United States. Charles R. Meade was the proprietor of a prominent New York photographic portrait studio. He made a pilgrimage to France in 1848 to meet the founder of his profession and while there became one of the very few people to photograph Daguerre.

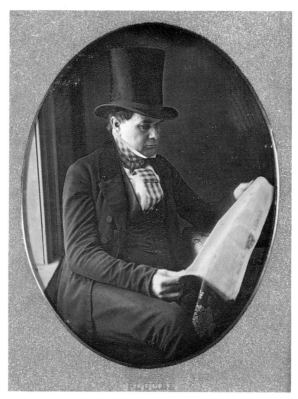

30 JOHN PLUMBE, JR.
American (b. Wales), 1809–1857
Unidentified Man Seated Reading a Newspaper, 1844
Quarter-plate daguerreotype
9 × 7.1 cm (3½ × 2¾ in.)
84.XT.1565.22

Very soon after the first daguerrean instruction manual arrived in North America
in the late fall of 1839, John Plumbe had the novel idea of establishing a chain of
daguerrean studios. By 1843 he was doing business in Boston, Albany, Saratoga
Springs, New York City, Philadelphia, and, in 1846, Washington, D.C., where
President Polk and former President John Quincy Adams were among the celebri-
ties who posed for him. Plumbe finally had to turn the operations of his satellite
studios over to assistants, who were generally much less skillful than he. Quantity
apparently began to take priority over quality as he added even more studios in
Louisville, New Orleans, St. Louis, and Dubuque, where he committed suicide
at the age of forty-eight. There is no way of ascertaining whether this remarkable
study of a man, who may be a publisher, is by Plumbe, whose name is impressed
into the brass mask, or by an assistant. We would like to think it is Plumbe's work
and read it as testimony to his artistic genius, which exceeded his business sense.

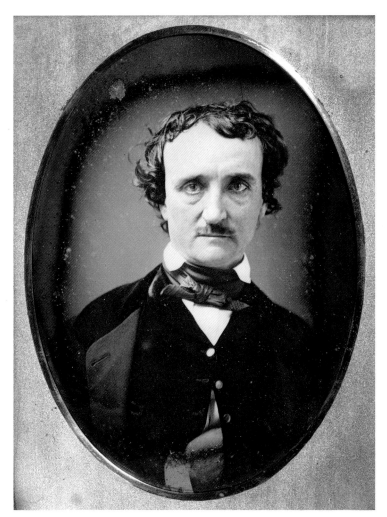

31 UNKNOWN AMERICAN PHOTOGRAPHER
Edgar Allan Poe, late May–early June 1849
Half-plate daguerreotype
12.2 × 8.9 cm (4¹³⁄₁₆ × 3½ in.)
84.XT.957

For reasons that are not entirely clear, relatively few daguerreotypes of notable poets, novelists, or painters have survived from the 1840s, and some of the best we have are by unknown makers. The art of the daguerreotype was one in which the sitter's face usually took priority over the maker's name, and many daguerreans failed to sign their work. This is the case with the Getty *Poe*.

Four of the eight times that Poe is known to have been photographed occurred within the last year of the writer's life. He presented this portrait to Annie Richmond, one of the two women to whom he made romantic declarations in the months following the death of his wife in early 1847. Poe, who has been described as a libertine, a drug addict, and an alcoholic, is represented here as a man whose haunted eyes and disheveled hair reveal the potential for mercurial emotions.

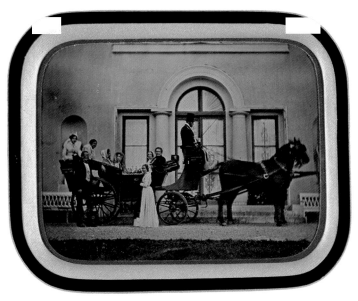

32 JEAN-GABRIEL EYNARD
French, 1775–1863
Family Portrait with Bride and Carriage, 1849
Sixth-plate daguerreotype in passe-partout
10.9 × 14.7 cm (4⅜ × 5¾ in.)
84.XT.255.9

For the wealthy Swiss amateur Jean-Gabriel Eynard, photography was a source of personal and family amusement. He learned the daguerreotype process in Paris in the early 1840s and, assisted by his gardener, went on to create one of the most significant bodies of daguerreian work to survive. He posed himself (pl. 34) with an arrangement consisting of a copy of Daguerre's manual, a framed daguerreotype representing the temples of Saturn and Divine Vespasian in the Roman Forum, and a bronze statue. In a series of more than one hundred daguerreotypes, Eynard, with the aid of his gardener, Jean Rion, sensitively recorded the multiple aspects of his daily existence at the Château Eynard in Geneva. The daguerreotype was the slowest and most tedious of the pioneer processes, and group portraits were particularly difficult because the attention of the subjects tended to wander. This makes all the more remarkable the high artistic quality of the scenes recorded here, both the formal family portrait (pl. 32) and the domestic portrait of his household staff (pl. 33).

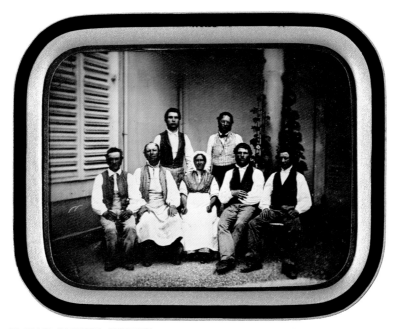

33 JEAN-GABRIEL EYNARD
French, 1775–1863
Portrait of Seven Servants, ca. 1848
Half-plate daguerreotype in passe-partout
11.1 × 14.7 cm (4⅜ × 5¹³⁄₁₆ in.)
84.XT.255.13

34 JEAN-GABRIEL
EYNARD
French, 1775–1863
*Self-Portrait with Daguerreotype of the
Roman Forum,* ca. 1853
Half-plate daguerreotype in passe-
partout
11.4 × 8.4 cm (4½ × 3⅜ in.)
84.XT.255.38

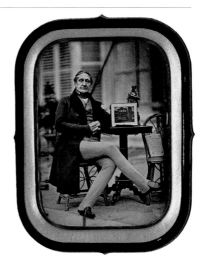

35 RICHARD BEARD
British, 1802–1885
Mrs. R. Holdsworth, February 16, 1853
Hand-colored quarter-plate
daguerreotype
7.8 × 6.5 cm (3⅛ × 2⁹⁄₁₆ in.)
84.XT.266.14

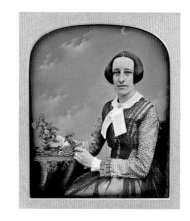

Daguerreotype plates were sometimes
skillfully colored (pls. 35–36) to give
them a natural appearance, and this
was one reason that daguerreotypes
displaced miniature painting for por-
traiture. As many women as men are
the subjects of these early portraits.
However, photographers did not
always identify themselves on the photographs, and thus it is impossible to know
which images may have been created by women. What is certain is that more
women photographers worked in the daguerreian era than are presently listed in
most general histories of the subject.

36 ATELIER HÉLIOGRAPHIQUE,
PARIS
Girl Holding a Basket, ca. 1849
Hand-colored quarter-plate
daguerreotype
9.1 × 6.8 cm (3⅝ × 2¹¹⁄₁₆ in.)
84.XT.403.24

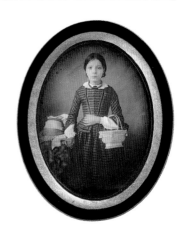

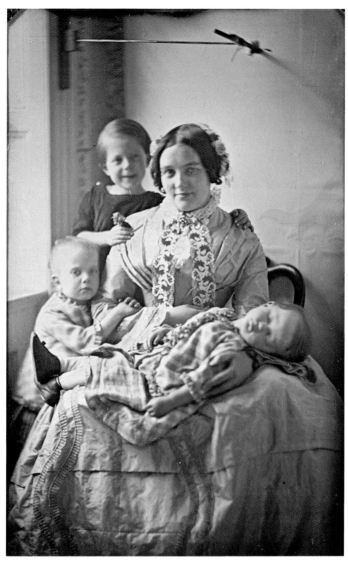

37 HERMANN CARL EDUARD BIEWEND
German, 1814–1888
Portrait of the Artist's Wife and Their Three Children, June 22, 1851
Half-plate daguerreotype in passe-partout
15.3 × 9.8 cm (6 × 3⅞ in.)
84.XT.172.1

Daguerreotypes can be the most affecting of all early photographs when the sitters have no mask to hide behind or when the mask is momentarily removed by the photographer's skill. The daguerreotype was normally a very formal medium, and it is the casualness of Biewend's study of his wife, Hélène, with their three children that distinguishes it from the work of Eynard and most other daguerreian artists. Biewend inscribed the relevant information in ink on the paper backing; such information about daguerreian subjects is rare. Even the national origin of the subject must often be deduced from circumstantial evidence.

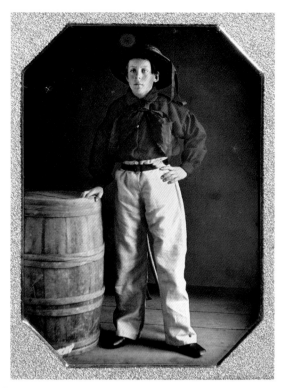

38 UNKNOWN AMERICAN
PHOTOGRAPHER
Portrait of a Boy, 1850
Hand-colored quarter-plate
daguerreotype
9 × 6.5 cm (3¹⁷⁄₃₂ × 2⁹⁄₁₆ in.)
84.XT.1571.2

39 UNKNOWN AMERICAN
PHOTOGRAPHER
Portrait of a Man with a Saddle, 1850
Hand-colored half-plate daguerreotype
11.9 × 8.8 cm (4¾ × 3⁷⁄₁₆ in.)
84.XT.269.15

Among the dreams shared by pioneer photographers was that of abolishing the
headclamp and other mechanical devices required to keep sitters motionless.
Biewend did so and left the unused apparatus visible at the top of his picture of
his wife and children (pl. 37), accepting the resulting blur in the heads of his
figures. The illusion of spontaneity was also achieved by substituting other props.
For example, the boy in baggy trousers seen above supports himself on a barrel as
though he has been pictured at work; however, the base of the posing stand can
be seen between his legs.

 Photographers sometimes went to considerable lengths to embellish the sitter's
personality. The man here has been posed holding a cheroot, wearing a broad-
brimmed hat, a thick muffler swaddling his neck, and a heavy overcoat or cape,
with his arm resting on a finely crafted leather riding saddle. Are these the accou-
terments of a man who travels by horseback, or of an actor in a role?

 In America, daguerreotypes were usually mounted for presentation and

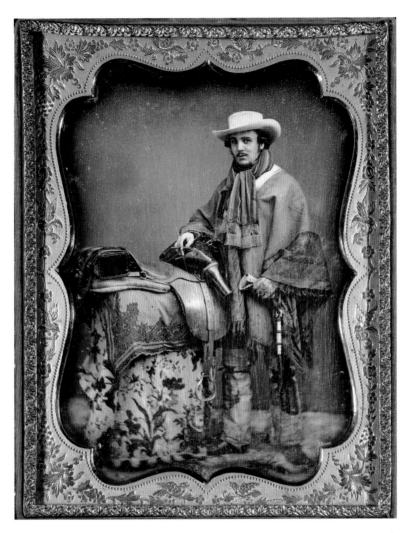

safekeeping in cases made of papier-mâché or thermoplastic (a pressed mixture of resin and sawdust) with velvet cloth lining. Europeans presented their daguerreotypes more simply, sometimes using leather cases lined with silk and other times sealing the silvered copper plate between a paper backing and a cover of black lacquered glass with paper tape.

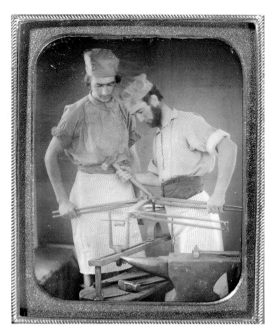

40 UNKNOWN AMERICAN PHOTOGRAPHER
Portrait of Two Metalworkers, 1855
Sixth-plate daguerreotype in Mascher magnifying case
6.9 × 5.7 cm (2¹¹/₁₆ × 2¼ in.)
84.XT.1572.5

Painters had a long tradition of showing sitters—usually heads of state, art patrons, military leaders, and the like—with the symbols of their station. Daguerreian artists learned from these examples and extended their reach to ordinary people, who are shown with the paraphernalia of their occupation or hobby. The two blacksmiths were surely photographed in their own shop, while the carpenter perhaps brought the tools of his trade to the photographer's studio. The study of an unidentified man includes nine daguerreotypes in their frames and others in their papier-mâché or thermoplastic cases. We have to wonder why he is pictured with this display. Is he holding portraits of friends or family? Is he a salesman or a photographer proudly demonstrating his art?

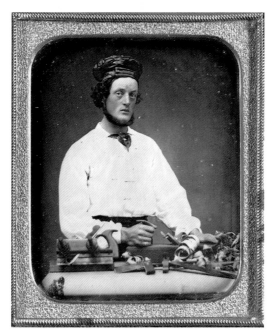

41 UNKNOWN AMERICAN PHOTOGRAPHER
Unidentified Man with Carpentry Tools, ca. 1855
Hand-colored sixth-plate daguerreotype
6.9 × 5.7 cm (2¹¹⁄₁₆ × 2¼ in.)
84.XT.1570.2

42 UNKNOWN AMERICAN
PHOTOGRAPHER
Portrait of an Unidentified Daguerreo-
typist Displaying a Selection of
Daguerreotypes, 1845
Hand-colored sixth-plate daguerreotype
6.6 × 5.3 cm (2⅝ × 2¹⁄₁₆ in.)
84.XT.1576.1

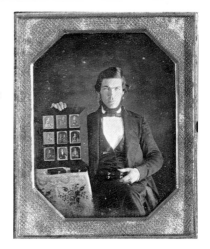

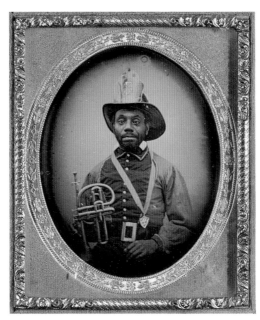

43 UNKNOWN AMERICAN PHOTOGRAPHER
Fireman in Uniform Holding a Brass Musical Instrument, 1855
Sixth-plate daguerreotype touched with color
6.3 × 4.8 cm (2⅜ × 1¹⁵⁄₁₆ in.)
84.XT.1582.3

Pride in accomplishment is a natural human emotion, and it is the prime motiva-
tion of the occupational portrait, in which the subject is shown with the symbols
of his mastery. Here we see a fireman with the cornet used to warn passersby of
the fire wagon's approach. We are forced to imagine what heroic deed qualified
the man for the medal that is suspended from his neck by a broad silk ribbon.
Was it possibly a dramatic rescue or for leadership of his comrades in a dangerous
situation? Photographed at a time when most people of African descent in Amer-
ica were slaves, this man clearly had achieved a position of honor and respect.

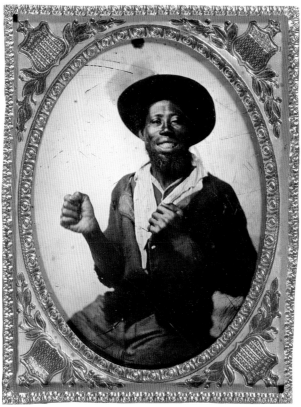

44 UNKNOWN AMERICAN PHOTOGRAPHER
Smiling Man, 1860
Quarter-plate ambrotype
8.9 × 6.5 cm (3½ × 2%₆ in.)
84.XT.439.3

From America of the decade when slavery was abolished we see two free black
men, one a fireman who plays the cornet (pl. 43), the other this man, who is, we
imagine, a boxer, and not incidentally the first person ever to be photographed
smiling. Of the millions of photographs made in the United States before World
War I, only a small number show people of color; likewise, there were very few
black photographers in the daguerrean era. However, the history of this aspect
of American photography has yet to be written, and the facts are elusive. Perhaps
the single largest category of early photographs of blacks is portraits of Civil War
soldiers.

The ambrotype is an underexposed collodion-on-glass negative that appears
positive in reflected light if the back of the glass is coated with black lacquer.
Made in the same standard sizes and housed in the same cases as daguerreotypes,
ambrotypes were faster to make and required less costly raw materials. They began
to displace Daguerre's process for most studio portraiture after 1854, when a
specific practical variant of the ambrotype process was patented in the United
States and England by James Ambrose Cutting.

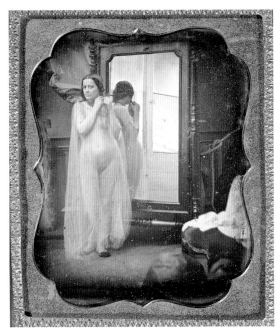

45 UNKNOWN FRENCH PHOTOGRAPHER
Female Nude at Mirror, 1850–52
Hand-colored sixth-plate daguerreotype
6.3 × 5.7 cm (2½ × 2¼ in.)
84.XT.1582.31

Eroticism has had a far-reaching and integral connection with the arts, with its connections to popular traditions of religion, mythology, and magic. The earliest photographs representing erotic subjects were daguerreotypes that originated in France. Erotic imagery created there in the mid-to-late eighteenth century by Antoine Watteau, François Boucher, and Jean-Honoré Fragonard came to an end with the revolution and was succeeded after 1830 by a somewhat morbid and repressed sexuality, manifested in the work of Théodore Chasseriau, Prud'homme, Gerôme, and others. Nude studies by photographers were generally of female subjects and were destined for use by artists in place of living studio models.

The point at which a nude study becomes pornographic cannot be precisely defined. According to the British aesthetician Samuel Alexander, "if the nude is so treated that it raises in the spectator ideas or desires inappropriate to the material subject, it is false art, and bad morals." The art historian Kenneth Clark rebutted this view: "No nude, however abstract, should fail to arouse in the spectator some vestige of erotic feeling, even though it be only the faintest shadow—and if it does not do so, it is bad art and false morals."

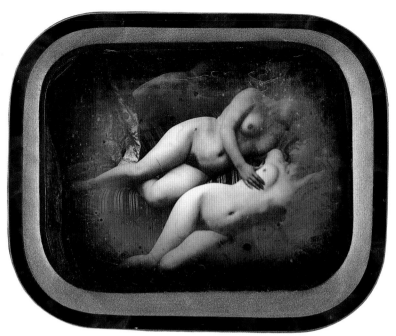

46 UNKNOWN FRENCH
PHOTOGRAPHER
Nude Study with Two Female Figures, ca. 1855
Hand-colored half-plate daguerreotype
10.8 × 14.4 cm (4¼ × 5¹¹⁄₁₆ in.)
84.XT.172.6

The nude figure was not a common subject in early European photography; it is
found almost exclusively in France in the 1840s and 1850s. There are few if any
daguerreian male nudes, and almost all the existing daguerreotypes of nudes rep-
resent individual female models carefully posed as if they were fixtures in a draw-
ing academy. This study of two women gazing adoringly at each other would have
been doubly shocking at the time it was created. The worship of a material object,
whether animate or inanimate, was taboo in Judeo-Christian society, where such
emotions were reserved for adoration of the Deity. This daguerreotype would also
have startled anyone who believed that heterosexual activity was the only appro-
priate form of sexual expression.

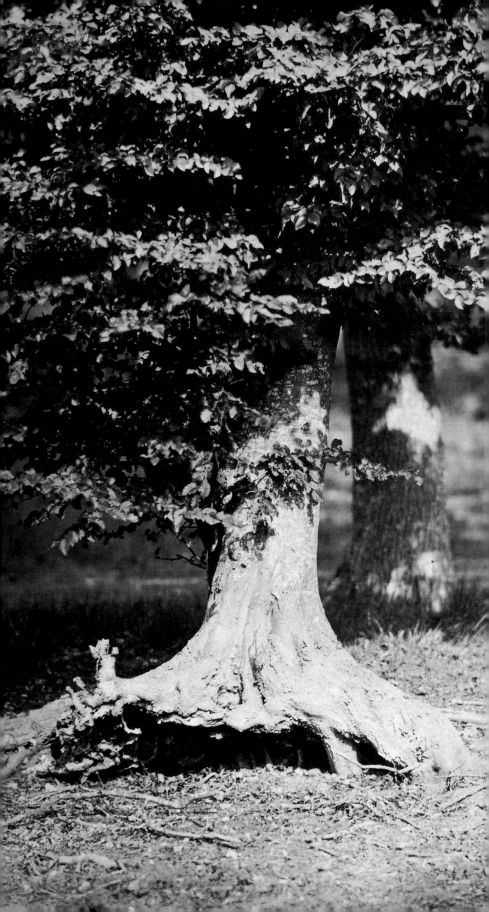

TRUTH AND BEAUTY

The year 1851 marked the beginning of a prolific golden age in the history of photography as new ways to make photographs reliable, uniform, and permanent were discovered. In that year, William Henry Fox Talbot released his patent on the calotype process, and glass negatives began to replace those on paper. By about 1855 the daguerreotype had become obsolete, and by 1860 it had been fully superseded by methods descended from Talbot's 1840 discovery that the image on a photogenic drawing negative could be reliably reversed into one or more positive prints. New materials and techniques quickly evolved that provided the impetus for creative artists to freely explore the potential of photography to reconcile truth and beauty.

While this golden age of photography was international in scope, its strongest creative impact was felt in France and England, where some of the best photographers were first trained as painters. During the decade of the 1850s, photographers were experimenting with the language of photography in order to define the potential of their art. They were also indulging their curiosity about what things would look like when transformed into a photograph.

The audience for photographs was continuously expanding, and along with this growth came a raising of the standards photographers set for themselves. The act of perception itself began to emerge as the chief aesthetic element in the work of the best photographers. If we are to judge by the very low survival rate of some of the pictures made at this time—many exist in just one or two prints—there was very little appreciation by the general public for the subtle visual, psychological, and emotional actualities that the best photographers were beginning to succeed in expressing.

In the 1850s and '60s, alongside the impetus to produce pure art, there also flourished an impetus to exploit the commercial potential of photography. The most successful commercial discovery was Disdéri's carte-de-visite, a small-format portrait mounted on a card and intended for distribution by the sitter to friends and admirers.

Photographers of the era were strongly influenced by painting and literature. They saw their work as a form of visual poetry and as a graphic art comparable to lithography and etching. The most important technical and aesthetic experiments were directed at the medium's potential to reconcile truth and beauty, just as they had been in the masterworks of painting and printmaking.

47 GUSTAVE LE GRAY
French, 1820–1882
Study of Trees and Pathways, ca. 1849
Salt print from a waxed-calotype negative
45.2 × 26.4 cm (7¹³⁄₁₆ × 10⅜ in.)
84.XM.637.6

About 1839, Le Gray was accepted as an apprentice in the studio of the painter Paul Delaroche, where he encountered several individuals who would affect the course of painting and photography. Delaroche himself was a friend of Daguerre's and submitted a deposition in July 1839 to the committee chaired by François-Jean-Dominique Arago, testifying that photography would be helpful and not hurtful to artists. The daguerreotype "will become, for the most skillful painters, a subject of study and observation," Delaroche declared. Charles-François Daubigny had joined Delaroche's circle the year before and was one of the first French painters to devote himself exclusively to painting and drawing landscapes. About 1849, when Le Gray took up photography, his first work was in the forest of Fontainebleau and nearby Barbizon, where Daubigny and Théodore Rousseau were painting from nature. Le Gray's study of a forest scene skillfully overcomes the limitation of the silver salts then in use, which were "blind" to the color green and overly sensitive to blue, thus severely distorting the tonal scale of forest scenes by making the foliage darker than it appears to the eye. Le Gray cleverly chose a time of day when the sun was low in the sky (and so there was less blue in the light) and when the raking angle of the sun's rays filled the lower reaches of the scene with light. The foreground trunks are illuminated from the side, while the sinewy shapes of trees standing farther into the forest are outlined against the sky. Le Gray accepted the sacrifice of detail in the brightest and darkest areas of the picture. Light itself governs the form, becoming the content of the photograph.

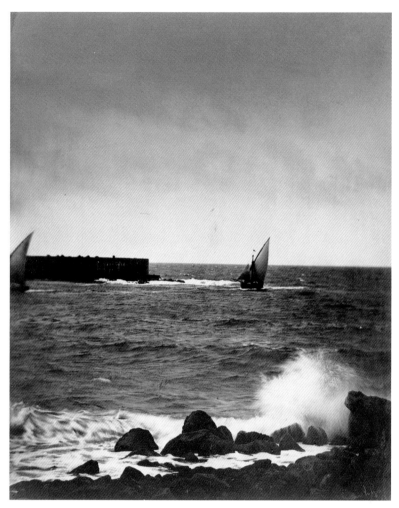

48 GUSTAVE LE GRAY
French, 1820–1882
The Broken Wave, Sète, ca. 1857
Albumen print
41.4 × 33.5 cm (16⅜ × 13¾ in.)
84.XM.347.11

After having worked with landscape, architectural, and portrait photography
for seven or eight years, Le Gray suddenly shifted direction about 1855 and made
a series of some thirty seascape and maritime studies that created surprise and
even puzzlement because of their originality. A constant experimenter, he was
undaunted by the obdurate chemical and mechanical limitations that kept other
photographers from achieving on paper what they could see with their own eyes.
Subjects like a moving boat and a wave breaking on the rocks were thought to be
outside the scope of photography because the wet collodion was not receptive
enough to light, and exposures—made by manually removing and replacing the
lens cap—were slow. No earlier photographer so successfully captured the
dynamic forces of nature.

49 HENRI-VICTOR REGNAULT
French, 1810–1878
Sèvres, the Seine at Meudon, ca. 1853
Carbon print by Louis-Alphonse Poitevin (French, 1819–1882)
31.1 × 42.5 cm (12¼ × 16¹³⁄₁₆ in.)
92.XM.52

Regnault, a professor of physics at the Collège de France, where he performed classic experiments in thermodynamics and the properties of gases, obtained samples of Talbot's printing calotype papers from Jean-Baptiste Biot. Biot was the chief advocate of Talbot's method in France, and Regnault's good luck may have resulted from the meeting between Talbot and Biot in Paris in 1843. By 1852, the year before this negative was made, Regnault had become director of the porcelain factory at Sèvres and was hopeful that photographs could be as permanent as painted porcelain. This print was made with highly durable carbon ink using Alphonse Poitevin's carbon ink process, which was related to lithography (see pl. 3).

This is an important complement to Silvy's *River Scene (La Valleé de l'Huisne* (pl. 50), where a similar interest in idyllic landscape composition related to Barbizon School and early Impressionist painting is evident. Regnault experimented with different printmaking processes. Using a waxed-paper negative, he created a print of great clarity. This unusual collaboration between Regnault and Poitevin is a carbon print made by that process's inventor. It is a benchmark in the history of the photomechanical printing of photographs.

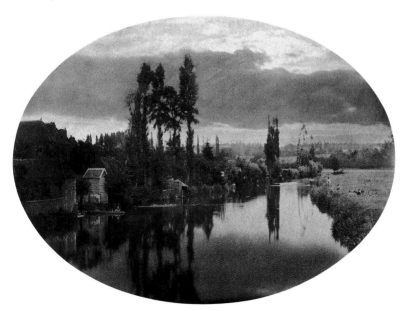

50 CAMILLE SILVY
French, 1834–1910
River Scene—La Vallée de l'Huisne, negative, 1858; print, 1860s
Albumen print
25.7 × 35.6 cm (10⅛ × 14 in.)
90.XM.63

Silvy, who lived and worked in France and England in the 1850s and 1860s, is best known to the twentieth century through his *River Scene,* an image that has survived in just four prints, each very different in appearance. Inspired by painters of the Barbizon School, Silvy's four versions of this subject are the photographic counterparts of experiments by Corot and Daubigny with the cliché-verre and etching. As Mark Haworth-Booth has discovered, each of Silvy's *River Scene* prints shows a different treatment of sky and atmosphere, changes that were achieved by utilizing multiple negatives and different toning methods. Silvy appears to have created two master negatives, one for the clouds and the other for the landscape. Some prints, including this one, may have been copied from the originals using skillfully made paper negatives that introduced a grainy image structure. This print was perhaps made in the 1860s, when the Barbizon School was giving way to Impressionism.

51 NADAR
French, 1820–1910
Finette of Mabille, ca. 1855
Salt print from a wet-collodion-on-glass negative
22.3 × 15.6 cm (8²⁵⁄₃₂ × 6⅛ in.)
84.XM.436.496

The majority of Nadar's subjects were men who achieved prominence in the arts, letters, or politics, with the majority known to us by their full names. Here we see an elegantly costumed and coiffed young woman identified by Nadar by her first name, Finette, and by her milieu, Mabille, a pleasure garden where dancing girls performed. The elegant paisley shawl, bold silk ribbon, tight-fitting kidskin gloves, and finely crocheted scarf woven with real flowers are the unabashedly sexual costume of a demimondaine. The selective focus that leaves her forearm blurry reinforces the idea of this as a snapshot of someone who has just walked into the photographer's studio. The natural-seeming pose, gesture, and expression required a close collaboration between the artist and his model.

52 NADAR
French, 1820–1910
Self-Portrait, ca. 1854–55
Salt print
20.5 × 17 cm (8⅟₁₆ × 6¹⅟₁₆ in.)
84.XM.436.2

Before he dedicated himself to photography in the early 1850s, Nadar was—as he tells us in his autobiography—a poacher, a smuggler, a bureaucratic functionary, and a fighter for the cause of Polish liberation. *Nadar* was the nickname Gaspard-Félix Tournachon used in the 1840s to sign his stinging lithographic caricatures. While his drawings depended on bold exaggeration for their success, his photographs are marked by a spontaneous naturalism. Here, gentle light falls from above, leaving the right side of his face in partial darkness. His deeply shadowed eyes gaze at the observer, as though the camera did not exist. Equally expressive are his hands.

53 ANDRÉ-ADOLPHE-EUGÈNE DISDÉRI
French, 1819–1889
The Organ-Grinder, ca. 1853
Salt print
15 × 12.1 cm (5²⁹⁄₃₂ × 4¾ in.)
90.XM.56.4

The power to depict the flux and flow of daily life was largely denied to photographers of the 1840s and early 1850s, because all of the standard processes required the subject to be completely motionless. Despite such practical limitations, Le Gray had devised a way to arrest the motion of a breaking wave (pl. 48), and Nadar had succeeded in making his portrait subjects appear as though they had just walked off the street and into his studio (pl. 51). Other photographers, such as Disdéri and Nègre, actually went into the streets to photograph colorful characters. In 1852, Disdéri created a wet-collodion formula that he claimed increased the light sensitivity of this material. He exploited it commercially through a new type of small-format photograph most frequently used for portraits that he called *cartes-de-visite*. However, to achieve the look of instantaneity, strategic planning was the photographer's best ally. Here the inertia of the heavy musical instrument is played off against the stance of the model, who braces himself to oppose the force of gravity. Notice the blurred fingers turning the handle, which is secure evidence that Disdéri had not discovered a revolutionary chemical means of greatly increasing the sensitivity of his plates. Instead, he has used his materials to create an illusion. The pose and gesture, however fictional they may be, nevertheless express the emotions aroused by music.

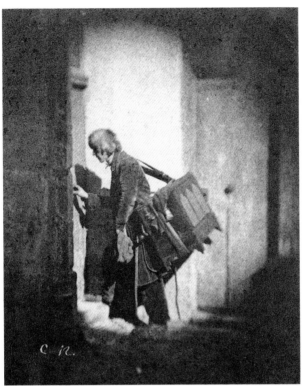

54 CHARLES NÈGRE
French, 1820–1880
Organ-Grinder at 21, Quai Bourbon; Île Saint-Louis, Paris, before March 1853
Salt print from a paper negative
10 × 8.2 cm (3¹⁵⁄₁₆ × 3¼ in.)
84.XM.344.1

Like Disdéri, Nègre uses clever posing to fool our eyes into believing that the
motion of his subject has been stopped; such trickery was required to stop motion
before Muybridge (pls. 127–29) proved it could actually be done. The figure is
posed as though he is leaning into his stride and is about to step through a door
we cannot see. Actually he is bracing himself against the wall with one hand.
Nègre was more than a trickster, though. By using a large aperture and organizing
his composition at the center of the plate, he was able to shorten his exposure
time greatly, although he was forced to accept a darkening of the edges as a conse-
quence. By designing the composition around the interaction of bright highlight
and deep shadow, he could use light to vitalize an otherwise static composition.
Nègre and Disdéri heroized the workingman a decade before Gustave Courbet
and Jean-François Millet did so in painting. In the process, they aligned them-
selves with the Realist movement in art and literature.

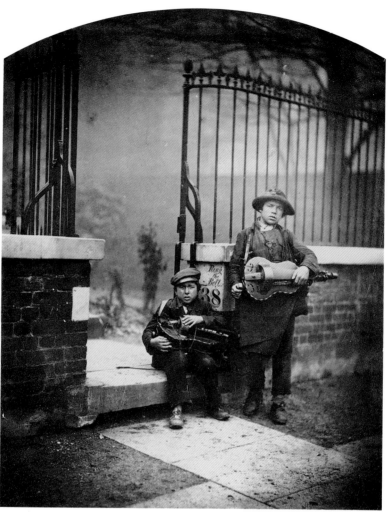

55 CAMILLE SILVY
French, 1834–1910
Street Musicians, ca. 1860
Albumen print
27.8 × 22.2 cm (11 × 8¾ in.)
85.XM.516

Between the early 1850s, when Disdéri and Nègre made their groundbreaking studies of street musicians, and the early 1860s, new lenses with greater light-gathering powers and the enhanced sensitivity of wet-collodion chemistry made photographs of everyday situations more attainable. Photographers also began to incorporate atmospheric effects into their photographs. Silvy, who was born to a well-off family in the farming village of Nougent-le-Rotrou (pl. 50), spent much of his life as a professional photographer in London, where his portrait studio specialized in the carte-de-visite photographs that made Disdéri a rich man back in France. In this photograph, the artist had two goals: to portray the romantic ideal of two children earning a livelihood as players of the hurdy-gurdy and to capture the atmosphere outside the door of his studio in Porchester Terrace, London.

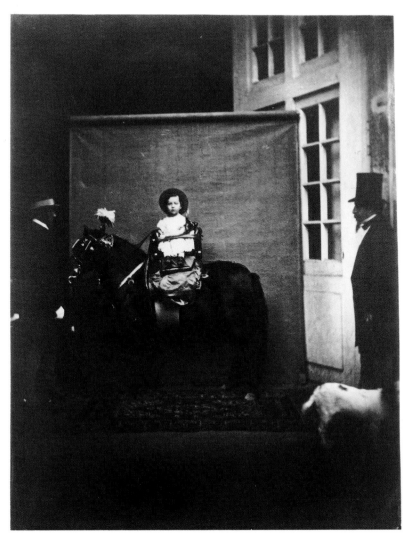

56 PIERRE-LOUIS PIERSON
French, 1822–1913
Napoleon III and the Prince Imperial, ca. 1859
Albumen print from a wet-collodion-on-glass negative
21.1 × 16 cm (8¼ × 6⁵⁄₁₆ in.)
84.XM.705.1

The revolution of early 1848 was a victory for the workingman in France, and it opened the door for the election of Louis-Napoleon Bonaparte to the presidency. His popularity was great, and he was elected to a ten-year term as president on December 20, 1848. However, on December 2, 1851, Louis-Napoleon staged a coup d'état and declared himself emperor. In early 1853, he married a Spanish noblewoman, Eugénie de Montijo, who in March 1856 bore a son, Eugène-Louis-Jean-Joseph, who was made the Prince Imperial. A version of this image that was cropped to show just the prince on his pony was sold as a carte-de-visite; however, the untrimmed version reveals a setting in which the emperor and his dog are treated as silhouettes at the edge of the picture and play almost equally significant roles in the composition of the photograph.

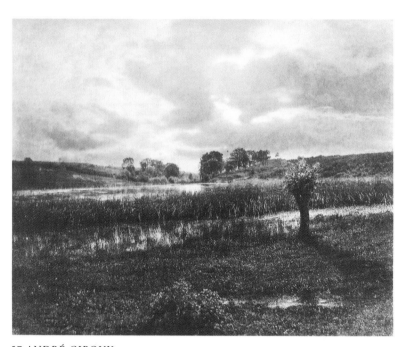

57 ANDRÉ GIROUX
French, 1801–1879
The Ponds at Obtevoz (Rhône), ca. 1855
Salt print
26.7 × 33.8 cm (10½ × 13⁵⁄₁₆ in.)
84.XP.362.3

The son of Alphonse Giroux, who manufactured Daguerre's cameras, André Giroux was a painter twenty years older than Le Gray (pls. 47–48, 58). Giroux was among the first photographers to experiment with retouching his negatives to achieve atmospheric effects and intense painterly highlights, seen here in the bright streaks reflecting off the pools. A wet-collodion-on-glass negative could not record brilliant reflections by purely photochemical means until the advent of orthochromatic emulsions in the late 1880s. Giroux's effects were created by drawing and scratching on his negatives; his photographs recall etchings by Barbizon School artists like Charles-François Daubigny.

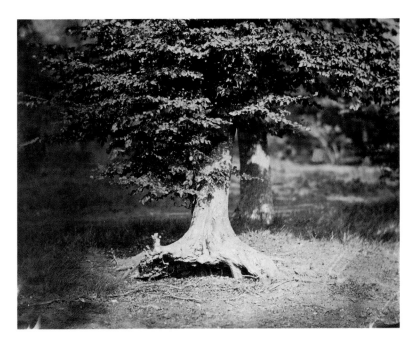

58 GUSTAVE LE GRAY
French, 1820–1882
The Beech Tree, ca. 1856
Albumen print
31.9 × 41.3 cm (12⅞ × 16¼ in.)
84.XM.637.22

Even though in his seascapes he sometimes printed clouds from a second nega-
tive, Le Gray was generally a purist who believed the best photographs resulted
from the direct use of materials rather than from the kind of manual intervention
favored by Giroux (pl. 57). In focusing on the lower trunk of a beech tree, Le
Gray directs our eyes to a commonplace subject whose intrinsic interest is mini-
mal; the image anticipates the tree studies of Courbet and Corot. This particular
light-washed tree has nothing heroic about it save its wounded root. Its signifi-
cance lies in the artist's power to observe and record the ineffable effects of light
and shadow.

59 ÉDOUARD BALDUS
French, 1815–1882
Mulatière Bridge, 1855–56
Albumen print
28.4 × 43.6 cm (11¾₆ × 17¼ in.)
84.XO.401.5

60 CHARLES MARVILLE
French, 1816–1879
The Horse Market, negative,1860s;
print, after 1871
Albumen print
26.2 × 36.8 cm (10¾₆ × 14½ in.)
84.XM.346.18

Marville and Baldus were almost exact contemporaries and surely knew each other as friendly competitors in the specialized world of field photography. Along with their younger colleague Collard (pls. 61–62), they shared the intuitive understanding that photographs of architecture and landscape depend to a large degree on the skillful handling of space. Perspective is an element in landscape photographs that is evasive and ever-changing and is often not apprehended as a structural element, even though it is felt as a force. Architectural photography depends almost exclusively on the photographer's ability to control perspective in order to locate mass in its spatial context and to structure the composition. Baldus, Marville, and Collard carefully chose the positions for their cameras to maximize the power of the lens to reorganize parallel lines so that they appear to converge in the distance. Baldus establishes an oblique viewpoint, a compositional strategy that recalls Marville's audacious treatment more than a decade before of the Ecole des Beaux-Arts (pl. 27).

The best photographers of the 1850s and 1860s spent much creative time proving two points: that they were in control of their materials and that they could earn a livelihood from subjects other than portraiture. Trained as an artist

in drawing and engraving, Marville was a collaborator with Blanquart-Evrard (pl. 26) in the early 1850s and aligned himself with the Barbizon School. Forest scenes gave way to the urban subjects for which he received government commissions. When Baron Haussmann became prefect of the Seine district in 1853, one of his first actions was to commission a team of photographers—including Le Gray, Nègre, Baldus, and Marville—to record the city. Working in the winter when the trees are bare, Marville here concentrates his gaze on the horse market, empty of all its usual activity save for a single bystander. By deciding to frame the composition within two walls, Marville anticipates Atget (pls. 102, 161, 176), who saw Paris as if through the proscenium of a theater stage.

Baldus made his photograph to record the completion of a bridge located on the new railway line from Paris to Lyons, no doubt having been commissioned by the management of the railroad company. His photograph is a foil to Marville's: it shows a place that would normally be void of human presence at a moment when it is populated. The blurry, out-of-plumb figure tugging on a line set dead center at the bottom edge would not have been possible to capture photographically a decade earlier.

61–62 HIPPOLYTE-AUGUSTE
COLLARD
French, 1811–after 1887
Viaduct, ca. 1870
Albumen print
25.2 × 35.3 cm (9¹⁵⁄₁₆ × 13¹⁵⁄₁₆ in.)
84.XP.776.1

*Roundhouse for Thirty-two Locomotives
at Nevers on the Bourbonnais Railway,*
ca. 1860–63
Albumen print
31 × 22.4 cm (12¼ × 8¹⁵⁄₁₆ in.)
84.XO.393.28

For nearly two decades, Baron Haussmann directed the work of demolishing old buildings in Paris to make way for a network of broad boulevards that replaced narrow streets dating back to the middle ages. He was also responsible for new parks, bridges, and buildings for public assembly. While photographers like Le Gray, Nègre, Baldus, and Marville concentrated on documenting the parts of old Paris that were scheduled for replacement or renovation, Collard gave himself over to recording the new construction. He occupies a special place among French photographers of this period because of a concern for elements of formal design that looks forward to the twentieth century.

Bridges and sprawling interior spaces do not easily lend themselves to summary in a single picture, yet that was what Collard attempted. In order to accomplish this, he had to apply great intelligence to the choice of where to place his camera and how to find the best light for his subject. Positioning himself under the viaduct, Collard chose a spot that is centered, not on the outside of the structure but rather toward the middle of the right-hand arcade, thus establishing an unobstructed line of sight to a point in the far distance. The time of day is late afternoon or early morning, when raking light establishes deep shadows that define the severe spatial recession.

After 1850, France's railroads expanded rapidly under private ownership and with the encouragement of Napoleon III. Enormous albums of photographs were commissioned to communicate visual information to investors in the new transportation system. Here, six steam engines are arrayed like specimens in a collector's cabinet. The vast space was made possible by the use of cast iron to support the many skylights that elegantly served the photographer's purposes. The challenge for him was to stretch the lens's field of vision to its technical limits.

63 ADOLPHE BRAUN
French, 1812–1877
Still Life of a Hunting Scene, ca. 1860
Carbon print
77.3 × 56.3 cm (30⅞₆ × 22⅛ in.)
84.XP.252.1

Still life as a distinct category of painting was a product of European art of the Baroque period, originating almost simultaneously in Italy and Flanders. It was often considered "below" history and sacred subjects in importance. In the mid-nineteenth century, the genre was still thought by some artists to be a lesser form, but photographers nevertheless looked to this painting tradition for inspiration.

After a start photographing floral arrangements, Adolphe Braun began to specialize in photographing paintings in museums for documentary purposes, and he traveled widely to the European museums and royal collections. He would have seen the still life paintings of Frans Snyders that often included the carcasses of dead game. The large size of this photograph and the fact that it is printed in the highly durable carbon process suggest that it was intended for permanent framed display, like a painting.

64 ROGER FENTON
British, 1819–1869
Still Life with Fruit and Decanter, 1860
Albumen print
35.4 × 43.2 cm (13¹⁵⁄₁₆ × 17 in.)
85.XM.354.4

When the word *experimental* is used in relation to photography, Fenton's name does not generally spring to mind. Probably trained in the studio of Paul Delaroche, Fenton shared a common characteristic with Le Gray, Nègre, and Regnault (who were all apprentices with Delaroche about the same time): much of their work does not appear to stretch boundaries. But when Fenton's underlying artistic ideas are studied, we see that experiment was essential to achieve the results he produced. The genius of this still life with pineapple, grapes, peaches, and plums lies in its formal contradictions. The arrangement is simultaneously broad and detailed, spare and complex. The large organic masses of colossal specimens of pineapple, squash, and plum are defined by the densely textured surface details. The subtle translucency of the glass decanter and its square shape are played against the adjoining curve of a woven basket. A kind of visual magic makes this tilted basket seem to float.

65 ROGER FENTON
British, 1819–1869
Seated Odalisque, ca. 1858
Albumen print
36.2 × 43.8 cm (14¼ × 17¼ in.)
92.XM.53 [Purchase, partial gift of R. Joseph and Elaine Monsen]

The European fascination with the Islamic Orient in the first half of the nine-teenth century was reflected in two ways in later photographs. On the one hand, photography was used to record the architecture, landscape, and people of the region, as Moulin did; on the other, it was used to appropriate Islamic motifs into works of art for the sake of art alone, as Fenton did. On February 20, 1855, Fenton sailed on the H.M.S. *Hecla;* his destination was Balaklava in the Crimea, where Russia was at war with Turkey, England, France, and Sardinia over the final disposition of the decaying Ottoman Empire. The Crimean War focused the at-tention of Europeans on Middle Eastern culture and politics, resulting in a new wave of Orientalism in art. The soldiers returned with handicrafts—textiles, musical instruments, and decorative objects—obtained in the bazaars of Sebas-tapol and Constantinople, and Fenton incorporated these objects as props in a series of photographs he made in his well-lighted studio in England. Fenton has posed his model, who is outfitted in the voluptuous costume of a Turkish dancer, as she reclines on a divan in a pose that recalls the odalisques of sixteenth-century Italian painting. She cradles a goblet drum, her bare foot sensuously exposed, and she gazes invitingly at the observer with the practiced charm of a great courtesan.

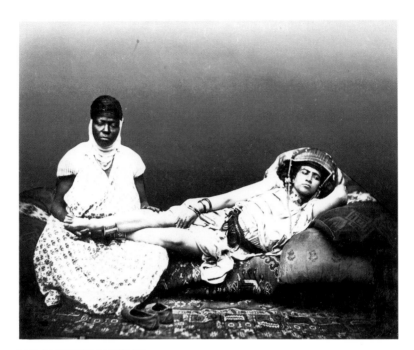

66 F. JACQUES MOULIN
French, ca. 1800–after 1869
A Moorish Woman with Her Maid, ca. 1865
Albumen print
18.2 × 22.8 cm (7⅛ × 8³¹⁄₃₂ in.)
84.XO.431.31

F. Jacques Moulin traveled to North Africa a decade later in the entourage of
Napoleon III, who had designs on the commercial potential of the ports of the
Middle East and Africa. Once there, he gained access to the inner sanctums of
Islamic society. In this photograph we are shown, not a model dressed in the
costumes of a foreign land, but two women in their native habitat. Created the
same year that Édouard Manet's *Olympia* was first shown in the Paris Salon to a
great public uproar because of its subject and its absence of shadows and model-
ing, Moulin's photograph would have created just as much outrage had it been
displayed in any Moslem land, because it violated Islamic laws about the sanctity
of womanhood.

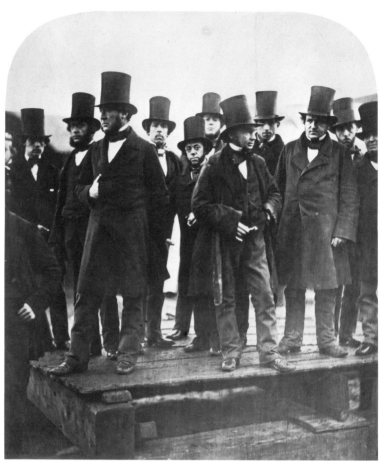

67 ROBERT HOWLETT
British, 1831–1858
I. K. Brunel and Others Observing the "Great Eastern" Launch Attempt,
November 1857
Albumen print
24.8 × 21.4 cm (9¾ × 8⅜ in.)
89.XM.68.2

Even when done in the photographer's studio, group portraits were difficult, because if one figure moved, the resulting blur was thought to violate the integrity of a photograph (see pl. 37). For this reason, photographers were slow in approaching situations that involved more than four people. Howlett, who was one of the daring innovators in British photography of the 1850s, may have been challenged to exceed what was believed possible by his friend, Isambard Kingdom Brunel, who was one of the most brilliant designers of ships, bridges, tunnels, and harbors of his generation. Brunel is shown here on the occasion of an unsuccessful launching of the *Great Eastern* steamship, the largest vessel of its time. The photograph brilliantly captures a large group of men, who may have been investors in the enterprise, observing the enormous vessel that was stuck on the launching ways. The variety of intersecting poses and overlapping gestures recalls the figures in Hill and Adamson's *Newhaven Fishermen* (pl. 23), who were at the opposite end of the social spectrum.

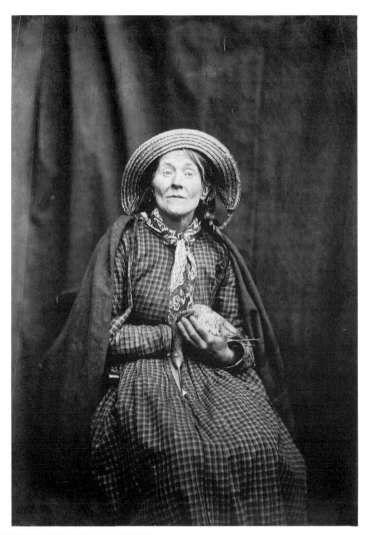

68 HUGH WELCH DIAMOND
British, 1809–1886
Seated Woman with Bird, ca. 1855
Albumen print
19.1 × 13.8 cm (7½ × 5⅟₁₆ in.)
84.XP.927.3

In 1856, Diamond published a paper entitled "On the Application of Photography to the Physiognomic and Mental Phenomena of Insanity." It was based upon work he did in his capacity as superintendent of the female department of the Surrey County Asylum, a post he assumed in 1848. Diamond was a physician, who joined Herschel (pls. 1–2) and Brewster (pls. 19–20) in duplicating Talbot's photogenic drawing process not long after it was announced in 1839. Thus, he was one of the first Englishmen skilled in photography, which he very soon applied to his psychiatric work. This study of a woman tenderly cradling a dead waterbird fills us with empathy. On her face we read an emotional state that is comparable to Poe's (pl. 31). His face expresses repressed anxiety; here we see eyes that are disturbing, but a face that is at peace with what she sees of the world.

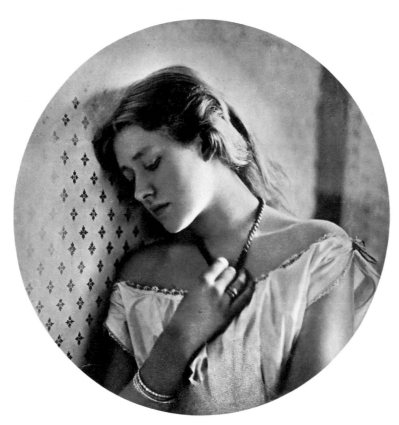

69 JULIA MARGARET CAMERON
British, 1815–1879
Ellen Terry at Age Sixteen, negative, 1864; print, ca. 1875
Carbon print
24.1 cm (9½ in.) in diameter
86.XM.636.1

Cameron was possibly the first photographer who had a clearly defined theory of her art and who articulated her credo, in a statement consisting of a single sentence written to her mentor, Herschel (pls. 1–2), on New Year's Eve 1864: "My aspirations are to ennoble Photography and to secure for it the character and uses of High Art by combining the real and the Ideal and sacrificing nothing of Truth by all possible devotion to Poetry and beauty." Made at the very beginning of the photographer's career, this study of the actress Ellen Terry (1847–1928) in the year of her marriage at the age of sixteen to Cameron's good friend, the painter G. F. Watts, expresses the perennial conflict in photography between—in Cameron's terms—the Real and the Ideal. Terry represents the ideal of youthful beauty, which is defined by an accumulation of truthful details—a perfectly formed face, flawless skin, and a seductive mane of loose-flowing hair. Yet the photograph itself is physically imperfect and shows later repairs to the negative that were required to remedy Cameron's still uncertain technique.

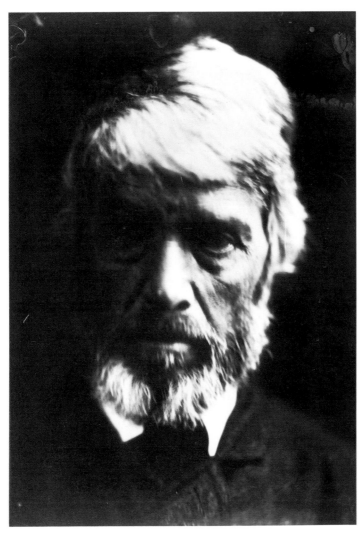

70 JULIA MARGARET CAMERON
British, 1815–1879
Thomas Carlyle, 1867
Albumen print
36.4 × 25.8 cm (14⁷⁄₁₆ × 10⁳⁄₁₆ in.)
84.XM.443.23

"'Man of genius:' O Maecenas Twiddledee, hast thou any notion what a Man of
Genius is? Genius is 'the inspired gift of God,'" wrote Carlyle in 1866, in his
essay "The Gifted." We can imagine Cameron and Carlyle in impassioned con-
versation about "genius" and their shared admiration for John Milton, whose
poem "Il Penseroso" is spoken by a sage who worships melancholy. Carlyle had
lost his wife, Jane, the year before this portrait was made, and he was still grieving
for her. Cameron's photograph is a reconciliation of opposites, with light as its
chief metaphor. By dividing Carlye's face in half with a blaze of raking light,
Cameron here explores the relationships of light and dark that are central to
Milton's poem and its pendant, "L'Allegro."

WITNESS TO HISTORY

The decades of the 1860s and 1870s produced persistent experiments with the language of photography in order to define the outer limits of expression in the new materials and to aggressively investigate subjects that were new to the visual arts. Photographers tested new ways of seeing as well as new techniques, so that experiments in perception and in technique unfolded side by side.

Glass plates had to be coated and sensitized in portable dark chambers just before each exposure; negatives were much less light sensitive than those of today, and exposures were made by removing and replacing the lens cap manually. Commercially available photographic materials before about 1890 were sensitive chiefly to blue light. Thus, in photographs of landscapes, green leaves and sky were badly distorted, with leaves turning black and the sky reading as white. Clouds were absent, unless they were printed from a separate negative.

During the era of exploration and discovery, photographers traveled to six of the seven continents and illustrated nearly every aspect of the physical world, from its smallest elements to social types. Photographers explored issues ranging from the practical to the philosophical. Portraits of political and religious leaders gave photography a new role as propaganda. One of the first persons to recognize the journalistic potential of photography was Mathew Brady, who hired a team of photographers to travel with the Union Army during the Civil War. The new medium was pressed into service by architects and engineers to record buildings and public works projects, and by industrialists to portray steam locomotives and the largest sailing vessels that had yet been constructed.

The grand scale of their subjects drew photographers to increase the size of their pictures. The most practical way to do so was to increase the size of the camera so as to produce a negative of the same size as the desired print. The largest cameras manufactured in commercial quantities were designed to accommodate sheets of glass twenty by twenty-four inches in size, compared to the eight-by-ten- and five-by-seven-inch plates that were standard. The mammoth plate camera was nearly two feet square, with a bellows that could extend four feet from the plane of focus. Fitted with a lens weighing nearly five pounds, the plate camera was the ideal instrument with which to record grand landscape panoramas and the products of heavy industry.

71 SAMUEL BEMIS
American, 1789–1881
View of a Barn, 1840–41
Whole-plate daguerreotype
15.8 × 21.3 cm (6⅟₁₆ × 8⅜ in.)
84.XT.180.2

When photographers first traveled some distance from home for the purpose of making photographs, their subjects were rarely landscapes, humans, or animals. Instead they sought out art and architecture. Samuel Bemis, who was a Boston dentist, visited the White Mountains region of New Hampshire in 1840 and made one of the earliest photographs of an outdoor scene that has survived from North America. Bemis concentrated his attention on a small wooden barn near Crawford's Notch in the White Mountains. The barn's construction is somewhat unusual in that its surface consists of vertical running planks butted edge to edge, but the most commanding aspect of this picture is less the design of the structure than the remarkable way in which its cubic essence is defined by light and shade.

72 PHILIPPOS MARGARITIS AND PHILIBERT PERRAUD
Greek, 1810–1892; French, 1815–?
The Temple of Athena Nike, Greece, ca. 1847
Quarter-plate daguerreotype
9.1 × 6.9 cm (3¹⁵⁄₁₆ × 2¾ in.)
84.XT.65.4

When Europeans took their daguerreian equipment outdoors, they were more than likely to focus it on a structure of great antiquity and historical importance, such as the Parthenon. This process of making a daguerreotype outdoors was tedious and demanding and could not be counted on to produce reliable results. Moreover, the daguerreotype—being a unique picture on a sheet of silvered copper—cannot be cheaply or readily copied for publication. Thus, daguerreotypes were not very efficient tools for disseminating visual information. If they were to achieve this goal, they had to be copied by an engraver and printed in ink on paper.

Considering the importance of the Acropolis to Western civilization, it is surprising that this daguerreotype of a temple near the Parthenon is the earliest to have survived. Made by a partnership of a Frenchman and the first Greek photographer, this image can be dated by the existence of construction materials in place for the renovations that ended about 1847.

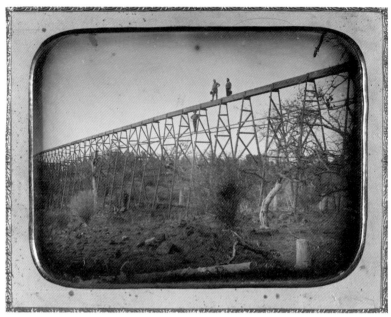

73 UNKNOWN AMERICAN PHOTOGRAPHER
Flume Near the North Fork of the American River, 1849
Half-plate daguerreotype
8.5 × 11.8 cm (3⅜ × 4¹¹⁄₁₆ in.)
84.XT.1581.7

The California Gold Rush of 1848 caused a frenzy of building and drew opportunity-seekers from around the world. All of this activity brought daguerreian photographers out of their studios to record the sudden changes in the American landscape. Patent restrictions on Talbot's calotype prevented its free use outside of England and Scotland, and thus almost all early California mining scenes are daguerreotypes. Henry Snelling, America's first theorist of photography, advised that "impatience is a great drawback to perfect success." The subject of this daguerreotype—a wooden aqueduct near the American River in northern California—would have tested the patience of even the most skillful photographer. Once the photographer had decided on the best viewpoint for this particular picture, a tree had to be felled in the foreground in order to eliminate the obstruction. The men standing on the flume, who are no doubt among its builders, then had to be posed.

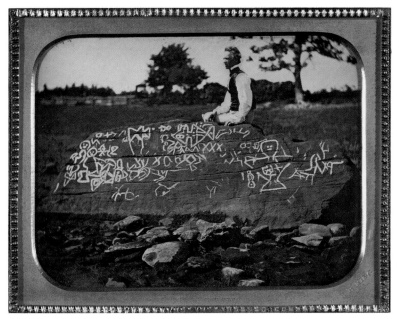

74 ATTRIBUTED TO HORATIO B. KING
British, 1830–1905
Seth Eastman at Dighton Rock, 1853
Half-plate daguerreotype
8.8 × 12 cm (3½ × 4¾ in.)
84.XT.182

America was slower than Europe to shift from the daguerreotype to negatives on paper and glass. When photographers of the pioneer generation focused on subjects such as this one—which, for scientific reasons, deserved to circulate beyond the limited number of eyes that could behold a unique daguerreotype—they must have felt a particular loss at not being able to easily duplicate the image. Selected examples of the ancient picture writing of Pharaonic Egypt had already been recorded on paper negatives by Maxime Du Camp in the late 1840s and by Felix Teynard and John Beasly Greene in the early 1850s. The artist Seth Eastman was commissioned to create illustrations for H. R. Schoolcraft's book *Indian Tribes of the United States* (1854). Collaborating with the Massachusetts daguerreian H. B. King, Eastman highlighted the petroglyphs with chalk and seated himself on the New England monolith, while King operated the camera. Based on this photograph, Schoolcraft decided the carvings—first recorded in 1680— were authentic survivals from American prehistory. Since Schoolcraft's time, the carvings have been attributed to Viking sailors, Portuguese explorers, and even Phoenician voyagers.

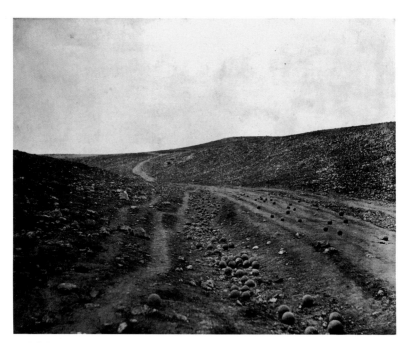

75 ROGER FENTON
British, 1819–1869
The Valley of the Shadow of Death, 1855
Salt print
27.4 × 34.7 cm (10⅞ × 13¾ in.)
84.XM.504.23

Among the first writers to present a unified critical and historical approach to photography was Ernest Lacan, who in 1859 perspicaciously wrote that 1855 had been a "watershed year in photography that divided the primitive from the modern." In 1843, Fenton went to Paris to spend a two-year apprenticeship in Paul Delaroche's studio, and he was—with Gustave Le Gray, Charles Nègre, and Henri Le Secq—among those whose work a decade later defined the transition from primitive to modern in early photography. Fenton's opportunity for innovation came when he received a commission from the publisher Thomas Agnew to create a photographic record of the Crimean War. Armed with letters of introduction to the British commanders, Fenton was prevented by the limitations of his materials from photographing at the front lines. His most powerful work derives from his experience as a landscapist, as here, where he shows the plain of Balaklava littered with cannonballs that, in this context, become the poetic symbols of destruction. Fenton made over three hundred negatives, many of them portraits of officers and groups of enlisted men. In September 1855, these photographs were exhibited at the gallery of the Watercolour Society in London.

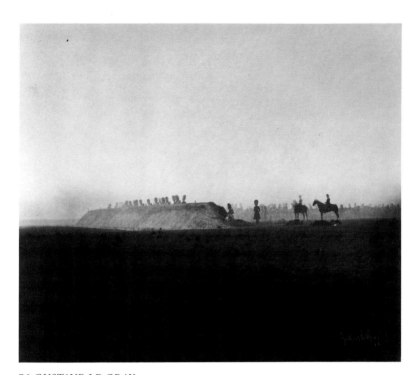

76 GUSTAVE LE GRAY
French, 1820–1882
Cavalry Maneuvers, Camp at Châlons, 1857
Albumen print
31 × 36.7 cm (12³⁄₁₆ × 14⁷⁄₁₆ in.)
84.XO.377.12

Like Fenton, Le Gray was a seasoned landscape and portrait photographer. In 1857, Napoleon III commissioned Le Gray to commemorate the inauguration of, and chronicle life in, the vast military camp established that year on the plain at Châlons-sur-Marne. Designed to accommodate twenty-five thousand imperial guards and staff, the camp sprawled over thirty thousand acres of mostly flat terrain. Le Gray's photographs comprise images of cavalry exercises on a grand scale and, like Fenton's Crimean work, include genre studies of troops in bivouac, formal portraits of officers, records of ceremonies (including High Mass), and multipart overall panoramas (counterparts of Fenton's Crimean panoramas) of the camp as seen from the emperor's central pavilion. In this photograph, lines of cavalry behind a field bulwark are cloaked in an atmospheric mist new to photography. They occupy a narrow band across the center of the picture, leaving a great empty swath of pale sky and a dark, nearly vacant foreground. In contrast to Fenton's spare and unusual *Valley of the Shadow of Death* (pl. 75), this photograph romanticizes the scene by miniaturizing the figures—a practical necessity to mitigate the blurring effect caused by men and horses in action.

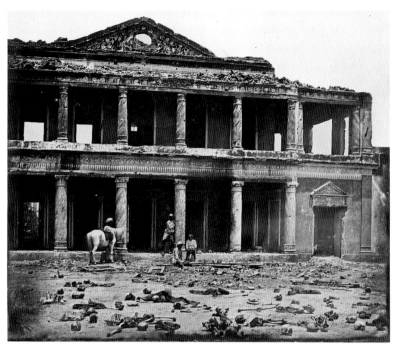

77 FELICE BEATO
British (b. Italy), 1825–1903
Interior of "Secundra Bagh" after the Massacre, 1857
Albumen print
24 × 28.9 cm (9¾₆ × 11¾₆ in.)
84.XO.1168.7

Roger Fenton chose not to photograph scenes of suffering and distress; Felice
Beato took the opposite approach in reporting on the aftermath of the bloody
Sepoy Rebellion of 1857–58, when the native soldiers (sepoys) of the Bengal
Army of the British East India Company rebelled against their foreign employer
for reasons that were as much religious as political. The Bengalese soldiers feared
they would be forced to adopt Christianity, and they resented being issued rifle
cartridges lubricated with beef and pork lard, in violation of Hindu and Moslem
laws. The rebel leader was Nana Sahib, who directed the massacre of the English
garrison and colony at Cawnpore, including women and children. The British
retaliated by dispatching to India Sir Colin Campbell, who had led the Highland
Brigade to victory over the Russians at the battle of Balaklava (pl. 75). The feroc-
ity of the British reaction is reflected in Beato's study of the skeletons of some of
the two thousand rebels killed at Lucknow in November 1857. The corpses went
unburied and were stripped of their flesh by scavengers of carrion. Were the bones
rearranged by the photographer and his assistants to create a macabre still life? In
all likelihood they were, so as to concentrate them in the flat foreground area to
achieve maximum visual effect. The facade of the building is pocked with shell
craters from cannons fired at close range.

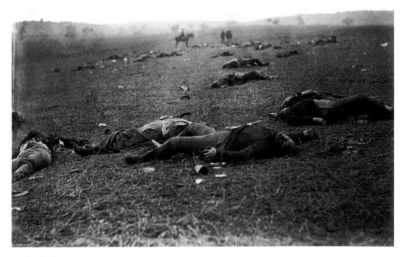

78 TIMOTHY H. O'SULLIVAN
American, 1840–1882
A Harvest of Death, July 4, 1863
Albumen print by Alexander Gardner
17.7 × 22 cm (7 × 8¹¹⁄₁₆ in.)
84.XO.1232.1.36

Located in southern Pennsylvania near the Maryland border is the town of Gettysburg. The farmland surrounding Gettysburg was the site of the greatest battle of the Civil War on July 1–3, 1863, when Robert E. Lee faced George Gordon Meade, who had just succeeded George Hooker as commander of the Army of the Potomac. Made on Independence Day, O'Sullivan's photograph shows two dozen of the 43,000 men who died. The mouth of the nearest corpse is wide open, graphically preserving the agony of his death. Gettysburg was the turning point of the war; thereafter, the fortunes of the Confederacy declined markedly. Four months later, on November 19, Abraham Lincoln delivered his celebrated address at this site: "We have come to dedicate a portion of that field, as a final resting place for those who here gave their lives that that nation might live. It is altogether fitting and proper that we should do this. But, in a larger sense, we cannot dedicate—we cannot consecrate—we cannot hallow—this ground. The brave men, living and dead, who struggled here, have consecrated it far above our poor power to add or detract."

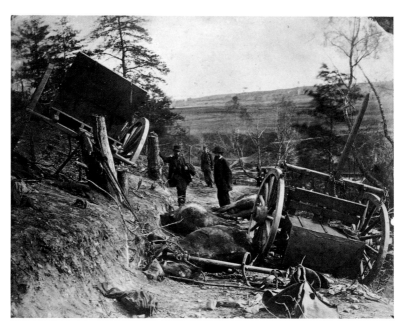

79 ANDREW JOSEPH RUSSELL
American, 1830–1902
Scene of Battle, Fredericksburg, Virginia, May 3, 1863
Albumen print
24.9 × 32.7 cm (9²⁷⁄₃₂ × 12²⁹⁄₃₂ in.)
84.XM.481.2

Confederate General Robert E. Lee defeated Union General Ambrose Burnside at Fredericksburg, Virginia, on December 13, 1862, at a cost of more than twelve thousand Union lives. Lee spent the winter entrenched on the south side of the Rappahannock River until Burnside's successor, George Hooker, took command of the Army of the Potomac and moved against Lee on May 2–4, 1863, at Chancellorsville, a hamlet ten miles west of Fredericksburg. Russell's photograph may represent a scene in the Wilderness around Chancellorsville, where Stonewall Jackson, Lee's ablest and most trusted lieutenant, was mortally wounded by the fire of his own men during a brilliant fifteen-mile nighttime flanking movement. Russell's sharp eye for dramatic detail is evident in this photograph of a Confederate caisson and its dead horses, which had been destroyed by a single Union shell. The block and tackle secured to the tree stump were no doubt being used to move the cannon and its caisson through the Wilderness when the shell struck. The figure leaning against another stump is Herman Haupt, chief of construction and transportation for the Union military railroads (see pl. 95). Haupt was also the inventor of the pontoon system that General Hooker used to cross the Rappahannock in pursuit of Lee, whose last great victory was at Chancellorsville.

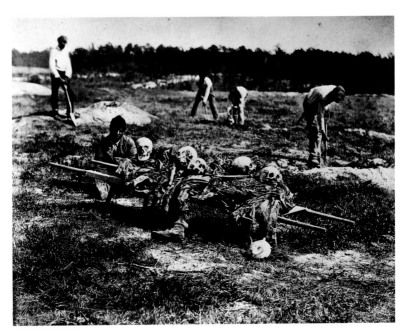

80 JOHN REEKIE
American, active 1860s
A Burial Party, Cold Harbor, Virginia, April 1865
Albumen print made by Alexander Gardner
17.3 × 22.6 cm (6¹³⁄₁₆ × 8¹⁵⁄₁₆ in.)
84.XO.1232.2.94

When the Civil War came to its end on April 9, 1865, unfinished business could finally be conducted, such as the overdue interment of the dead. The gravediggers at work here are burying the skeletons of men who had died a year earlier, when Grant attacked Lee's strongly entrenched forces at Cold Harbor. The Union lost seven thousand men in a few hours—a rate of death even greater than at Gettysburg. The total losses for both sides during the two months of the Wilderness campaign in the summer of 1864 were an estimated sixty thousand Union lives and twenty thousand Confederates. Death on this scale forecloses the performance of the customary burial procedures. The mourning, the wakes, and the prayers that serve to mark the rite of passage of a person from life into death could not be performed for these tens of thousands of casualties. It must be left to speculation whether this burial team of five black men was hired to do this work or was acting from independent spiritual or religious motivation.

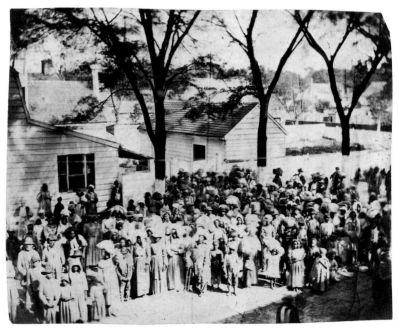

81 TIMOTHY H. O'SULLIVAN
American, 1840–1882
Slaves, J. J. Smith's Plantation, Beaufort, South Carolina, 1862
Albumen print
21.4 × 27.5 cm (8⅜6 × 10¹³⁄₁₆ in.)
84.XM.484.39

The first European nation to abolish slavery in its American colonies was Britain, which, after more than a century of debate, did so in August 1838, six months before Talbot (pls. 5–12) and Daguerre (pls. 3–4) made known their respective methods for creating photographs. Britain's example was gradually followed by other European nations.

The issue of slavery was, of course, one of the principal causes of the Civil War. On September 22, 1862—five days after the Battle of Antietam (pl. 82)—Abraham Lincoln issued his preliminary Emancipation Proclamation and instructed his armies to implement this order as their lines advanced into the Confederate states. Among the first African-Americans to be liberated were those on the cotton plantation of J. J. Smith, near Beaufort, South Carolina. Since the first freeing of slaves took place in contested areas at the front lines of the war, and not as an official event in Washington, photographs of slaves being freed are extremely rare. O'Sullivan happened to be in the vicinity of the Smith plantation and so was able to make this picture. One hundred or more individuals are shown with their belongings packed in burlap bundles, ready for the first time in their lives to walk in any direction they please and to travel as far as they wish to go: an epochal event recorded in this picture as it could never be recorded in history books.

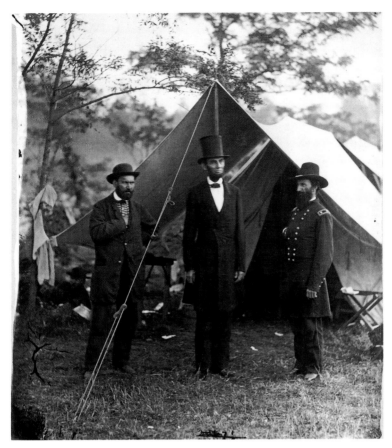

82 ALEXANDER GARDNER
American, 1821–1882
Lincoln on the Battlefield of Antietam, Maryland, 1862
Albumen print
22 × 19.6 cm (8⅝ × 7¾ in.)
84.XM.482.1

After the Second Battle of Bull Run, Robert E. Lee crossed the Potomac River in early September 1862 to occupy positions in Maryland and Virginia. The invasion was checked at Antietam by the forces of General George McClellan, whose failure to pursue Lee back across the river after the battle cost him his job.

Lincoln was the first American president to recognize the importance of photography and to make time in his schedule to be photographed. Here we see the commander-in-chief conferring with Major General John McClernand and Major Allan Pinkerton, who organized an espionage system behind Confederate lines. The genius of this photograph lies in Gardner's skillful composition built around the visual details of camp life. The tent and tent lines dominate. The eye is thus drawn as much to the fastenings on the lines as it is to the faces of the principals. Despite compositional interruptions, the imposing figure of Lincoln remains the center of interest.

At the lower left we see evidence of the dried collodion peeling from the glass surface of the plate, graphic evidence of the technical uncertainties faced by pioneer photographers.

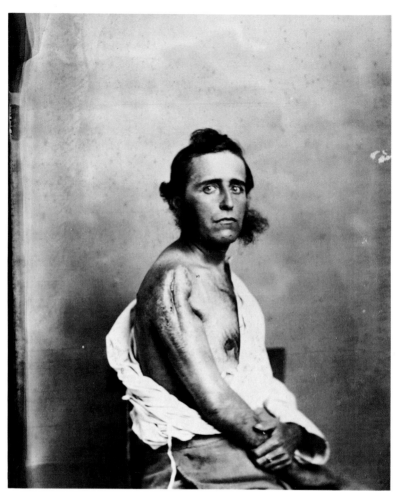

83 WILLIAM H. BELL
American (b. England), 1830–1910
Successful Intermediate Excision, ca. 1862
Albumen print
21.7 × 18 cm (8%₆ × 7⅛ in.)
84.XO.1365.8

William Bell, who later accompanied Lieutenant George Wheeler on one of his explorations to the Arizona Territory (see pl. 90), was one of the first photographers to specialize in medical photography, which was treated as a type of portraiture. We see here not a clinical specimen but rather an individual human being treated with great respect. The surgical procedure is described on a printed paper mounted below the photograph as a "successful intermediate excision of the head and three inches of the shaft of [the] right humerus for gunshot fracture." This type of wound was typical of injuries experienced by Civil War soldiers, many of whom survived to lead productive lives. The discovery of ether (see pl. 84) made surgery less painful and made new types of medical procedures possible in the field.

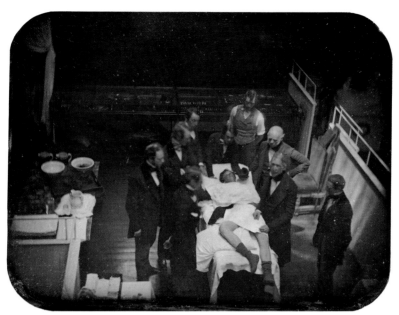

84 ALBERT SANDS SOUTHWORTH AND JOSIAH JOHNSON HAWES
American, 1811–1894; 1808–1901
Use of Ether for Anesthesia, Massachusetts General Hospital, early 1847
Whole-plate daguerreotype
14.6 × 19.9 cm (5¾ × 7⅞ in.)
84.XT.958

If there was a single blessing attached to the Civil War, it was that the war followed the discovery of ether as a surgical anesthetic. Its medical use was first announced by a dentist, William T. G. Morton, on September 30, 1846. The first public demonstration was performed two weeks later at the Massachusetts General Hospital during an operation performed by John C. Warren, who removed a vascular tumor from the left side of the neck of a patient named Gilbert Abbott. The event was recorded by the photographers Southworth and Hawes, whose everyday work consisted of wonderfully posed and lighted portraits of Boston's leading citizens. Resting partway between theater and journalism, this remarkable daguerreotype shows Morton holding a mask saturated with ethyl ether near the face of the patient, who seems to have worn his socks throughout the procedure. The candid circumstances prevented the photographer from using head clamps and posing stands; for this reason the heads of all the figures (except the patient) moved during the exposure and are therefore blurred. This is one of the very few photographs made before 1860 that depicts an epochal event at the instant it happened.

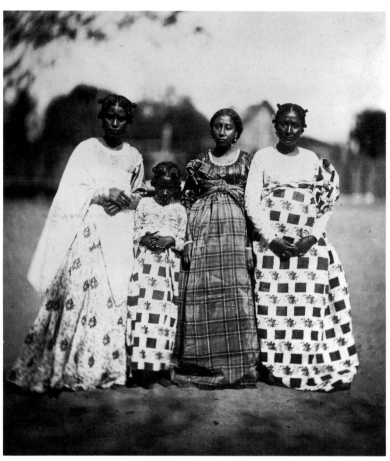

85 CLAUDE-JOSEPH-DÉSIRÉ CHARNAY
French, 1828–1915
Women of Madagascar, 1863
Albumen print from a wet-collodion-on-glass negative
18.1 × 16.3 cm (7¾₆ × 6⁷₁₆ in.)
84.XP.752.47

By the mid-1860s, when negatives on glass had replaced both paper negatives and silvered-copper daguerreotype plates, photographers had devised ingenious and practical ways to make portable their big cameras, heavy glass plates, and the chemicals needed to sensitize and develop their negatives. The profession of expeditionary photographer was just becoming established, and some of its most successful practitioners were men like Felice Beato (pl. 77), Alexander Gardner (pls. 82, 89), and Timothy O'Sullivan (pls. 78, 81, 88, 90), who had gained their experience under battlefield conditions. Europeans like Charnay no doubt learned their craft as apprentices in the campaigns sponsored in the 1850s by the French government to record historical monuments. Charnay's background is obscure; however, by 1859 his skill and dedication to expeditionary photography were manifest in a series of photographs he made of pre-Columbian monuments in Mexico. Less is known about his travels in French-colonized Africa, where he made this study of three women and a girl who are wearing fancy dresses made of French printed cotton.

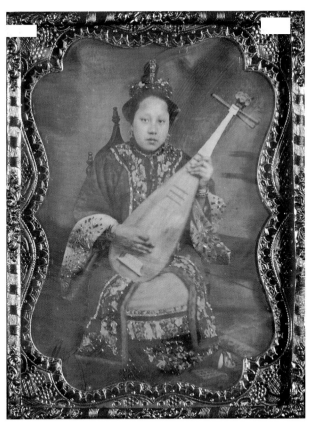

86 UNKNOWN AMERICAN PHOTOGRAPHER
Chinese Woman with Mandolin, 1860
Hand-colored quarter-plate daguerreotype
9.1 × 6.5 cm (3⅞ × 2⅞ in.)
84.XT.1582.11

This daguerreotype could be an anthropological specimen; its place of origin and the maker's name are unknown, hence all interpretation is dependent on circumstantial evidence. We know this woman is Chinese because of her costume and the type of instrument she holds, a *pei-pa* or Chinese mandolin. The chair is of American manufacture, as are the thermoplastic case in which the daguerreotype is housed and its brass retainer; the retainer is original to this image and can be dated on style to the early-to-mid-1850s. There was a large Chinese population in San Francisco at the time this image was created, and we can speculate it was made in that city and represents an entertainer. The daguerreotype was the work of a photographer for whom this subject was simultaneously exotic and attractive.

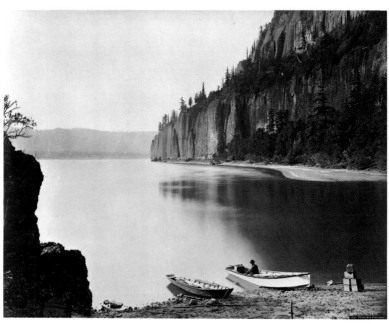

87 CARLETON E. WATKINS
American, 1829–1916
Cape Horn, Columbia River, Oregon, negative, 1867; print, after 1875
Albumen print by Isaiah West Taber
40.5 × 52.3 cm (16⅟₁₆ × 20¹¹⁄₁₆ in.)
85.XM.11.2

Watkins's career began in the 1850s and extended through the 1890s. He occupies a special place in the history of photography because of the great imagination and skill he applied to making his photographs in a career spanning four decades. While Gardner and O'Sullivan were traveling in the wheel tracks of Union generals in the east between 1862 and 1865, Watkins had the leisure to ripen his style to full maturity under more relaxed circumstances. He translated his perceptions into brilliantly structured photographs by creating complex compositions from very simple motifs that incorporate a seamless web of formal relationships. The three key elements of this picture are the massiveness of the rock formations at either side, the expectancy of the boat about to be loaded with boxes of oversized fruit, and the delicacy of the light reflected off the water.

Watkins designed his photographs to achieve a painterly interplay between surface pattern and spatial dimensions. The intricately connected compositional elements consisting of bold rock formations and luminous water are chiefly responsible for this picture's palpable sense of space. Watkins's compositions were so strong that his photographs were used as reference sources by painters such as Thomas Hill and Albert Bierstadt.

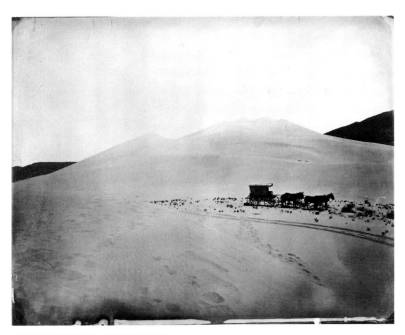

88 TIMOTHY H. O'SULLIVAN
American, 1840–1882
Desert Sand Hills near Sink of Carson, Nevada, 1867
Albumen print
22.3 × 29.1 cm (8¾₆ × 11⅞₆ in.)
84.XM.484.42

In 1862, Alexander Gardner quit the employment of Mathew Brady and established his own photographic enterprise in Washington, D.C., taking Timothy O'Sullivan with him. While employed by Gardner, O'Sullivan was present at most of the chief military engagements of the Civil War from the Second Battle of Bull Run to Appomattox, and when Gardner published his *Photographic Sketch Book of the War* in 1865, no less than forty-four of the one hundred photographs were by O'Sullivan. Many of them were simultaneously social documents and landscape compositions, as exemplified by *A Harvest of Death* (pl. 78).

O'Sullivan left Gardner in 1867 to accept Clarence King's invitation to join his newly formed Fortieth Parallel Survey, which became the first federal exploring party in the West after the Civil War. O'Sullivan's Civil War work proved to have been excellent preparation for his landscape work. He was allowed to roam the wilderness apart from the main surveying party in order to prospect on his own initiative for motifs that he judged would fulfill King's scientific needs. We see here a kind of self-portrait showing the wagon that served as his rolling darkroom, pulled by four mules positioned on a hill of wind-blown sand near the Carson Sink in Nevada. The wagon has just made a U-turn, and we see the footprints leading from the vehicle to the spot where O'Sullivan erected his camera to compose this heroic image of exploration and discovery.

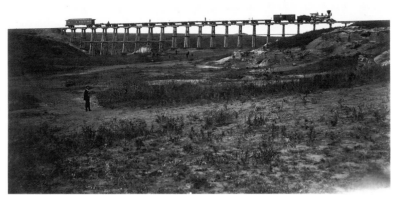

89 ALEXANDER GARDNER
American, 1821–1882
Trestle Bridge near Fort Harker, Kansas, 1867
Albumen print
33 × 47 cm (13 × 18½ in.)
84.XM.1027.22

The terrible destructiveness of the Civil War was followed by a program of building that was almost as intense. A national priority was set to complete the transcontinental railroad from its pre-Civil War terminus in Omaha, Nebraska, to the Pacific Ocean. In 1865, construction began from Omaha, working westward, with a succession of obstacles ranging from construction problems to Indian attacks. The Central Pacific line worked eastward from Sacramento and was united with the Union Pacific west of Ogden, Utah, where the "Golden Spike" was driven on May 10, 1869. Gardner's Civil War work put him in line for what was, until then, the most important commission received by an American photographer: the invitation to join the Union Pacific team to record scenes along the route under construction. The work was far less demanding than O'Sullivan's labors on the King survey, because Gardener traveled with his equipment by train. The work was also less demanding in an artistic sense, because the motifs—stations, sidings, bridges, water tanks, and the environs of existing cities through which the line passed—were preestablished.

The subject here is a temporary trestle of the type designed by Herman Haupt (see pl. 79) for quick implementation during the Civil War. Gardner treats the scene as though he were directing a theatrical performance. The train has, we suspect, been specially configured for this picture, with nine flatcars bookended by a coach at the left and the engine, coal car, and a single boxcar at right; all together they are just shy of stretching the trestle's full length. Three figures are strategically positioned on the flatcars for scale, while six more can be spotted in the dry gully, including one in the foreground who may be the photographer.

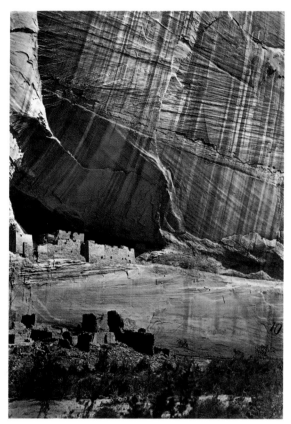

90 TIMOTHY H. O'SULLIVAN
American, 1840–1882
Ancient Ruins in the Cañon de Chelle, New Mexico, 1873
Albumen print
27.5 × 19.2 cm (10⅞ × 7⁹⁄₁₆ in.)
84.XM.484.4

The Clarence King surveying expedition (see pl. 88) was concluded in September 1869, and O'Sullivan returned to the East Coast. He remained there until 1871, when he joined the Geological Surveys West of the One-Hundredth Meridian (1871–75), under the command of Lieutenant George M. Wheeler of the U. S. Army Corps of Engineers. In contrast to King, Wheeler was a West Pointer and a career officer, with little of King's interest in the arts or the philosophical controversies that surrounded contemporary science and had informed O'Sullivan's first series of western views. In 1873, O'Sullivan led a group independent of the main party to Arizona's Zuñi pueblo and to the Cañon de Chelle, with its unoccupied cliff dwellings that were a satellite of the Anasazi civilization that flourished in the twelfth century. The so-called "White House Ruins" are shown in the context of the surrounding cliffs that are seen in a bold raking light which delineates the textures and striations of the monolithic formation. The vertical-oblique sweeping thrust of the surface stains and the physical scale and asymmetry of the geology are dynamic elements that dominate the stone dwellings. The photograph is affecting because it forces us to contemplate the actualities of human time versus the vastness of geological time. In this way, O'Sullivan reminds us of his Civil War work, in which mortality and the effects of time were underlying themes.

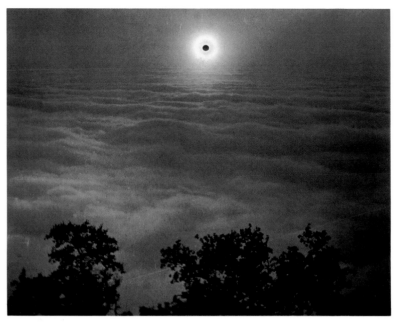

91 CARLETON E. WATKINS
American, 1829–1916
Solar Eclipse from Mt. Santa Lucia, January 1, 1889
Albumen print
16.5 × 21.6 cm (6½ × 8½ in.)
88.XM.92.83

The first successful photograph of a solar eclipse was made by Warren de la Rue near the west coast of Spain on July 18, 1860. This had been preceded by failed attempts to make calotypes of the eclipse of 1842 and Alexander Bache's unsuccessful attempt to make a daguerreotype of the eclipse of 1851. It so happened that three solar eclipses were visible in the western United States between 1878 and 1889. Progress in photography was making the new medium an increasingly valuable tool for astronomers and physicists; Watkins was in the right place at the right time.

We can imagine the photographer standing at the summit of Mt. Santa Lucia with a group of scientists, including Professor George Davidson of the newly created University of California and Professor Edgar Frisby of the U. S. Naval Observatory, waiting for 2:39 in the afternoon, when the moon began its transit directly between the earth and the sun. A violent winter storm had struck the Pacific Coast the day before; tension must have run high when the moon first approached the edge of the sun, appearing as a dark object moving across the sun's face, shutting more and more of the bright surface from view, until daylight faded to a brownish twilight and the temperature dropped noticeably. There was time for just one exposure at the instant of maximum eclipse (3:50 p.m.). Watkins's photograph transcends the documentary because he has so skillfully captured the surrounding context of sky, horizon, clouds, trees, and—the essence of this particular photograph and crucial to all photography—light. The word *photograph* literally means "writing with light." Since light is the energizing force in photography, it is to be expected that the sun and the shadows it casts have been a favorite subject for photographers.

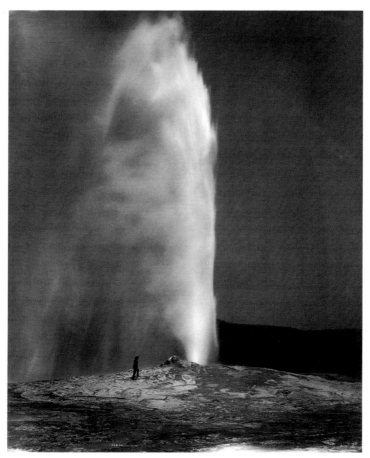

92 WILLIAM HENRY JACKSON
American, 1843–1942
Old Faithful, 1870
Albumen print
51.4 × 42.5 cm (20⁵⁄₁₆ × 16¾ in.)
85.XM.5.38

The valley of the Yellowstone River, Montana, home to the only geyser fields
known to exist outside of Iceland and New Zealand, was more remote than the
Yosemite Valley in California. Travelers could only get to Lower Geyser Basin by
taking the Union Pacific Railroad to Corrine, Utah, and then a Wells Fargo stage
to Virginia City, Montana, in a journey of three-and-a-half days. Yellowstone's
chief tourist attraction is Old Faithful, a hot spring that throws water and steam
150 feet into the air for five minutes once an hour. It was named by General
Washburn in 1870, the year before Jackson visited there with Ferdinand Vandi-
veer Hayden, a geologist in charge of the surveying expedition bearing his name,
who shrewdly used Jackson's photographs to persuade the United States Congress
to create Yellowstone National Park in 1872. To arrest the moving column of
steam and water on a mammoth glass negative required Jackson to face into the
sun and underexpose the surrounding landscape, thus creating an artificial night-
time effect. Seeing hot water burst forth from the earth in a fountain-like column
was, and still is, an astonishing sight, recorded here for the first time in a photograph.

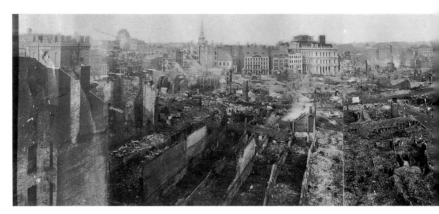

93–94 JAMES WALLACE BLACK
American, 1825–1896

Boston After the Great Fire, 1872
Albumen print
Panorama of three prints, each 26 × 99 cm
(10¼ × 39 in.)
92.XM.45

*The Corner of Perkins and Pearl Streets,
Looking to Broad Street*, 1872
Albumen print
19.5 × 18.9 cm (7¹¹⁄₁₆ × 7⁷⁄₁₆ in.)
84.XP.715.47

We are told by observers that Saturday, November 9, 1872, was a particularly beautiful day in Boston, with clear air and a brilliant sunset. At about 7:00 p.m., a fire was reported in a dry-goods warehouse at the corner of Summer and Kingston streets. It soon spread to adjacent buildings, and by the next day nearly everything standing on sixty acres of Boston's commercial center had been destroyed. James W. Black was one of the pioneer American experimenters with glass-plate negatives in the early 1850s, and one of the most skillful outdoor photographers before the Civil War. His studio on Washington Street was surrounded by many portrait studios, but fate singled him out to be the fire's chief chronicler. Black was one of the inventors of the mammoth-plate format and was continuously experimenting with ways to increase the size of his negatives and prints and the field of vision that photographs could record. Here we see examples of individual prints from eleven-by-fourteen-inch negatives, and a five-part segmented panorama showing the heart of the destruction.

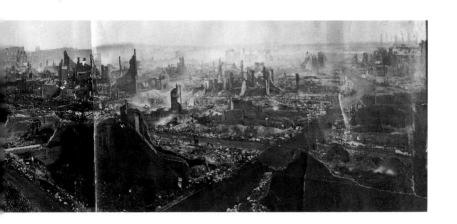

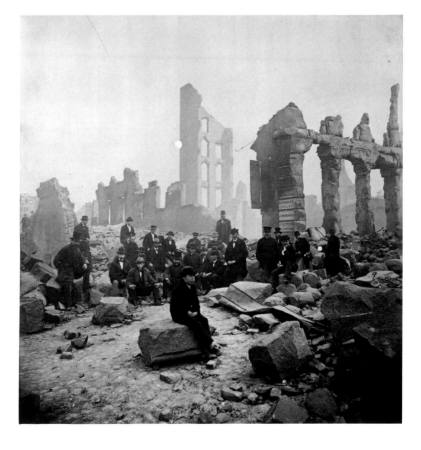

95 ANDREW JOSEPH RUSSELL
American, 1830–1902
Auger on a Blanket, 1863
Salt print
15.3 × 20.3 cm (6½ × 7³¹⁄₃₂ in.)
84.XO.1370.20

Russell was commissioned by Union General Herman Haupt (see pl. 79) to photograph the railroad trestles and pontoon boats that he had designed to be quickly assembled by enlisted men using simple tools. Here we see a corkscrew-like device used to bore holes in the supporting timbers of bridges for the placement of explosives. To compose his still life, Russell positioned the auger on a makeshift background and supported it with a folding wooden ruler. The album in which this image was mounted by Russell for Haupt was designed as an instructional tool to illustrate how to implement Haupt's ingenious inventions. When this artifact is removed from its original context by the process of photography, it becomes a piece of sculpture modeled in light and shade.

96 MARC FERREZ
Brazilian, 1843–1923
The Curved Bridge of the St. Anthony River Aqueduct, ca. 1883–89
Gelatin silver print
26.3 × 35.8 cm (10⅜ × 14⅛ in.)
85.XM.322.5

The first golden age of photography coincided with ambitious public works proj-
ects around the world, many of which were inspired by the building programs
in Paris directed by Baron Haussmann (pls. 61–62) under the patronage of
Napoleon III (pl. 56). Napoleon III's South American counterpart was Pedro II,
emperor of Brazil (1831–1889). One of Dom Pedro's pet projects was the new
water supply for the city of Rio de Janeiro. The Brazilian photographer Marc
Ferrez was among the first anywhere to experiment with orthochromatic dry-plate
negatives and the new silver-bromide-in-gelatin printing papers. (A wet-collodion
negative of this new stone aqueduct would have resulted in dense black foliage if
the high-key stonework were exposed for the maximum of detail.) The gelatin
printing paper introduced a high-gloss surface that anticipates twentieth-century
materials. As with the auger (pl. 95), the forms of this structure have been trans-
formed by photography into a work of sculpture. The transformative potential
of the photograph would be exploited by artist-photographers of the twen-
tieth century.

97–99 LOUIS-ÉMILE DURANDELLE
French, 1839–1917
The Eiffel Tower: Piers Nearing the First Level, January 7, 1888
Albumen print
27.1 × 43.3 cm (10⅞ × 17½ in.)
87.XM.121.4

Durandelle was one of the first photographers to concentrate exclusively on architecture. So far as we know, he never made a pure landscape or portrait. His magnum opus is a photographic study of the Paris Opéra under construction, fifteen years before the Eiffel Tower. His Opéra series concentrated on the ornamental veneer (especially the sculptures by J. B. Carpeaux). Unlike the Opéra, the Eiffel Tower was *all* structure. One artist denounced it as "useless and monstrous," while a novelist called it "arrogant ironmongery," and another critic called it "a disgraceful skeleton." Durandelle has used photography to record the building of the tower, begun on January 28, 1887, and completed on March 13, 1889. Durandelle anticipated the twentieth-century use of photography as a tool to record transformation through time, just as Eiffel foresaw a chief concern of mid-twentieth-century architecture, that form should follow function.

The Eiffel Tower: State of the Construction, November 23, 1888
Albumen print
43.1 × 34.6 cm (17 × 13¾ in.)
87.XM.121.16

The Eiffel Tower, March 31, 1889
Albumen print
44.8 × 34.7 cm (17⅞ × 13⅝ in.)
87.XM.121.19

100 A. C. VROMAN
American, 1856–1916
Interior of Mr. Hooker's House, Sichomovi, 1902
Platinum print
20.6 × 15.5 cm (8⅛ × 6⅛ in.)
84.XM.472.2

"Railroad man, book collector, bookseller, amateur archeologist, and photographer": so Beaumont Newhall described Adam Clark Vroman, who continued the tradition of field photography in the West begun in the 1860s by Watkins (pls. 87, 91), O'Sullivan (pls. 78, 81, 88, 90), and Jackson (pl. 92). Factory-coated dry plates had replaced wet plates for negatives, and although they still required heavy, breakable glass, the materials were much more sensitive to light and recorded more of the spectrum of light between ultraviolet and red. The faster materials made indoor photography more practical, thus permitting interior studies such as this. The house belonged to a man named Hooker, who was described by the photographer as the "governor" of the Hopi village of Sichomovi, which, in relative isolation on the western edge of the Pueblo lands, remained less influenced by Spanish customs and represented the purest survival of native culture. On the wall below the young woman we see examples of kachina dolls, an umbrella, photographs that may have been gifts from Vroman, and a ladder used to reach the upper room. The photograph is a tender environmental portrait, but it is also a social document that illuminates the Hopi way of life.

101 LEWIS W. HINE
American, 1874–1940
Cotton-Mill Worker, North Carolina, 1908
Gelatin silver print
11.7 × 16.9 cm (4⅝ × 6⅝ in.)
84.XM.967.5

If Vroman's photograph (pl. 100) describes the daily context of a well-born Hopi maiden, Hine's study of a North Carolina cotton-mill worker represents her opposite. This child of poor parents was working ten or twelve hours a day. Vroman used photography to express the nobility of Native American people, while Hine used it to inform the public that children were being abused and exploited. Employed by the National Child Labor Committee based in New York City, Hine expressed his genuine compassion for his photographic subjects, while also preserving their dignity and individuality. With photographs as their chief propaganda tool, by 1914 the labor commission had succeeded in having thirty-five states prohibit the employment of children under the age of fourteen. For the first time, a camera-artist had been the direct instrument of broad social change.

102 EUGÈNE ATGET
French, 1857–1927
Vieille Boutique Empire, 21, Faubourg St.-Honoré, ca. 1902
Albumen print
21.8 × 17.9 cm (8½ × 7 in.)
90.XM.120

About the only thing Atget had in common with Durandelle (pls. 97–99) was a love of Paris and of architecture. So far as we know, Atget, in the thousands of negatives he made all over Paris, never directly photographed the Opéra or the Eiffel Tower, on both of which Durandelle had concentrated so much careful attention. Atget spent nearly thirty years photographing details of often inconspicuous buildings, side streets, and cul-de-sacs, as well as public sculpture, typically by now-forgotten artists. Atget and Durandelle manifest different aspects of the impersonal and objective. Durandelle rarely made a picture that moves us to ask the question "Why was this photograph made?," while Atget persistently challenges strictly linear thinking by his highly intuitive approach to art. For example, in the reflection on the plate-glass facade is a self-portrait of Atget that seems to playfully assert: "Here I am, hiding in this picture."

103 LEWIS W. HINE
American, 1874–1940
Self-Portrait with Newsboy, 1908
Gelatin silver print
13.9 × 11.8 cm (5⁷⁄₁₆ × 4²¹⁄₃₂ in.)
84.XM.967.1

Dominating the foreground here is the shadow of a figure wearing a hat and coat through which the grid-like lines on the pavement intersect. The arm of the figure is raised, and from his hand the faint arched line of the shutter-release device can be traced, leading to a rectangular shadow representing the camera with its tripod. The time is probably early morning. The newsboy wearing the hat advertising Coca-Cola was being photographed for Hine's Child Labor project (pl. 101). His head is cocked at a quizzical angle, and his youth is communicated by the size of the newspapers in comparison to the length of his arm. In the half-decade between Atget's self-portrait and Hine's, the greatest change in the content of photographs was the transformation of the medium from an objective tool to a means of subjective expression. By 1910, it was accepted if not required for the photographer to be "present" in the photograph. Atget and Hine, masters of objectivity, allowed just one tiny element of the personal to enter these pictures.

PURISTS AND IDEALISTS

About 1880, photography experienced its first generational transition: Julia Margaret Cameron had died in 1879; Nègre in 1880; several years later, Le Gray was buried in Egypt. What in 1855 were mere differences of opinion by 1890 had become outright conflicts between two opposing schools of thought. One camp believed that objectivity was the most fitting pursuit for photography, an attitude in the spirit of the daguerrean portraitists, while the other group, using painting and engraving as its models, valued the power of a photograph to express the ideas and emotions of its maker.

At the center of this war was the difference between pure, unaltered visual expression and expression that starts with an idealized concept that is afterwards made visual. Purists believed photographs should result from the most direct application of the materials of photography—natural light, subjects photographed as they are found rather than rearranged, and hardware and chemistry that achieved a maximum range of tones and the highest resolution. The idealists, on the other hand, desired to control the light artificially, rearranged and posed their subjects, created compositions from mosaics of several negatives, and often used hardware and chemistry that exaggerated highlights and shadows in imitation of prints and drawings.

The last decades of the nineteenth century saw a process of action and reaction. Henry Peach Robinson, Oscar Rejlander, and Julia Margaret Cameron reacted against the naturalism of Talbot and Hill and Adamson; Peter Henry Emerson reacted against the artifice of Robinson and Rejlander (although he did admire Cameron). Frederick Evans reacted against those who used photography to emulate the effects produced by pencils and brushes, and he frequently vacillated between figuration and abstraction, as did the progressive photographers who came after him. The result of this dialectic was the Pictorialist style, in which experience was idealized and emotions were translated into pictures that were "made" and not "taken."

104 HENRY PEACH ROBINSON
British, 1830–1901
When the Day's Work Is Done, 1877
Albumen print
56.1 × 74.3 cm (22⅟₁₆ × 29⅝₆ in.)
84.XM.898

During the middle of 1867, Henry Peach Robinson, working in London, was composing the most influential treatise of his times on the art of photography: *Pictorial Effect in Photography: Being Hints on Composition and Chiaroscuro for Photographers.* Serialized in London's *Photographic News* in 1868 and published as a book in 1869, Robinson's essay opened the way for new thinking about photography as a medium for creative expression unleashed from documentary requirements. "If a picture is to be successful," wrote Robinson, "it must have a oneness of lines, a oneness of light and shade." Trained first as a painter, he built his compositions one figure at a time, using pasted-up cartoons that were touched with pencil and watercolor. Here, he lights his stage skillfully, poses his figures cleverly, and creates a finished print that entirely conceals the seams between the six negatives from which it was printed.

105 GUIDO REY
Italian, 1861–1935
The Letter, 1908
Platinum print
22.2 × 14 cm (8¾ × 5½ in.)
85.XP.314.7

The experimentalist branch of photography also found expression in the photo-pastels of C. Puyo in France and the pastiches of old master paintings produced by Guido Rey in Italy. Rey created tableaux vivants with models placed in re-creations of the settings of famous paintings, such as this study after Vermeer. Alfred Stieglitz (pls. 112, 114–15) exhibited this photograph in the Photo-Secession Gallery in 1908 and was evidently as fascinated as we are with the power of photography to create visual fictions.

106–7 P. H. EMERSON
British, 1856–1936

Gathering Water Lilies, 1886
Platinum print
19.8 × 29.4 cm (7¹³⁄₁₆ × 11⅝ in.)
84.XO.1268.10

On the Baulks, 1890
Photogravure
14.6 × 9.6 cm (5¾ × 3²⁵⁄₃₂ in.)
84.XB.696.6.17

"Wherever the artist has been true to nature, art has been good. Whenever the artist has neglected nature and followed his imagination, there has resulted bad art." So wrote P. H. Emerson, with Henry Peach Robinson's photograph (pl. 104) in mind. Emerson called his own aesthetic position "Naturalism," and his preferred mode of presentation was the album or book, where texts could accompany the photographs. One of the most important of his albums was issued as a limited edition of carefully printed platinum photographs, mounted by hand onto the pages of a volume entitled *Life and Landscape of the Norfolk Broads*, where *Gathering Water Lilies* was first seen. Emerson achieved compositional unity out of a great variety of competing elements that range from distracting reflections of light off the water, to the foreground branches, to the randomness of the lily pads and the river grasses. The composition is highly intuitive and yet admits to analysis. The structure of the photograph is built upon the diagonal axes that move corner to corner, from the bow through the stern of the wherry and toward the opposite corners, through the oars intersecting at the man's left hand, which is the center of the image. The point of sharpest focus is the surface of the woman's hat; its concentric circles of braided straw echo the circular field of focus established by the physics of lenses. "The image which we receive by the eye is like a picture minutely and elaborately finished in the center, but only roughly sketched in at the borders," Emerson wrote. This composition binds tender emotion to aesthetic form with poetic simplicity.

By 1890, when *On the Baulks* was made, Emerson had replaced platinum printing with photogravure as his favored method of working and had spent considerable time experimenting with different types of printing papers and different methods of acid-etching his plates. "Being the first person to study and publish etchings from photographic plates taken from Nature, I have had to bear all of

the trials and losses incidental to the experimentalist," he wrote of his trial-and-error-work. He had also begun to experiment more adventurously with selective focus and was troubled when the middle ground or background became too sharply focused as the result of subjects being in motion.

108 FREDERICK H. EVANS
British, 1853–1943
Kelmscott Manor: In the Attics (No. 1), 1896
Platinum print
15.5 × 20.2 cm (6⅛ × 7¹⁵⁄₁₆ in.)
84.XM.444.89

Evans found poetic and artistic inspiration in the architecture of the past. He was inspired by the nearness of the designer-craftsmen of the middle ages to their product and by the essential equality of the craftsmen to each other. In 1896, Evans visited the home of William Morris, the proselytizing medievalist. Kelmscott Manor dates from 1280 and is highly representative of the medieval manor house, an institution in which the role of the craftsman was central to all of everyday life. Evans methodically photographed the exterior and interior and selected decorations, including the attics. The Kelmscott Manor photographs occupy a special place in Evans's work because they are a record of the emotions inspired in him by handwork in the pre-industrial era.

Evans was photographing architecture and its ornaments using a vocabulary of light, volume, and texture. He wanted to communicate the softness of the wood, the hardness of the stone, and the filtered quality of the light. In this photograph he isolates the intersecting network of posts and beams, choosing his point of view carefully so as to make clear that they were carved by hand out of the trunks and branches of trees. Almost a decade later, Evans wrote that he hoped people would exclaim upon seeing his photographs, "What a noble, beautiful, fascinating building that must be, and how priceless an art is that sort of photography that can so record one's emotional rapprochement to it!" In focusing his attention on the details of architecture, Evans proved that a photographer could join in a single artistic temperament the classic and the romantic, the linear and the painterly, the objective and the abstract.

109 GERTRUDE KÄSEBIER
American, 1852–1934
Silhouette of a Woman, ca. 1899
Platinum print
20 × 10 cm (7⅞ × 3¹⁵⁄₁₆ in.)
87.XM.59.28

In 1898 and 1899, a group of American photographers, some of them recent art
school graduates, emerged on the scene in New York and Boston, with talents
so protean that they immediately changed the course of photography. Käsebier
was a wife and mother who took up art in midlife. Her mentors were F. Holland
Day (pl. 120) and Edward Steichen (pls. 111, 113), who were much her juniors
in years but with whom she aligned herself stylistically and politically. All three
haunted the newly established public art museums in New York and Boston,
resources that had not been available to the preceding generation of artists, and intro-
duced into their photographs recollections of old master paintings. Possibly in-
tended as a bridal portrait of her daughter, Gertrude, this profile figure is charged
with a fervor that recalls early Renaissance depictions of the Virgin Mary. It is
somehow more authentic in spirit than Guido Rey's composition derived from a
painting (pl. 105). Käsebier shows full mastery of her materials in handling the
figure, whose silhouette is softened by the focus on the background door frame.

110 GERTRUDE KÄSEBIER
American, 1852–1934
Alfred Stieglitz, 1901–2
Gum-bichromate print
28.9 × 23.4 cm (11⅜ × 9¼ in.)
84.XP.208.28

In 1902, Stieglitz, with Steichen as a major catalyst, formed the movement they
named the Photo-Secession and established its headquarters at 291 Fifth Avenue,
where Steichen's studio was located, and an address where Modernism was first
made known to the American public. Modeled on London's Brotherhood of the
Linked Ring and on the Secession movements in Paris, Vienna, and Munich, the
Photo-Secession was formed two years after F. Holland Day's short-lived compet-
ing group, the New School of American Photography, had made its debut in a
London exhibition. Stieglitz earned his first international recognition in 1888,
and in each decade through the 1930s he advanced his art through powerful new
images (pls. 112, 114–15). Gertrude Käsebier, one of his disciples, made this
photograph of him in the painterly gum-bichromate process that allowed her to
concentrate on the moody side of his temperament, creating a fitting portrait of a
man who was several people at once—an artist, a connoisseur, a writer and pub-
lisher, and a proselytizer for photography.

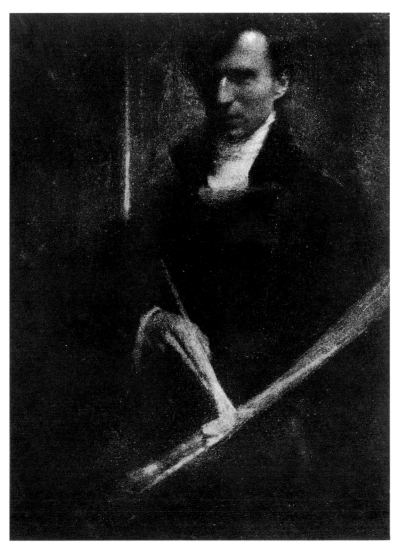

111 EDWARD STEICHEN
American (b. Luxemburg), 1879–1973
Self-Portrait, 1901
Pigment print
21 × 15.8 cm (8¼ × 6¼ in.)
85.XM.261

Steichen arrived in Paris in 1900, fresh from a meeting with Stieglitz (pls. 112, 114–15) in New York. This camera-made self-portrait that looks like a drawing shows Steichen wearing a smock and high-collared shirt and holding a palette in his obscured left hand, a brush in his right. The gum-bichromate process was the ideal technique for an artist who was uncertain whether painting or photography was his calling. Variable effects were made possible by working the pigmented gum with a brush as the photograph developed, a process that Steichen utilized to gain the very painterly effects on his collar, on his palette, and on the tip of his paintbrush.

112 ALFRED STIEGLITZ
American, 1864–1946
The Hand of Man, negative, 1902; print, ca. 1933
Gelatin silver print
8.3 × 11.2 cm (3¼ × 4⁷⁄₁₆ in.)
93.XM.25.7

Stieglitz took every opportunity to place contradiction and duality at the center of his art and life. He was a leader in Pictorial photography and a pioneer of Modernism, two movements that were largely, but not exclusively, conflicting in their means and ends. *The Hand of Man* exemplifies Stieglitz's desire to reconcile opposites. The title he chose establishes a poeticizing context that recalls the symbolism prevalent in the literature and painting of his contemporaries, yet it also alludes to photographs as products of a machine and the eternal dialogue between the handmade and the mechanical. Stieglitz's position seems to be that machines can be very beautiful and that a machine—the camera—can be a tool for the creation of art when guided by an artist.

The history of the printing of this 1902 negative is significant. It was first published in issue number one of *Camera Work* in January 1903, during the heyday of Pictorialism and well before Modernism in the visual arts was born. At a time when painterly gum prints, exemplified by his disciples Käsebier (pls. 109–10) and Steichen (pls. 111, 113), were the materials of choice for Pictorialists, Stieglitz's *Camera Work* gravure achieves a soft-focus quality that is the result of light passing through real atmosphere and is not an effect of sensitized pigments or a fuzzy lens. Yet this photograph's subject—the role of the machine in twentieth-century life—was central twenty years later to the Modernist aesthetic, at about the time this particular print was made on hard-surface, fine-grain, gelatin-silver paper. *The Hand of Man* was one of the few pre-1917 negatives that Stieglitz resurrected during the summer of 1933 for reinterpretation, which indicates that it was particularly important to him. "When I saw the new prints from the old negatives I was startled to see how intimately related their spirit is to my latest work," Stieglitz wrote when these photographs were exhibited in 1935.

113 EDWARD STEICHEN
American (b. Luxemburg), 1879–1973
Autumn, 1904
Gelatin silver print made to resemble platinum
18.6 × 34 cm (7⅜₆ × 13⅜ in.)
87.XM.73

Pigment prints like Steichen's self-portrait (pl. 111) are monotypes that could not be copied exactly. In order to produce multiple prints, Steichen devised ways of using copy negatives in combination with one or more printing methods, such as gelatin silver enlarging ("bromide") materials, to create replicas of unique pigment prints. The results were ingeniously deceptive facsimiles, such as this study representing a place near the vacation home Steichen rented in Mamaroneck in the winter of 1902–3 after returning from Paris. He chose to print this negative enlarged on a gelatin silver paper that had been designed to imitate the close-toned effects of platinum paper.

Steichen made this photograph with only the faint illumination of moonlight. He was experimenting to find out how far the light level could be reduced and how narrow in tonal range the print could be and still produce definable forms that would be visually interesting. Steichen was evidently abreast of current American painting and the style of Tonalism that was a hybrid of the monochromatic Whistlerian aesthetic and Impressionistic naturalism.

114 ALFRED STIEGLITZ
American, 1864–1946
Self-Portrait, negative, 1907; print, 1930
Gelatin silver print
24.7 × 18.4 cm (9²³⁄₃₂ × 7¼ in.)
93.XM.25.38

By 1907, the year Stieglitz created this self-portrait, he was a legend in New York, being sought out for advice by collectors, photographers, and artists. He spent the summer of 1907 in Paris, where he was introduced by Steichen to the art of Cézanne, Picasso, Matisse, and Rodin, whose work he would soon be the first to show in America at the Photo-Secession Gallery that had come to be known as 291, its address on Fifth Avenue. In 1907, he made works as different as his Impressionist-influenced autochrome study of his daughter (pl. 115) and his famous image of *The Steerage*, which may be the first "modern" photograph. He first met his future wife Georgia O'Keeffe about the time of this negative, when she was still an art student. He made this print for her some twenty years later and presented it as a gift to O'Keeffe.

115 ALFRED STIEGLITZ
American, 1864–1946
Kitty Stieglitz, 1907
Autochrome
14.2 × 9.8 cm (5⅝ × 3⅞ in.)
85.XH.151.5

Alfred Stieglitz arrived in Paris with his family in June 1907, just after the momentous announcement that Auguste and Louis Lumière had invented the autochrome color process—the first relatively easy-to-use process that could capture the true colors of the natural world. Stieglitz employed the new technique to make a portrait of his daughter, Kitty. He seated her on a Paris park bench, fashionably dressed in an oversized bonnet and fancy pinafore, holding a bouquet of flowers in her right hand and a butterfly net in her left. The image is closer to Mary Cassatt than it is to Picasso, though Stieglitz would soon move in the direction of the Spanish master.

The seductive color in Lumière plates was based on individual grains of starch-dyed green, red, and blue (the primary colors of light) coated in thin layers onto a glass plate, with a top layer of panchromatic gelatin silver emulsion that acted as the recording medium for what the minute color filters let through. There was, however, no practical way to make color prints except by commercial processes, with coarse halftone dots replacing the starch grains. Autochromes were, therefore, destined to be used principally for private experiments, such as Stieglitz's portrait.

116 EDWARD S. CURTIS
American, 1868–1952
Hopi, Watching the Dancers, 1906
Gelatin silver print
19.7 × 14.7 cm (7¾ × 5²⁵⁄₃₂ in.)
85.XM.241.2

About the same time that Steichen (pls. 111, 113) and Käsebier (pls. 109–10) were first achieving recognition in European salons, Curtis was winning prizes in American competitions for his landscape photographs, some of which incorporated Indians who were posed in romanticized landscape settings. However, it was during his work as the staff photographer for the 1899 E. H. Harriman expedition to Alaska that Curtis decided to devote himself to chronicling the appearance, costume, and habitation of all tribes and clans of the North American Indians. Created toward the end of this project, which had begun in 1900 with financial support from the banker J. P. Morgan, this study shows three Hopi women positioned on the roof of their dwelling in northeast Arizona. Hopi culture is here filtered through the eyes of an outsider, who gives no indication that the way of life we see represented was being corrupted by the influences that the photographer himself represented.

117 IMOGEN CUNNINGHAM
American, 1883–1976
The Wind, ca. 1910
Platinum print
23.9 × 17.8 cm (9⅜ × 7 in.)
88.XM.44.7

Cunningham made her first photographs in Seattle in 1901, the year after Curtis (pl. 116) began his monumental North American Indian project. Later, she worked out of his Seattle studio, where she was employed from 1907 to 1909. Shortly after going to work for Curtis, Cunningham learned about the photographs of F. Holland Day (pl. 120) and Gertrude Käsebier (pls. 109–10) through Stieglitz's publications *Camera Notes* and *Camera Work*. Day taught American photographers how to base photographs on literary texts, and Cunningham absorbed his message. The source here may be William Morris's medieval fantasy of primitive Norse life *The Wood Beyond the World* (1895) or his earlier poem "The Wind" (1858). Other influences include modern dance; painters such as Thomas Eakins (pls. 130–32), who looked back to classical antiquity for inspiration; and landscapists who worked with figures, such as George de Forest Brush and Thomas W. Dewing.

118 HEINRICH KUEHN
Austrian, 1866–1944
Women from Pustertal, 1913–14
Bromoil transfer
22 × 25.1 cm (8⅝ × 9⅞ in.)
84.XM.829.13

Kuehn came to Stieglitz's attention in 1894 and was exhibiting in the European salons before Day (pl. 120) or Käsebier (pls. 109–10) were shown in American exhibitions. He resided in Innsbruck, Austria, in a house designed by Josef Hoffmann, who was the founder of the Wiener Werkstatt. Over the door was carved the motto "Heil dir Sonne—Heil dir Licht" (Bless the sun, Bless the light), an homage to the sources of photography. Although Kuehn here utilizes the bromoil pigment-transfer process that achieves a painterly surface effect, he is more committed to what the eye perceives than to what techniques can create. "The greatest achievement of the photographer is to aim at great pictorial effect without adulteration," he wrote to Stieglitz. "The photographer may not paint." Always an experimentalist, Kuehn observed the scene from the bird's-eye viewpoint employed by acknowledged modernists such as Alvin Langdon Coburn and Paul Strand (pls. 153–55, 169).

119 LOUIS FLECKENSTEIN
American, 1866–1943
A Pastoral, 1905
Gelatin silver print
41.7 × 34.5 cm (16¼ × 13½ in.)
85.XM.315.9

Among the most persistent subjects of photographers are their spouses, children, and domestic assistants. Talbot (pls. 5–12) and Eynard (pls. 32–34) are the earliest photographers represented in this book who are known to have made their families the subject of major photographic works. Fleckenstein, working in Los Angeles half a century later, used the new automatic shutter and more light-sensitive roll film to stay the fleeting joy being experienced by his children, who are observed with all of the spontaneity permitted by a hand-held camera and fast, factory-coated negative materials. Fleckenstein was the first Southern California photographer to gain national prominence in Pictorialist circles. He also earned a place in history for his outspoken opposition to what he felt were Stieglitz's overly manipulative and exclusionary tactics in the politics of photography. Fleckenstein was, moreover, the first serious collector of photographs in California. While he was a less ambitious collector than Stieglitz, he preserved examples by the most prominent regional camera artists and also a few Europeans, some of them not represented in any other American collection of his time, most notably Guido Rey (pl. 105), whose work Stieglitz published but did not collect.

120 F. HOLLAND DAY
American, 1864–1933
Warrior, ca. 1905
Gum bichromate print
11.8 × 11.8 cm (4¹¹⁄₁₆ × 4⅝ in.)
84.XM.170.2

"There is no photographer who can pose the human body better than Day, who can make a piece of drapery fall more poetically, or arrange flowers in a man or woman's hair more artistically." So wrote critic Sadakichi Hartmann in the July 1899 issue of *Camera Notes*. Day was the first American to fuse with great success the fictional intent of Robinson (pl. 104) and the Naturalism of P. H. Emerson (pls. 106–7). Among American photographers he was far ahead even of Stieglitz in creating a totally modern and completely American style of photography. Using a sharp-focus lens and printing crisply in platinum, Day delineated all of the costume details of this fictional warrior with truth and precision.

121 BARON ADOLPH DE MEYER
American (b. Germany), 1886–1946
The Silver Skirt, ca. 1910
Platinum print
23.5 × 11.4 cm (9¼ × 4½ in.)
90.XM.14.1

De Meyer was truly cosmopolitan: born in Dresden, he lived in England and
France before settling in New York; he ended his life, fittingly for someone who
adored celebrity, in Hollywood. In 1897, while in London, he married Olga Cara-
ciolla, who was in the circle of the Prince of Wales (later Edward VII). In the roles
of wife, best friend, mannequin, and partner in social climbing, Olga was also
de Meyer's muse and the subject of several hundred camera studies over thirty-
five years. Dressed here in a lavish dinner gown, Olga is placed against formalist
architectural elements, signaling the photographer's awareness of the sea change
in art styles that began to unfold about 1910 in New York, where the couple soon
moved at the enticement of Condé Nast. Earning a salary of one hundred dollars
a week (which shocked Stieglitz and the other Secessionists), de Meyer became
responsible for helping to establish the profession of fashion photographer in
America. His work dominated the pages of *Vogue* and *Vanity Fair* until 1923,
when he was lured away to work for William Randolph Hearst at *Harper's Bazaar*.

122 GEORGE H. SEELEY
American, 1880–1955
White Crysanthemums, 1914
Gum bichromate print
44.6 × 53.8 cm (17⁷⁄₁₆ × 21³⁄₁₆ in.)
84.XP.462.3

Seeley and de Meyer were paired by Stieglitz, who deliberately put work by an American and a European side by side in 1907, when he installed a joint exhibition of their work at the Little Galleries of the Photo-Secession. Stieglitz also devoted issues of *Camera Work* to Seeley and de Meyer in 1907 and 1908, respectively, which made them known to the Photo-Secession audience. De Meyer was strongly influenced by American photography, while Seeley seems to have learned a great deal from his European counterpart. Seeley's study of chrysanthemums may be an homage to de Meyer's treatment of the same subject that was exhibited in 1909 at the Photo-Secession Gallery; it may also have been inspired by their first face-to-face meeting, after de Meyer moved from London to New York in 1914. While Seeley continued his reclusive life in Stockbridge, Massachusetts, de Meyer became an international celebrity through his employment by Condé Nast. In 1923, after moving back and forth between America and Europe, de Meyer went to work for Condé Nast's chief rival, William Randolph Hearst.

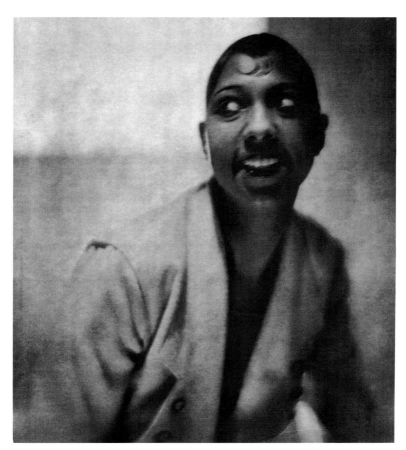

123 BARON ADOLPH DE MEYER
American (b. Germany), 1866–1946
Portrait of Josephine Baker, 1925
Gelatin silver print
39.1 × 39.7 cm (15⅜ × 15⅝ in.)
84.XP.452.5

In the decade after World War I, magazines began to substitute photographs for drawings as illustrations of fashion and glamour. It was soon apparent that much more went into the making of a successful glamour photograph than simply a camera and an attractive model, and the pioneers of fashion photography like Steichen (pls. 111, 113) and de Meyer became the most highly paid individuals in their field because of their skill at giving their subjects allure.

Two distinct types of feminine beauty were quickly popularized, one the All-American Girl with a trim figure, the other a more worldly type, with sophisticated makeup, hairstyle, and clothes. Josephine Baker epitomized this second ideal of beauty. Dancers like Baker were soon recognized as especially good models because of their innate poise and grace in movement. Such abilities were particularly important to photographers like de Meyer. Glamour photographers are not solitary workers, since it is almost impossible for one person to think effectively about backgrounds, focus, and lighting, while also attending to the details of clothing, makeup, and pose that are of great importance in this type of photography. De Meyer's roots in Modernism are evident in the softly focused geometry of the background.

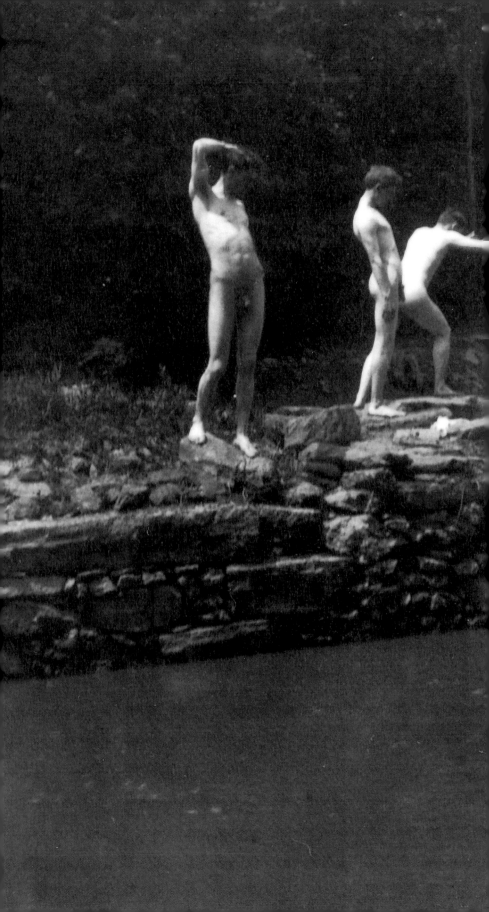

MATTER

&

SPIRIT

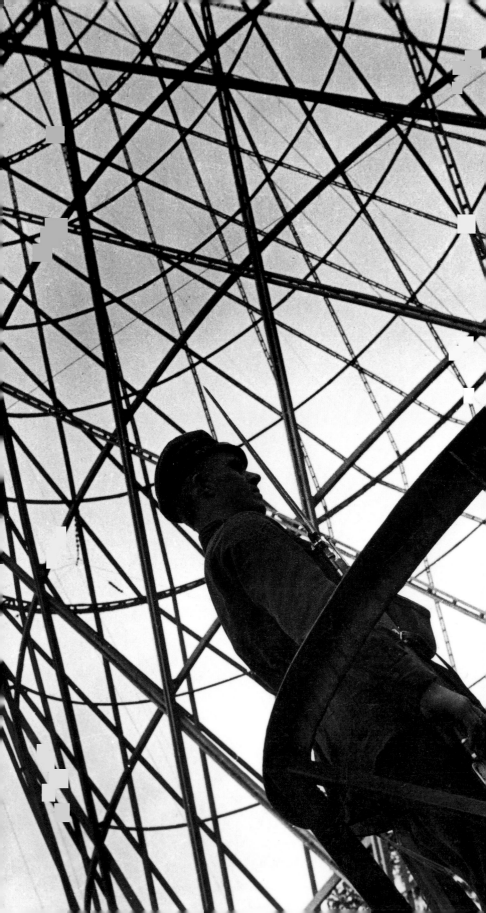

THE PAINTER-PHOTOGRAPHER

At the beginning of the nineteenth century, the Austrian art historian Adam von Bartsch coined the term "painter-printmaker" to describe a class of artists who learned the techniques of engraving in order to personally create their own plates and blocks rather than turn this work over to professional engravers. Something similar happened in photography. Beginning in the 1880s, artists began to use photographs as sketching tools to produce images that they transformed into paintings; sometimes they drew or painted directly upon the photographs to realize a new kind of picture that is a direct combination of science and art. Thus they became "painter-photographers."

Photography became attractive to painters once cameras were simplified and the light-sensitive materials could be commercially bought, developed, and printed; an artist could become a photographer without too much trial and error. The impetus for this interest was the advent of film on rolls—factory-supplied, flexible, light-weight, unbreakable materials that about 1890 replaced glass for making negatives—and the availability of outside services for developing and printing negatives. These technical advances opened the practice of photography to a much wider clientele than the new medium had had in the 1860s and 1870s.

The attraction of photography for painters and sculptors may be in part explained as a reaction to the elevated expectations of art as a perpetually transcendental experience and the longing for mechanical, but immediately responsive, pathways to commonplace events via the unconscious seats of the mind, where the most powerful energy for photography is located. For artists, the camera miraculously enabled them to shorten the time between having a perception and recording it with enormous detail. Not all photographs by painters are works of art, of course. But the artistic training of painters tends to insure visual literacy in their photographs, to induce the freedom to break rules, and to encourage seeing familiar objects in unfamiliar ways. It probably surprised even Muybridge that what began as a scientific experiment became so fascinating to artists.

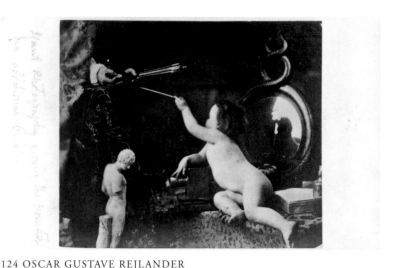

124 OSCAR GUSTAVE REJLANDER
British (b. Sweden), 1813–1875
The Infant Photography Giving the Painter an Additional Brush, ca. 1856
Albumen print
6 × 7.1 cm (2⅜ × 2¹³⁄₁₆ in.)
84.XP.458.34

Oscar Gustave Rejlander's allegory of painting is one of the most direct treatments by a photographer in the 1850s of the interaction between painting and photography. It was also a clever self-portrait, with the artist's own silhouette reflected in the parabolic mirror.

Devéria, a skillful draftsman trained at the Ecole des Beaux-Arts, produced a body of lithographs that helped to define the Romantic style in printmaking in the 1830s. He treated photography as a tool to be exploited rather than as a threat to his profession. Reproduced opposite (below) is an ordinary salt print from a paper negative, while above it is a very lightly printed and untoned print from the same negative that has been touched with ink to achieve a self-portrait that is at once a drawing and a photograph.

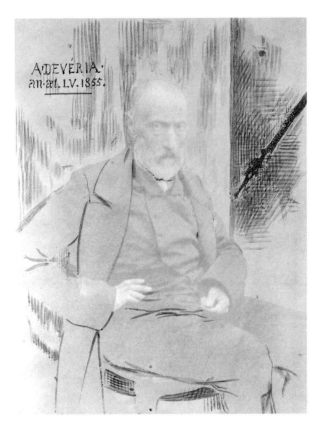

125–26 ACHILLE AND/OR THÉODULE DEVÉRIA
French, 1800–1857; 1831–1871
Achille Devéria, 1855
Salt print embellished with ink
18.4 × 14.1 cm (7¼ × 5⁹⁄₁₆ in.)
84.XM.485.29

Achille Devéria, ca. 1855
Albumenized salt print
20.1 × 15.4 cm (7⅞ × 6¹⁄₁₆ in.)
84.XM.485.31

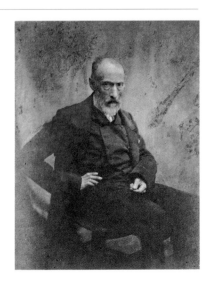

127 EADWEARD J. MUYBRIDGE
American (b. England), 1830–1904
Male Runner (detail), 1878–79
Iron salt process
4.2 × 3.2 cm (1²¹∕₃₂ × 1¾ in.)
85.XO.362.101

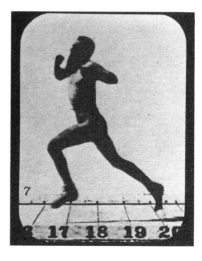

"Describe a wind on land and sea/Describe a storm of rain," wrote Leonardo da Vinci in his notebook at about the same time Columbus first landed in the New World. Ever since Leonardo's day, artists have been fascinated by things the eye cannot grasp in a single glance, such as storms, waves, and the flight of birds. Muybridge, an Englishman who emigrated to San Francisco in the mid-1850s, was the person who first photographed the progressive actions of bodies in motion. Taking himself as the subject, running naked with both feet off the ground at one point in his stride, Muybridge made one of the most audacious self-portraits in the history of art. Later, using a bank of twenty-four twin-lensed cameras fitted with crude shutters, he proved for Leland Stanford that a horse gallops with all four feet off the ground at once, thus forever changing the way artists represented the horse in motion. His published set of studies, entitled *Animal Locomotion* (1887), would influence artists from Degas to Francis Bacon.

128 *Gesturing* (detail), 1878–79
Iron salt process
4.2 × 3.2 cm (1²¹∕₃₂ × 1¼ in.)
85.XO.362.121

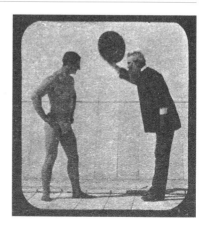

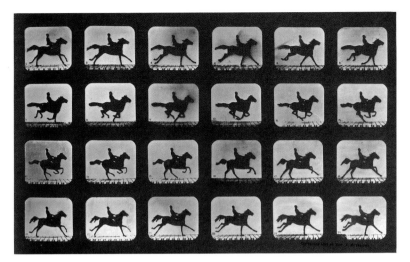

129a–b *Galloping* (full plate and detail), 1878–79
Iron salt process
Full plate: 18.9 × 22.6 cm (7⁷⁄₁₆ × 8¹⁵⁄₁₆ in.)
Detail: 4.2 × 3.2 cm (1²¹⁄₃₂ × 1¼ in.)
85.XO.362.44

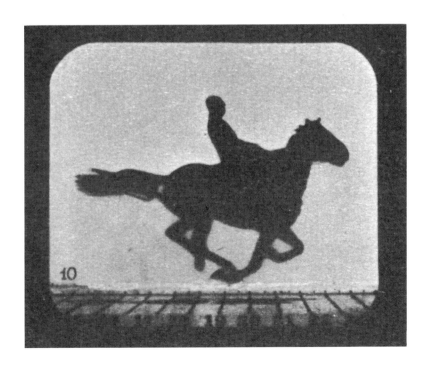

130–32 THOMAS EAKINS
American, 1844–1916
*Study of Muscular Action: Young Man
Leaning on a Horse's Leg*, 1883–85
Lantern slide
4.3 × 4 cm (1¹¹⁄₁₆ × 1⅝₆ in.)
84.XM.201.25

Eakins was possibly the first important
painter to create a significant body of
photographs. He was on the commit-
tee that persuaded Muybridge to move
from San Francisco to Philadelphia to
continue his animal locomotion studies there, and he was the first director of an
art school (the Pennsylvania Academy of Fine Arts) to insist that photography be
taught to aspiring artists. Despite his interest in Muybridge's motion studies,
Eakins's own photography experiments first involved static forms. His study of a
student-assistant poised on a ladder and leaning on the leg and thigh of a dis-
membered horse captures the powerful vectors and forces that animate a living
creature. Another sequence of seven photographs shows a student-model in suc-
cessive shifts of weight and posture. The studies were designed to be used by art
students to achieve greater accuracy in their drawing.

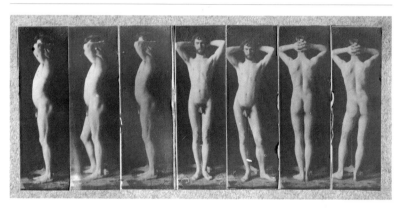

George Reynolds: Seven Photographs, 1883
Albumen prints
8.1 × 18.8 cm (3³⁄₁₆ × 7⅜₆ in.)
84.XM.254.23

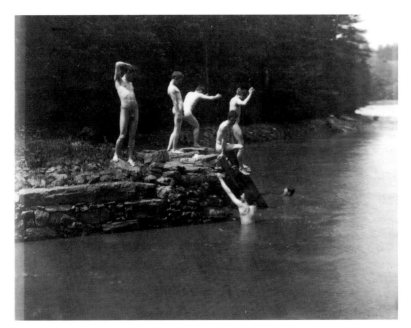

Eakins's Students at the Site for "The Swimming Hole," 1883
Albumen print
9.3 × 12.1 cm (3²¹⁄₃₂ × 4²⁵⁄₃₂ in.)
84.XM.811.1

Eakins was not at his most original in controlled studies of the static human figure. His work became more compelling when he used his camera to record people in dynamic situations, such as seven male students at a swimming hole near Bryn Mawr, Pennsylvania, where the figures are in both active and static poses. The camera was probably operated with the help of an assistant. Eakins's painting *The Swimming Hole,* now in the Amon Carter Museum, was created from sketches based on these photographs; it is probably the most famous nineteenth-century painting known to have been based on a photograph.

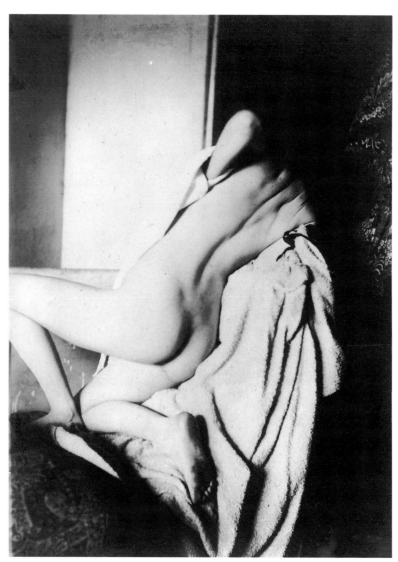

133–34 EDGAR DEGAS
French, 1834–1917

After the Bath, Woman Drying Her
Back, 1896
Gelatin silver print
16.5 × 12 cm (6½ × 4²³⁄₃₂ in.)
84.XM.495.2

Louise Halévy Reading to Degas,
ca. 1895
Gelatin silver print
28.7 × 39.7 cm (11⁵⁄₁₆ × 15⅝ in.)
84.XM.495.3

"The world wants photographs today. Genius devotes itself . . . to art, while the mediocre talent turns to photography," wrote the German novelist Wilhelm Raabe in his book *Der Lar* (1889). Eakins, Degas, and many other painters proved him wrong. Degas was an inveterate experimenter in the graphic arts, creating major works in monotype, drawing, etching, and lithography, before turning his awesome talents to photography between 1894 and 1896. However, twenty-five years before, at about the time he first met Nadar, Degas used carte-

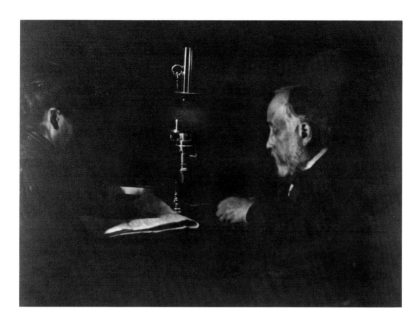

de-visite photographs as the sources for several portraits. In 1874 he drew a pastel of a dancer posing in a photographer's studio, which led to his 1896 study of a model drying herself after her bath. The movement shown here is complex and contorted, almost acrobatic. The photograph is related to a startling, almost voyeuristic series of drawings devoted to the motions of women dressing, bathing, and twisting their bodies while drying themselves.

Degas went on to tackle the hardest problem photographers faced: photographing in subdued and artificial light. He took his camera to dinner parties, especially those with the Halévy family, and at home often focused on his visitors. "Daylight," he wrote, "is too easy. What I want is difficult—the atmosphere of lamps or moonlight."

135–36 CHARLES SHEELER
American, 1883–1965
Side of a White Barn, 1917
Gelatin silver print
19.4 × 24.4 cm (7⅝ × 9⅝ in.)
88.XM.22.4

In 1910, Sheeler clipped from *Camera Work* a reproduction of Stieglitz's photograph of Picasso's great bronze *Head of a Woman,* which he mounted and hung on his studio wall, where it stayed for many years. The reproduction is emblematic of the influence that French Cubism exerted early in Sheeler's career. Five years later, Sheeler met Marcel Duchamp, whose Dadaist statements also influenced him. Sheeler's series of photographs of American vernacular architecture in 1917 are an experimental breakthrough in their ingenious fusion of Cubism and Dadaism. The starkly geometric *Side of a White Barn* at first looks more like documentation than art, because there is no concern whatsoever for decorative effects; the functional counts for all. In this photograph Sheeler has created an elegantly shaped low-relief sculpture; its subject is the relationships between elements of the wall surface (doors, windows) shaped by light.

Doylestown House—The Stove, 1917
Gelatin silver print
22.9 × 16.2 cm (9 × 6⅜ in.)
88.XM.22.1

This photograph has in common with *Side of a White Barn* a concern for the symbolic value of pure light, along with the status of the found object in the spirit of Duchamp. The interior is photographed at night, with a single source of artificial light blasting from the belly of the stove via the electric bulbs that had recently come into use by photographers. Sheeler reconciles the perennially opposing forces of light and dark, of mass and line, and of nostalgia and modernity. "[The photographs are] probably more akin to drawings than to my photographs of paintings and sculptures," wrote Sheeler to Stieglitz.

137 CHRISTIAN SCHAD
German, 1894–1982
Untitled Schadograph, 1919
Gelatin silver print
5.8 × 8 cm (2⁵⁄₁₆ × 3³⁄₁₆ in.)
84.XP.1109.3

138 CONSTANTIN BRANCUSI
French (b. Romania), 1876–1957
Mlle Pogany II, 1920–21
Gelatin silver print
22.5 × 16.3 cm (8²⁷⁄₃₂ × 6⁷⁄₁₆ in.)
84.XM.802

Christian Schad, a realist painter, and Constantin Brancusi, an abstract sculptor, appeared on the horizon of photography in 1918–19, the former in Zurich, the latter in Bucharest. Schad's unique and highly imaginative contribution to the vocabulary and syntax of Dadaism occurred about 1919, when he decided to use photography to create an enigmatic set of highly abstract miniature compositions made up of tiny pieces of refuse that were placed onto photographic paper so that they could draw their own edges and shadows. Schad created these compositions out of semitransparent fragments of cloth, paper, and string. Wrinkled, torn, and damaged objects exerted a powerful fascination for Schad. "They had a patina and held a kind of magic for me. . . . A fresh immediate reality emerged. An unimportant object can take on a new form being worked upon, distorted, made into a collage, or turned upside down," Schad said, describing a procedure that was later used effectively by Man Ray and Moholy-Nagy. These images abolish any signs that they were made by the human hand, replacing artistic gesture with lines and shapes that resemble natural forms, such as pine pitch or the pearl in an oyster.

In 1908, Brancusi startled the world with abstract and quasi-figurative sculptures roughly hewn out of stone. After his relocation to Paris, he shifted to more figurative pieces such as *Mlle Pogany II*, which were realized in highly polished bronze that, like Schad's photograms, introduce confusion between the handmade and the mechanically produced. Brancusi preferred to photograph his own sculpture, and he then used these photographs to establish the principal viewpoint from which a piece should be seen. He also experimented with light reflected from the surface as a dynamic new compositional element in his sculptures, and he used photography to record this effect.

139–40 MAN RAY
American, 1890–1976
Anxiety, 1920
Gelatin silver print
9.4 × 11.9 cm (3¹¹⁄₁₆ × 4¹¹⁄₁₆ in.)
86.XM.626.7

Duchamp with "Water Mill within Glider,
in Neighboring Metals," 1923
Gelatin silver print
8.5 × 15.1 cm (3⅜ × 5¹⁵⁄₁₆ in.)
86.XM.626.4

Progress in art often advances from the creative collaboration between two highly gifted individuals. Such was the case with the creative partnership of Marcel Duchamp and Man Ray, which had its beginnings in New York in 1915 and flourished in New York and Paris between 1920 and 1924. Duchamp arrived in New York from Paris in June of 1915 at the age of twenty-eight. He was the creator of a painting, *Nude Descending a Staircase,* that, from the time in 1913 when it was displayed at the Armory Show, was better known than he.

Man Ray's *Anxiety,* a work directly inspired by Duchamp, has as its subject cigar smoke trapped in a glass box containing a broken clock. In this photograph, forms are distorted and time is held in abeyance; the true subject is neither vapor nor solid, but rather the effects of chance and the nonrational. The collaboration between Man Ray and Duchamp continued at an intense pace in 1920, when they became interested in the connections between the technological and the psychological. Man Ray's study of Duchamp embracing his *Large Glass* manifests the powerful interaction between the imagination and technology, a realm of inquiry the two artists were exploring jointly.

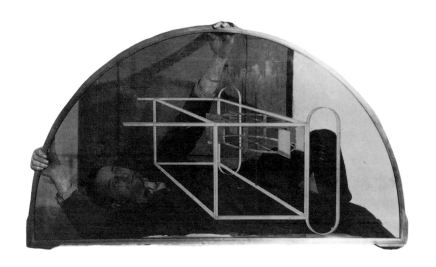

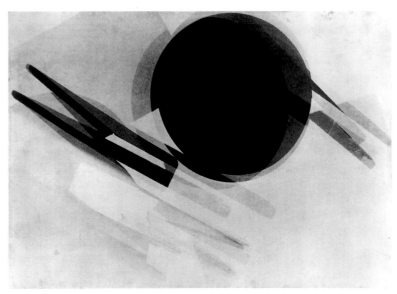

141–42 LÁSZLÓ MOHOLY-NAGY
American (b. Hungary), 1894–1946
Photogram Number 1—The Mirror, negative, 1922–23; print, ca. 1928
Gelatin silver print
63.8 × 96.5 cm (25⅛ × 36¼ in.)
84.XF.450

The epochal *Photogram Number 1* (in the title of which the word *photogram*—in German *fotogramm*—was coined) is a work that was far more ambitious than the 1919 cameraless imagery of Schad or the 1922 Rayograms of Man Ray. In their article "Produktion-Reproduktion" of July 1922, Moholy and his wife, Lucia, described a method by which an image could be created on film without a camera "by means of mirror or lens devices." The highly composed network of lines and shapes is exclusively Constructivist; there is a complete absence of the Dadaist elements that underlie the cameraless photographs of Schad. The piece—comparable in size to Moholy's paintings of this period—may have been created by means of a cameraless process, possibly on a paper negative that was later enlarged. It was typical of the new style, based on the use of industrial materials, engineering theory, and mechanical procedures, that was formulated in the Soviet Union and came to be known as "Productivist Art."

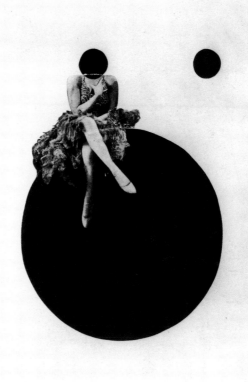

The Olly and Dolly Sisters, ca. 1925
Gelatin silver print
37.4 × 27.5 cm (14²³⁄₃₂ × 10¹³⁄₁₆ in.)
84.XM.997.24

One way Moholy-Nagy introduced the competing elements of "production" and "reproduction" into his work was to mount photographs onto backgrounds to which he could add his own drawing. The montages were then copied by rephotographing them; the new print had a homogenous surface and the look of a manufactured artifact rather than a handcrafted one, which the original montage unmistakably was. His *Olly and Dolly Sisters* of about 1925 appropriates a publicity photograph of one member of a vaudeville team; with the addition of three black circles, the composition achieves an effect of abstraction combined with the emotional appeal of popular culture.

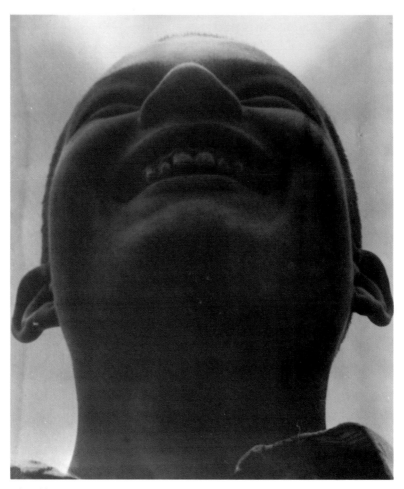

143–44 ALEXANDER RODCHENKO
Russian, 1891–1956

Pioneer, 1930
Gelatin silver print
56.8 × 48.4 cm (22⅜ × 19⅛ in.)
84.XM.258.43

Sentry on the Shukhov Tower, 1929
Gelatin silver print
23.9 × 15.6 cm (9⅜ × 6⅛ in.)
85.XM.155

Form generally determines content in Constructivist art, not the reverse, and the relationship of content to form became a critical question about 1925, when Stalin implemented the New Economic Policy that represented a limited return to free markets and a semicapitalist system of wages and private ownership. As a result, art was being pressed into the service of political policy and commerce simultaneously.

In *Sentry on the Shukhov Tower* of 1929, Rodchenko amalgamates the principles of Constructivism and Productivism. The image is "constructed" from a geometry of intersecting lines, while the subject is the result of Soviet "productivity." The industrial and the human, the Constructivist and the symbolic, are fused into one image.

Rodchenko was no purist, and he cropped and enlarged his negatives to serve his own compositional needs. The greatly enlarged close-up study of a boy at a youth camp typifies the radical viewpoints favored by Rodchenko and other proponents of a "new vision" in photography. The greatly oversized scale of this print (like its counterpart by Moholy-Nagy [pl. 141]) was ideal for the Constructivists, who believed their art should merge with the life and work of Soviet society.

145 OSKAR SCHLEMMER
German, 1888–1943
Self-Portrait at Typewriter, Prellerstrasse Studio, 1925
Gelatin silver print
10.8 × 7.6 cm (4¼ × 3 in.)
84.XP.124.45

Oskar Schlemmer was a versatile artist who worked in painting, theater, dance, design, and, in a very limited way, photography. During his term as an instructor at the Bauhaus, he came into contact with the theories of Moholy-Nagy, who also taught there and made photography a required part of the curriculum. Seated at his writing desk with a Stolzenberg typewriter before him, Schlemmer created this self-portrait, possibly with the assistance of a remote cable release that curves through the left foreground. Whether the artist deliberately made a double exposure following the example of his friend Moholy-Nagy, or whether the double exposure was a complete accident, we do not know. Either way, the photograph demonstrates how powerful chance can be in the creation of a photograph and proves how quality in a photograph is partially dependent on the artist's skill at controlling the unpredictable elements of a mechanical procedure.

146 RENÉ MAGRITTE
Belgian, 1898–1967
The Giant (Paul Nougé), 1937
Gelatin silver print
8.1 × 5.3 cm (3³⁄₁₆ × 2¹⁄₁₆ in.)
87.XM.87

The removal of an everyday object from its expected context was a favorite strat-
egy of the Surrealist art practiced by René Magritte, who was living in Paris
between 1927 and 1930, just after André Breton wrote his first Surrealist mani-
festo. Breton wrote: "The most powerful image for me is one characerized by a
high degree of arbitrariness . . . either because it is self-contradictory to a high
degree . . . or because it contains an insufficient formal justification within itself . . .
or because it provokes laughter." Magritte completely accepted these premises and
returned in 1930 to Brussels, where a loosely knit circle of writers and artists,
including the writer Paul Nougé, socialized together and created Surrealist-
inspired works. Magritte frequently brought his camera along on outings with
this group, when they would jointly devise juxtapositions that turned the com-
monplace into the extraordinary. Here the act of holding a chessboard transforms
an emblem of intellectual entertainment into a structural extension of the human
body intended to provoke laughter. André Breton's definition of Surrealism as the
resolution of "dream and reality, into a sort of absolute reality, a *surreality*, so to
speak," is achieved in Magritte's photograph.

147 WOLS
German, 1913–1951
Untitled, ca. 1935
Gelatin silver print
7.7 × 5.5 cm (3¹⁄₁₆ × 2⁵⁄₃₂ in.)
84.XM.140.205

Wols (Alfred Otto Wolfgang Schulze) was a painter most closely associated with the Art Informal group, a post-World War II movement in Europe that made art from everyday objects. Wols created a spare and unusual still life from what appears to be a bruised and irregular orange. Unlike a commercial photographer, Wols has striven to produce a perfectly composed image of a noticeably imperfect object. The crenolated edges of the print are a sign that Wols sent his negative to a commercial photofinisher rather than print the photograph with his own hands. He did not see his photographs as examples of consummate craftsmanship as, for example, Charles Sheeler did (pls. 135–36, 151).

148 SIGMAR POLKE
German (b. Poland), b. 1941
Untitled, Düsseldorf, 1968
Gelatin silver print
17.9 × 23.9 cm (7¹⁄₁₆ × 9⅜ in.)
84.XM.137.10

Although ambiguity is often considered a great shortcoming in the written or
spoken word, it can be a very powerful force in photography when the camera is
in the hands of a painter or sculptor. Polke, who was trained as a painter at the
Staatliche Kunstakademie in Düsseldorf, acquired a camera about 1966 and
began to use it like a pencil to create puzzling doodles that superficially recall
some of the earliest experiments by Talbot, Bayard, and Atkins. One of Polke's
first strategies was to isolate everyday articles composed of repeated modules—
such as folding rulers used by carpenters, nails, and coat hooks, as seen here—
that he could readily rearrange. These components were then photographed and
thrown away, so that the resulting picture is both a document of past actuality and
a work of art destined for consumption. Polke deliberately ignores the guidelines
for exposure and development established by the manufacturers of photographic
materials. By doing so, he deliberately puts his skill at photography in doubt and
challenges us to have faith in his genius.

149 YASUO KUNIYOSHI
American (b. Japan), 1889–1953
Coney Island, 1938
Gelatin silver print
19.2 × 24.2 cm (7⅟₁₆ × 9⁹⁄₁₆ in.)
84.XM.188.6

About 1920, fresh out of the Art Students League of New York where he had
studied painting, the Japanese-American Kuniyoshi bought a plate camera and,
following the example of Sheeler, became a photographer of works of art for
collectors and galleries. In 1935, he purchased a Leica camera and used its small
size and extreme portability as assets to enable him to make snapshots of people
without their knowledge. Bold compositional elements sometimes resulted from
chance occurrences, such as the out-of-focus railing that cuts across the fore-
ground here. Kuniyoshi used these photographs as preparatory sketches for
paintings and prints, as though the camera and film were drawing materials
interchangeable with graphite and ink.

150 RALSTON CRAWFORD
American, 1906–1978
Third Avenue Elevated, New York City, 1948
Gelatin silver print
11.4 × 8.6 cm (4½ × 3⅜ in.)
84.XM.151.129

Crawford, whose Precisionist style and concern for tough industrial subjects owes much to Charles Sheeler (pls. 135–36, 151), used the camera as a sketch pad even more persistently than either Sheeler or Kuniyoshi. For him, the transformations that occurred from negative to finished print were satisfying processes in themselves. "The various formal combinations arrived at through the enlarging (with various croppings) of a single negative are highly informative," he wrote. This study of a painted steel support for the elevated railway in New York is marked in ink by the artist to indicate the elements he finally used in a painting derived from the photograph. The interplay between pure structure and surface decoration central to the photograph is unimportant to the series of related paintings, which concentrate on design and color. Photography allowed Crawford to pursue two contradictory ideas at once—his attraction to highly specific detail and his love of broadly decorative effects abstracted from the everyday world.

151 CHARLES SHEELER
American, 1883–1965
Wheels, 1939
Gelatin silver print
16.8 × 24.4 cm (6⅝ × 9⅝ in.)
88.XM.22.7

Created more than two decades after Sheeler's pivotal studies of vernacular American architecture in Bucks County, Pennsylvania (pls. 135–36), this photograph was made while the artist was working on a commission from *Fortune* magazine that resulted in a portfolio of paintings entitled *Power*. Two years later, a headline in a *Life* magazine article declared "Charles Sheeler Finds Beauty in the Commonplace." From very close up we see one drive wheel, half the bogie, and one condenser releasing its charge of steam from a giant New York Central locomotive observed from a vantage point normally afforded only to crewmen. Sheeler used a detail to stand for the power and scale of the entire massive unit; however, the photograph itself was not his ultimate objective but rather a painting derived from it that now hangs in the Smith College Museum of Art. When considered side by side, the painting and photograph have an inverse relationship best described by Sheeler himself in the caption that accompanied the photograph in *Fortune*: "Photography is nature seen from the eyes outward, painting from the eyes inward." Sheeler's photograph transforms the commonplace into an image that is—in his words—"so luminous, so formally beautiful, so rich in design."

152 BERND AND HILLA BECHER
German, b. 1931; b. 1934
Cooling Tower, 1968
Gelatin silver print
23.9 × 17.9 cm (9⅜ × 7¹⁄₁₆ in.)
84.XM.125.37

Bernd and Hilla Becher hold an attitude about craft in photography diametrically opposed to their European counterparts such as Magritte (pl. 146), Wols (pl. 147), and Polke (pl. 148), who gave their negatives to local photofinishers to print and who chose to remain ignorant about the chemistry of photography. Bernd and Hilla Becher go to extremes to achieve perfect negatives, all exposed on overcast days and developed to achieve minimum contrast and maximum definition; their exhibition prints are as fastidiously made as August Sander's (pls. 159, 162). Their obsession with technique is a necessity to achieve the objective of absolute comparability between different views of the same structure and views of different structures of the same type that, for reproduction and display, are often arranged in groups of three, six, nine, and eighteen. When their multiprint typologies are exhibited, they can command the wall like a good-sized painting. By choosing to photograph the artifacts of modern industry, Bernd and Hilla Becher are walking in the footsteps of Sheeler (pls. 135–36, 151) and Renger-Patzsch (pls. 170–71, 201).

WITH NEW EYES

It frequently happens that the individual artist finds his or her own style swinging like a pendulum back and forth between the simple and the complex, the linear and the painterly, the classical and the romantic; between nature and the machine, the figurative and the abstract, the purely decorative and the purely philosophical. Photography is no different from the other arts in this regard, and photographers, like other artists, are challenged by conflicting goals and objectives that can be self-assigned or established by society.

The period between about 1915 and 1936 is considered the epoch of Modernism in photography. Modernism has been defined as the process through which the arts in general became more personal, intimate, and concerned with experiences of a subtle kind, and the artist is seen as an individual who risks failure through repeated experiments, the results of which often challenge the comprehension of the audience.

Another definition can be advanced that Modernism is the successful unification in a work of art of two perennially conflicting world views—the kinds of dualities that Alfred Stieglitz, for example, was continuously exploring. One view holds that the world is a moral order governed finally by irrational yet spiritual forces, of which art is the supreme manifestation. Many experimental artists attempted a reconciliation of this belief with the conflicting vision of the world as governed wholly by the rigid laws of nature, which are obdurately indifferent to moral and spiritual ideals. The common ground between the spiritual and the natural lies in the workings of accident and chance, forces in which art and science share an interest. Experimental photographers used their materials to arrest chance events by means of a kind of controlled intuition. In the process they sought to bring art and science into harmony for the first time since the Renaissance.

153–54 PAUL STRAND
American, 1890–1976

Twin Lakes, Connecticut, 1916
Gelatin silver-platinum print
31.2 × 23.7 cm (12⅜ × 9⁵⁄₁₆ in.)
86.XM.683.98

Black Bottle, negative, ca. 1919; print, 1923–39
Gelatin silver print
35 × 27.6 cm (13¹³⁄₁₆ × 10¹⁵⁄₁₆ in.)
86.XM.686.5

At the age of seventeen, in 1907, Strand visited the Photo-Secession Galleries, where he met Alfred Stieglitz (pls. 112, 114–15, 156–57) and was inspired by him to work seriously in photography. Eight years later, Strand created a revolutionary body of work that incorporated fresh subjects observed from radical viewpoints. The breakthrough occurred during a summer retreat at Twin Lakes, Connecticut, where he created Cubistic still-life arrangements from household articles and transformed domestic architecture into Modernist abstractions. This direction continued with the *Black Bottle* of three years later. There is Modernist

complexity in the angled shadows and irregularity in the four black shapes of the sink's overflow drain holes lined up side by side, so perfectly positioned by the photographer that they could have been cut out and pasted there. Strand's composition makes us see commonplace objects afresh, the way a poet does. Yet the poetic objective has been achieved through accurate, precise, and definite observation, even though some parts are radically out of focus.

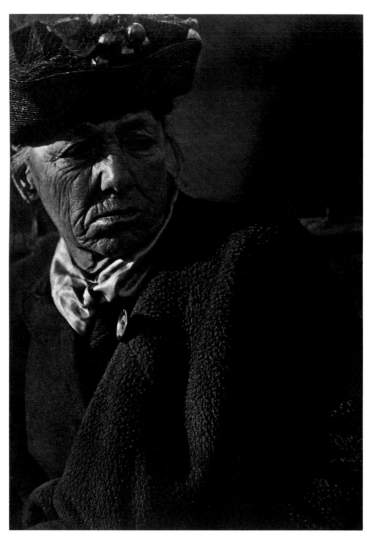

155 PAUL STRAND
American, 1890–1976
Portrait—New York, 1916
Platinum print
34.3 × 25.1 cm (13½ × 9⅞ in.)
89.XM.1.1

When Strand first visited Stieglitz in 1910, he had been listening to the advice of
Lewis Hine (pls. 101, 103), who was one of the most socially concerned photog-
raphers of the twentieth century. One of Strand's contributions to a new aesthetic
was to bring together Hine's humanism with Alfred Stieglitz's formalism (see pls.
112, 114–15, 156–57). This photograph made in New York's Washington
Square Park is less a portrait than an archetype of old age and urban survival. The
woman has been photographed without her knowledge by the use of a prismed
lens. The composition is off-center, with hard-edged light and an oblique view-
point that establishes a sense of sculptural immobility. Strand turned to socially
conscious themes in the 1930s and never returned to complete abstraction.

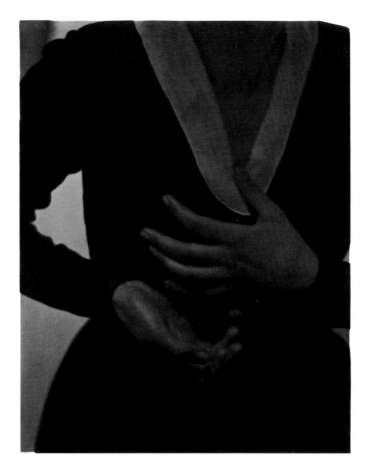

156 ALFRED STIEGLITZ
American, 1864–1946
Georgia O'Keeffe: A Portrait, June 4, 1917
Platinum print
24.4 × 19.5 cm (9⅝ × 7¹¹⁄₁₆ in.)
91.XM.63.3

About the same time that Strand was making his stylistic breakthrough in the Twin Lakes series, his mentor Stieglitz also experienced an astonishing, almost involuntary change of direction. The catalyst for Stieglitz was Georgia O'Keeffe, a young painter whose art and personal style influenced him and his circle enormously. She was living in New York during the first half of 1916 and was included in a group exhibition at Stieglitz's gallery. Toward the end of the exhibition she visited the gallery for the first time, appearing "thin, in a simple black dress with a little white collar [and with] a sort of Mona Lisa smile"; so Stieglitz recalled years later. This study was among the first of a series that eventually amounted to more than 325 photographs of O'Keeffe that probed different aspects of the woman's persona. Hands are an important motif in the series. Stieglitz shows us hands that give shape to art, and he challenges us to imagine how they could also stroke and caress, grasp and hold, or scratch and claw. He tells us in visual language how they can stand for everything in nature that is subject to dramatic change.

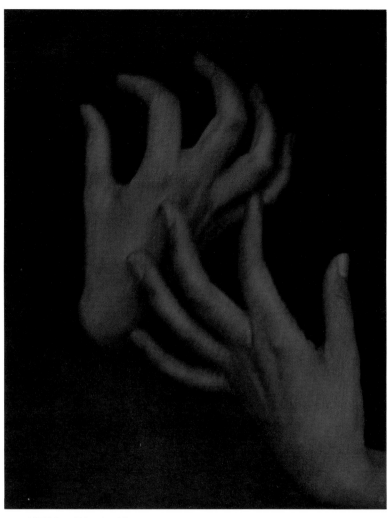

157 ALFRED STIEGLITZ
American, 1864–1946
Georgia O'Keeffe: A Portrait—Hands, 1918
Palladium print
24.3 × 19.4 cm (9%₆ × 7% in.)
91.XM.63.6

In 1918, O'Keeffe moved to New York and became Stieglitz's constant companion. Their relationship grew from friendship into love, and as it deepened Stieglitz moved increasingly closer to his model. He focused his camera on every surface and detail of her body, but constantly returned to her hands as a mirror of her spirit. Her gestures recall the rhythm of the music that was so important to O'Keeffe; at the same time, they are themselves living drawings that echo and vivify the abstract biomorphism of drawings by O'Keeffe that Stieglitz exhibited. Seen one way, the gestures here are primitive and full of tension; seen another, the fingers especially have an active/passive aspect, like the tendrils of a climbing plant. "My hands had always been admired . . . but I never thought much about it," recalled O'Keeffe when she looked at this photograph again sixty years later.

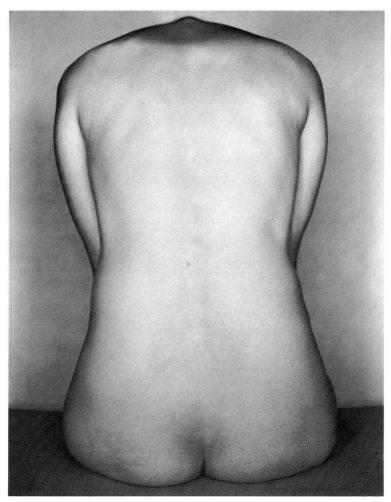

158 EDWARD WESTON
American, 1886–1958
Nude [Cristal Gang], 1927
Gelatin silver print
23.8 × 18.7 cm (9⅜ × 7⅜ in.)
86.XM.676.1

Edward Weston emerged as a portrait photographer in the Los Angeles suburb of Tropico (now Glendale) between 1912 and 1922. He was influenced by the spare and arid landscape of Southern California and by the local obsession with natural food and physical culture. In an attempt to sort out the contradictory possibilities of his art, he made a trip East in 1922, during which he met Alfred Stieglitz in New York and saw his studies of O'Keeffe (pls. 156–57), which impressed him enormously. Soon after returning home, he decided to change the direction of his life and art completely. He fled Los Angeles for Mexico City accompanied by Tina Modotti (pl. 178) and there he began to express a new, more internalized universe. He returned to Los Angeles in 1926 and began a series of metaphoric photographs involving the human figure and still-life arrangements. Here the female figure is made to resemble a cross between a piece of fruit and a spare desert landscape.

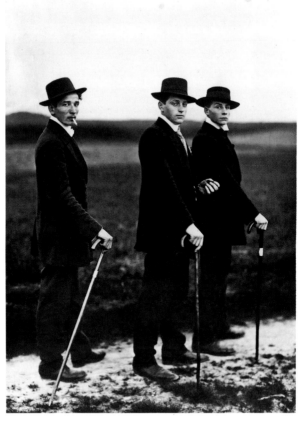

159 AUGUST SANDER
German, 1876–1964
Young Farmers, ca. 1914
Gelatin silver print
23.5 × 17 cm (9⅜6 × 6¹⅟₁₆ in.)
84.XM.126.294

Like Weston, Sander began his career as a successful commissioned portraitist work-ing chiefly from a studio in his home. But like Walker Evans (pl. 160), he had an interest in rural and agrarian areas. During the height of World War I, at a time when he was forced to earn his livelihood by searching for clients in the country-side around Cologne, Sander created an enigmatic composition representing three young men in dark suits, each with a cane in his right hand. It was his first mas-terpiece. Its effect is achieved by the powerful way in which chance elements have been used. The subjects seem to have been caught off guard in the course of trav-eling along the dirt path upon which they stand. The earth is oddly light colored, more like beach sand than agricultural soil, and the terrain behind them is flat except for a small hill. The exposure has been made with the aperture of the lens at its maximum opening, thus causing the background to be out of focus and creat-ing a diffuse texture on which the figures look collaged. The spontaneity and sense of a situation unfolding are in contrast to the static poses typical of Sander's work to this point. It is hard to imagine this photograph being a portrait commissioned by the three young men; it is easy to believe that it was one of the first pictures Sander made in the full awareness that his own art was cultural history.

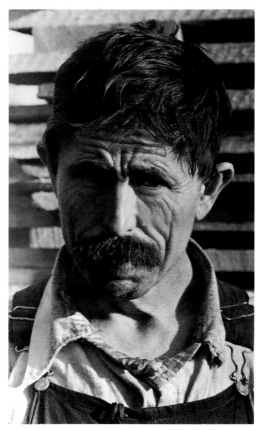

160 WALKER EVANS
American, 1903–1975
Fred Ricketts, Cotton Tenant Farmer, 1936
Gelatin silver print
19.9 × 12.3 cm (7¹³⁄₁₆ × 4²⁷⁄₃₂ in.)
84.XM.956.286

Twenty years after Sander immortalized three anonymous German farmers (pl. 159), Walker Evans traveled to Alabama with the writer James Agee to chronicle the lives of three American farm families. One farmer was given the name "Fred Ricketts" to protect his privacy and that of his family. As a tenant farmer, Ricketts was one rung on the social ladder above a sharecropper, who did not even own a mule. Evans's approach is to describe his subject with great objectivity. The harsh light falling from directly overhead places Fred Ricketts's eyes in deep shadow and accentuates the furrows of his prematurely wrinkled face. Shown here wearing a work shirt heavily soiled and frayed at the collar, the farmer was photographed by Evans using his camera for 8 × 10-inch negatives and later cropped to achieve the final composition.

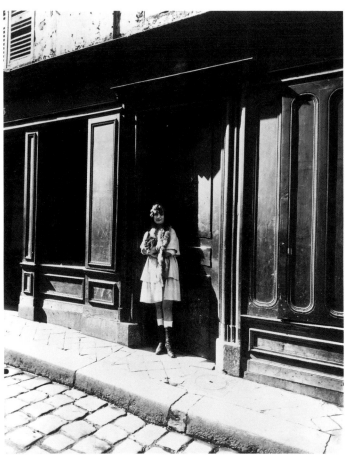

161 EUGÈNE ATGET
French, 1857–1927
Brothel, Versailles, 1921
Gelatin silver-chloride printing-out paper print
21.7 × 16.4 cm (8⁹⁄₁₆ × 6½ in.)
85.XM.350

Before his death in 1927, Atget was practically unknown outside of Paris, even to professionals in the field of photography. His genius was first recognized about 1924 by two young Americans living and working in Paris—Berenice Abbott (pl. 174) and Man Ray (pls. 139–40, 163, 166). They both appreciated the elements of contradiction, ambivalence, and ambiguity that made him seem to them more an artist than a journeyman practitioner. Atget had visited Versailles many times to photograph the royal château and its gardens. On one visit to the nearby city, he recorded a woman standing in the sidewalk doorway wearing a fur stole draped over her shoulders, high-topped lace boots, and a dress with the hemline well above her knees, which in 1921 was the uniform of a woman who earned her living from the streets. Her face has the beginnings of a smile, and she looks directly at the photographer with an expression of trusting familiarity. The photograph's message is ambiguous and equivocal, because Atget gives equal compositional weight to the architecture and the figure; in so doing, he skillfully reconciles competing visual elements.

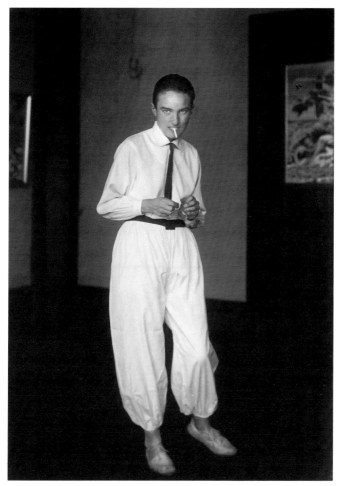

162 AUGUST SANDER
German, 1876–1964
Frau Peter Abelen, Cologne, 1926
Gelatin silver print
23 × 16.3 cm (9⅟₁₆ × 6⅟₁₆ in.)
84.XM.498.9

The enigma of Sander's work—like Atget's—is that his photographs are simultaneously traditional and modern. He used a tripod-mounted plate camera at a time when handheld cameras were attracting many photographers, and he usually posed his figures in an environment that revealed something about their life, a strategy that he appropriated from painting and professional portraiture. Sander became skilled at causing his subjects to project a sense of expectation and then arresting the precise psychological moment. Dressed in stylish culottes, Frau Peter Abelen stands in a gallery surrounded by her husband's paintings. She has a cigarette secured between her teeth, and she is about to light it with the match and striker she is holding. We have a powerful sense of tense psychological reality. The woman is androgynous, and her expression falls somewhere between anticipation and anger. Similarly, we do not know whether Sander is accusing or praising her in his portrayal.

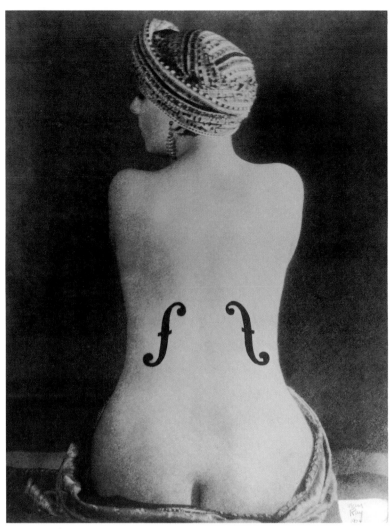

163 MAN RAY
American, 1890–1976
The Violin of Ingres, 1924
Gelatin silver print
29.6 × 23 cm (11⅝ × 9 in.)
86.XM.626.10

The goal of many experimental artists of the 1920s was to fully integrate the figurative and the abstract into a single seamlessly joined work of art that had vigorous content and appealed first to the sense of sight and second to reason. *The Violin of Ingres* (Le Violon d'Ingres) shows Alice Prin, who was better known as Kiki of Montparnasse, from the back, posed to resemble the model in *The Turkish Bath* of 1859–63 by Jean-Auguste-Dominique Ingres. Besides setting up the obvious visual pun, Man Ray was also making a reference to Ingres's hobby of playing the violin and to Marcel Duchamp's love of seeing one thing in the shape of another. Man Ray was also making an irreverent comment upon art that has been sanctified by museums and commenting sardonically upon cherished notions of human sexuality.

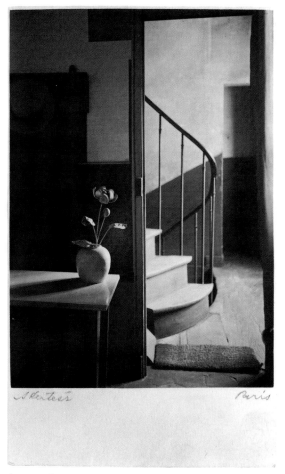

164 ANDRÉ KERTÉSZ
American (b. Hungary), 1894–1985
Chez Mondrian, 1926
Gelatin silver print
10.9 × 7.9 cm (4⁵⁄₁₆ × 3⅛ in.)
86.XM.706.10

Paris had been considered the world capital of art for fifty years before Kertész
arrived there from Budapest in September 1925, almost simultaneously with
Berenice Abbott's (pl. 174) discovery of Atget (pls. 102, 161, 176). Kertész dined
at the café Le Dome, where other expatriates gathered, including Brassaï (pl.
190), Sergei Eisenstein, Michel Seuphor, and Piet Mondrian. Through Seuphor,
he met Mondrian and gained the opportunity to photograph him and his studio.
Kertész described for a friend the shaping of this composition, which is mortised
and tenoned in light: "The door to [Mondrian's] staircase was always shut, but as
I opened it in my mind's eye the two sights started to present themselves as two
halves of an interesting image that I thought should be unified. I left the door
open, but to get what I wanted I had to move a sofa." Kertész called himself a
"naturalist Surrealist" because of his skill at recording a scene as he found it,
though he was not afraid to eliminate an intrusive visual element, such as the sofa.

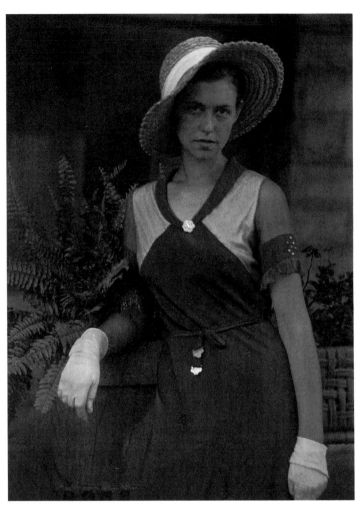

165 DORIS ULMANN
American, 1882–1934
Grace Combs, Hindman, Kentucky, ca. 1928–34
Platinum print
20.2 × 14.9 cm (7¹¹⁄₁₆ × 5⅞ in.)
87.XM.89.78

Our vision of the rural South before World War II has been largely formed by public works photographs, including those of Walker Evans (pls. 160, 175). However, a decade before the first of the government-commissioned photographers arrived in 1935, Doris Ulmann had been there in her chauffeur-driven Packard limousine, all the way from New York. A student of Clarence White, Ulmann achieved a style that amalgamated Pictorialism with honest documentation. The Appalachian hollows of West Virginia and Kentucky were particularly fertile regions for her work. "They all want to go and dress up," Ulmann said of the country women who were usually recorded in their workday clothes. This young woman somehow persuaded Ulmann to photograph her as she wanted others to see her—as stylish and alluring—like the models she would have seen in magazines.

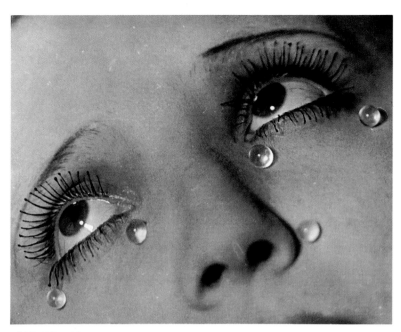

166 MAN RAY
American, 1890–1976
Tears, 1930–33
Gelatin silver print
22.9 × 29.8 cm (9 × 11¾ in.)
84.XM.230.2

In addition to being the art capital of the 1920s, Paris was also the fashion capital, and it was in this area that Man Ray made a significant mark by infusing glamour photography with an element of Surrealist absurdity. A friend of Man Ray's remarked about this photograph, in which glass beads have been placed on a fashion model's face: "The eye is the surreal object par excellence; it is the instrument that sees, that cries, that laughs, that reads, that is negated or wounded. The eye is the opening to mystery." By effectively utilizing found objects, the artist is able to transform a mannequin from an empty vessel of surface beauty to an object of intellectual puzzlement.

167 T. LUX FEININGER
American (b. Germany), b. 1910
Three Members of the Bauhaus Band with Ladder, ca. 1928
Gelatin silver print
11.3 × 8.3 cm (4¹⁵⁄₃₂ × 3¼ in.)
85.XP.384.94

American jazz was a significant influence on European artists, especially students at the Bauhaus, where Moholy-Nagy's (pls. 141–42) polyvalent approach encompassed raw materials that ranged from pure light to pure sound. T. Lux, son of the painter Lyonel Feininger, was steered away from photography by his father while a student at the Bauhaus, but he was drawn back to it by Moholy, who lectured that photography was a powerful tool for the artist and who urged his students to teach themselves and experiment with it. Operating in the spirit of the inspired amateur, Feininger studied the social dynamics of his school pals as they learned to cope in the Jazz Age. He used a highly flexible handheld camera to achieve maximum spontaneity in keeping with the subject represented; his picture is in striking contrast to the Constructivist abstractions of Moholy, Rodchenko, and El Lissitzky, which represent the high-art branch of experimental photography in the 1920s. The traditional distinction between teacher and student was dissolved at the Bauhaus, and so too was the hierarchy of materials, thus allowing a snapshot to be as worthy of serious regard as an oil painting or a carefully composed abstract photographic image.

168 JAROMÍR FUNKE
Czechoslovakian, 1896–1945
Student Dormitory, Brno, Czechoslovakia, ca. 1930
Gelatin silver print
39.6 × 29.5 cm (15⅝ × 11⅝ in.)
84.XM.148.82

Meaningful innovation in photography in the 1920s and 1930s was by no means restricted to artists in Moscow, Berlin, Paris, and New York, although the germinal influences tended to be disseminated to progressive regional centers from the capitals west of the Danube. Prague, with its axis oriented toward Berlin, was an important outpost of Modernism in Eastern Europe. Russian Constructivism, the New Objectivity of Germany, and French Surrealism were studied, digested, and reborn with new and often highly independent identities. Funke's photograph and the architectural subject represented in it demonstrate how quickly creative ideas were transmitted from one place to another. The dramatic viewpoint of the photograph and the radical, forty-five-degree rotation from plumb would have been unthinkable without Rodchenko's (pls. 143–44) experimental Constructivist studies of 1927–29. The design of these buildings likewise reveals the influence of Walter Gropius's designs for the faculty residence at the Dessau Bauhaus.

169 PAUL STRAND
American, 1890–1976
Lathe, Akeley Machine Shop, New York,
ca. 1923
Gelatin silver print
25.3 × 20.2 cm (10 × 8 in.)
86.XM.686.4

170 ALBERT RENGER-PATZSCH
German, 1897–1966
Flatirons for Shoe Manufacture,
ca. 1926
Gelatin silver print
23 × 17 cm (9⅟₁₆ × 6¹⅟₁₆ in.)
84.XM.138.1

Modernism in general has been defined by Meyer Schapiro as an attitude that
allowed art to become more "deeply personal, more intimate, and concerned with
experiences of a subtle kind [by] artists [who] are willing to search further and to
risk experiments or inventions which in the past would have been inconceivable
because of fixed ideas of the laws and boundaries of the arts." In choosing such
unexpected subjects as industrial artifacts, Strand and Renger-Patzsch risked
having their meaning misunderstood, for they were expressing themselves as
poets, not as reporters. Like the lyrical poet, the photographer possesses an acute
and exhilarating respect for the eminence and reality of the object; the new object
that has been created in the form of a photograph has no other reason to exist

than the pleasure it brings. Poet-photographers make up their own language from picture to picture and keep us interested in spare and unusual compositions by not photographing in the ways we expect. The poetic photograph has the power—sometimes brutally direct—to create deep and unnameable feelings about commonplace objects.

171 ALBERT RENGER-PATZSCH
German, 1897–1966
Factory Smokestack, ca. 1925
Gelatin silver print
23.3 × 17.1 cm (9⅛₆ × 6¾ in.)
84.XM.138.23

At the outset of his career in the early 1920s, Renger-Patzsch was fascinated by the duality of nature and the machine. The same years in America found the concepts *machine* and *nature* expressed like a mantra in the work of some of the very best photographers, most notably Paul Strand (pls. 153–55, 169) and Edward Weston (pls. 158, 185). Paul Strand became obsessed with the highly precise forms of his Ackeley motion-picture camera and the lathes used to manufacture it, while also being fascinated by plants and rocks. In 1922, Weston, on his way from Los Angeles to New York, stopped for a few days in Middletown, Ohio, where he studied the interaction of meandering ventilation pipes and the adjacent geometric architectural forms. In Germany, Renger-Patzsch was totally in tune with the spirit of such experimental attitudes, which by 1927 led him to formulate a credo to express his position: "The secret of a good photograph . . . resides in its realism . . . [its] rigid linear structure—only photography is capable of that—. . . the mechanical reproduction of form—is what makes [photography] superior to all other means of expression."

172 MARGARET BOURKE-WHITE
American, 1904–1971
Machine Nuts, ca. 1925
Gelatin silver print
33.4 × 23.6 cm (13⅛ × 9¼ in.)
86.XM.24

Sigmund Freud published his essay "The Ego and the Id" in 1923, about the time Renger-Patzsch gazed from the base of a giant smokestack to its top; the first English edition of the essay was published in 1927, not long after Bourke-White created this study. "The popular theory of the sexual instinct corresponds closely to the poetic fable of dividing the person into two halves—man and woman—who strive to be reunited through love," wrote Freud. Freud said that mental life must be divided into what is conscious and what is unconscious, a division that photographs frequently mirror. While the conscious aspect of a photograph can be defined with reasonable precision, the role of the unconscious can only be speculated upon. Whether Renger-Patzsch intentionally created a classic icon of the male symbol and Bourke-White a counterpart female symbol, or whether these pictures are simply involuntary manifestations of the unconscious, will never be known for certain.

173 IMOGEN CUNNINGHAM
American, 1883–1976
Aloe, 1920s
Gelatin silver print
20.8 × 16.5 cm (8³⁄₁₆ × 6½ in.)
87.XM.74.1

"In one word, if I have not been absolutely feminine, then I have failed," wrote the American expatriate painter Mary Cassatt in 1893. Yet defining what is "absolutely feminine" in photography is not easy. Bourke-White (pl. 172), for example, treats a subject that may be interpreted as feminine only by employing somewhat obscure analysis, and few other women of her time would have shared, we expect, her opinion of what she termed "the beauty of industry." Likewise, Imogen Cunningham, who cited Gertrude Käsebier (pls. 109–10) as a prime influence, chose a subject that is often associated with traditional female interests—the world of plants. Yet her treatment of the aloe transforms it into a bold, aggressive, and somewhat ominous masculine presence.

174 BERENICE ABBOTT
American, 1898–1991
The West Side, Looking North from the Upper 30s / Nightview, ca. 1932
Gelatin silver print
33.8 × 26.9 cm (13⅜₆ × 10⅙₆ in.)
84.XM.1013.4

One of the often-repeated ideas of gender description is the identification of the female as tender-hearted and the male as tough-minded. The photographs of Bourke-White (pl. 172) and Cunningham (pls. 117, 173) reproduced here refute this notion: they are tough-minded pictures by women. Berenice Abbott complicates the formula by combining traditional masculine and feminine qualities in more or less equal parts, as exemplified in her nighttime view of midtown Manhattan looking down from the north side of the Empire State Building. The tender-mindedness of this image stems from the way the light softens the edges of the buildings, blurring the distinctions between them and contributing to an optimistic, idealistic, contemplative, and ultimately romantic interpretation of a tough and unyielding subject, the center of Manhattan island.

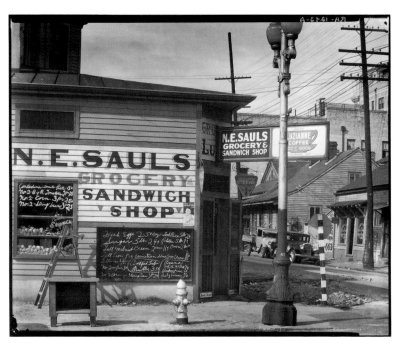

175 WALKER EVANS
American, 1903–1975
Street Scene, New Orleans, Louisiana, December 1935
Gelatin silver print
20.7 × 25.4 cm (8⅟₁₆ × 10 in.)
84.XM.129.8

Evans's most often-reproduced body of work was created in a three-year creative explosion between the summer of 1935 and the summer of 1938. Toward the end of 1935, he visited Louisiana on assignment for the Farm Security Administration, and it was there that he made this picture. Although it has a documentary appearance, the photograph owes more to French art than might at first be expected. Evans had visited France and respected its cultural life. Tristan Tzara described the power of French Dadaism to transform incongruous elements into an "unexpected, homogeneous cohesion as soon as they take place in a newly created ensemble." Evans shared this conviction with the artists of Dada.

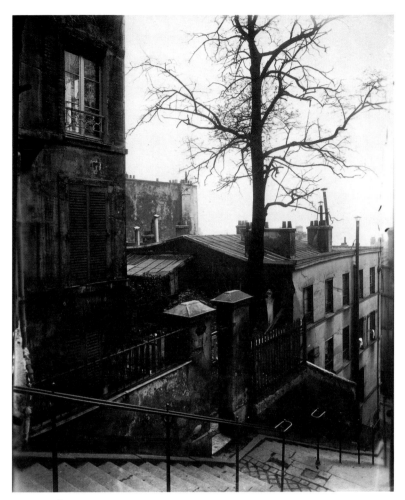

176 EUGÈNE ATGET
French, 1857–1927
Staircase, Montmartre, 1924
Albumen print
21.8 × 17.8 cm (8%6 × 7 in.)
90.XM.124.1

In 1924, Atget created a study of a group of apartments seen from one of the stairways of Montmartre. (It was, coincidentally, the same year that Berenice Abbott [pl. 174] first saw one of his photographs and became the most devoted apostle of his art.) Trees were a favorite Atget subject, and this elegant and well-proportioned specimen stands in definite contrast to another favorite subject, architecture. In this block we see neither noble materials nor heroic design, but rather journeyman production that attempts to reconcile utility and beauty. The eye is teased by the elegance of the leafless tree that dominates the picture; it is intrigued by the askew chimney pipes and by an agglomeration of textures ranging from mildew to decaying wood and from decomposing plaster to scarred stone. The tree by comparison seems ageless, like the sculpture at its base.

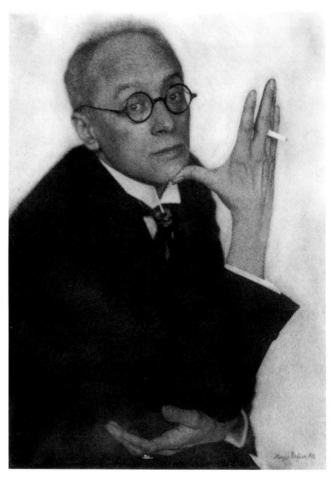

177 HUGO ERFURTH
German, 1874–1948
Franz Blei, 1928
Oil pigment print
22.2 × 17.6 cm (8¾ × 6⁹⁄₁₆ in.)
84.XP.453.3

From the Latin verb *protraho* meaning "to reproduce" or "to copy" derive the
French noun *portrait* and its exact English cognates—words associated with the
concept of imitating or copying. This leads to perennial dilemmas for artists: how
far can they depart from reality? How far they can go in idealizing the model by
exaggerating some aspects of a person's habit or appearance? How far can they
go in repairing human defects? Every portrait can be analyzed in terms of these
problems and the ways they are solved. Erfurth—the foremost German portraitist
between the world wars—selected a pose in which his model, who was a scholar
of erotic poetry, suggests his eccentric worldliness. His chin rests on an extended
thumb and he squeezes an unlighted cigarette. Erfuth made this print in a paint-
erly oil process with a grainy texture that caused wrinkles to vanish and the bald-
ing forehead to seem less so. If the ultimate goal of portraiture is to communicate
something of the sitter's personality through pose and gesture, then the artist has
achieved that goal here.

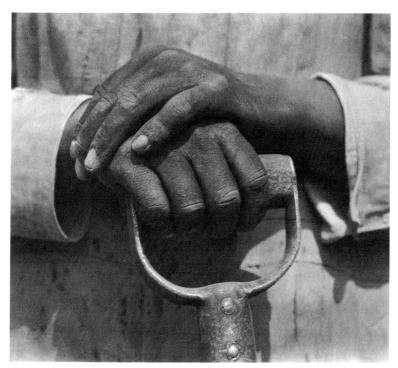

178 TINA MODOTTI
Italian, 1896–1942
Hands Resting on Tool, 1927
Platinum print
19 × 21.6 cm (7½ × 8½ in.)
86.XM.722.3

Very few photographers are as opposite in their styles or objectives as Modotti and
Erfurth. These differences shine through instructively in this pair of photographs
of hands, made within a year of each other and a continent apart. Photographers
reveal themselves by what they choose to study. Erfurth's attraction to the intel-
lectual and social elite of Weimar Germany is as evident as Modotti's affinity for
the Mexican poor. A revolutionary and a devoted Communist all of her life,
Modotti believed that photography and politics are inseparable. Her biography is
full of drama and change; it is a spy novel leavened by art, where love and death
intermingle in her birthplace in Italy, her adolescence in San Francisco, her con-
version to art in Los Angeles, and her fusion of art and politics in Mexico City.
Modotti learned photography from Edward Weston in Los Angeles (pls. 158,
185), but she had little interest in his art-for-art's-sake approach and quickly
focused on gritty subjects that symbolize labor and the struggle for civil rights.
Through her picture, Modotti declares that the hands of a *campesino* are as wor-
thy a subject as those of the highest-born aristocrat.

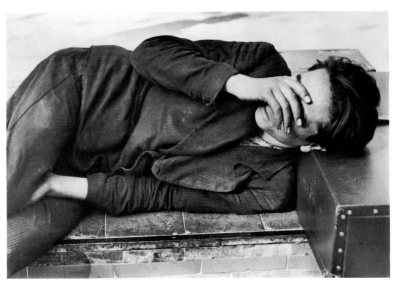

179 HENRI CARTIER-BRESSON
French, b. 1908
Spain, 1933
Gelatin silver print
19.4 × 28.7 cm (7⅝ × 11⁵⁄₁₆ in.)
84.XM.1008.9

A decade after Modotti (pl. 178) emigrated to Mexico with Edward Weston
(pls. 158, 185), Cartier-Bresson traveled there. In Mexico in 1934, Cartier-
Bresson met Alvarez Bravo and Paul Strand (pls. 153–55, 169) and provided
a living example of what Surrealism in photography could be. While Strand ig-
nored Surrealism, Alvarez Bravo embraced it. Cartier-Bresson had been to Spain,
where this photograph was made the year before he went to Mexico. It shares
with Alvarez Bravo's *Good Reputation* (pl. 180) a fascination with the unex-
pected: we do not expect to see a person in public in such a profound and vulner-
able state, the left hand tucked between the legs and the right hand covering the
eyes to suggest total emotional and mental withdrawal from the world around.
For Surrealists, photographs were full of meanings that resulted from the inter-
section of unexpected happenings, and the artist's objective was to stimulate
the emotions with the element of surprise.

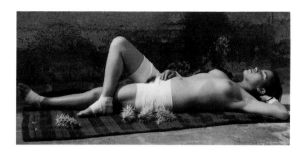

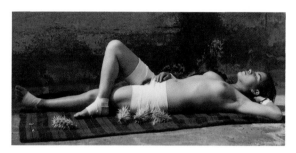

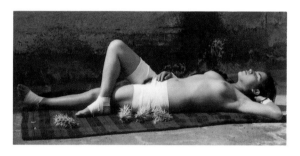

180 MANUEL ALVAREZ BRAVO
Mexican, b. 1902
The Good Reputation 1, 2, 3, 1938–39
Gelatin silver prints
Each: 8.8 × 18.9 cm (3½ × 7⁷⁄₁₆ in.)
92.XM.23.37

Alvarez Bravo created this version of the work he called *La buena fama*—the only one to survive in its original three-part format—at the suggestion of André Breton. Breton was in Mexico City in 1939 to help organize an exhibition of Surrealist art at the Galería de Arte Mexicano that was cryptically entitled *Aparición de la gran esfinge nocturna* (Appearance of the Great Nocturnal Sphinx). Inspired by Breton, Alvarez Bravo imagined his triptych as the cover of the exhibition catalogue. The negatives were made on the roof of the national arts school where he taught; the model was a volunteer from the life-drawing class known to us only by her first name, Alicia. As the photographer recalled on a visit to Los Angeles in 1992, the bandages were supplied by a physician friend, and the symbolic cactus pears were procured from a local outdoor market by the school porter. Posed in bright sunlight in a position of unnatural vulnerability, the model has been dressed in a totally non-functional costume that focuses our attention on the tufts of pubic hair, which caused censors to declare the work unacceptable for reproduction on the cover.

181 PAUL OUTERBRIDGE
American, 1896–1958
Woman with Meat Packer's Gloves, 1937
Three-color carbro print
39.7 × 24.8 cm (15⅝ × 9¾ in.)
87.XM.66.2

"The response to beauty arises from a need in the human soul," wrote Outerbridge. "The choice of subject, material, and especially colors, used by an artist may reveal his underlying personality." The human figure is one of the most persistent themes in the history of photography, with the body frequently treated as a dictionary of formal relationships that bring with them an immediate emotional reaction in each viewer. Simply by choosing the female figure, Outerbridge tells us something of his personality; by adding color he reveals more; and by adding the mask and the shocking element of the spiked gloves, he introduces a charged psychological dimension. Outerbridge was a pioneer in the use of color photographs for mass-media commercial advertising, and he carefully studied the emotional associations of colors. The color scheme here consists of the blue background, a yellowish flesh tone, and the brown of the gloves. About yellow he wrote: "From one point of view it suggests cheerfulness and sunlight and from another [it] seems to have a tie up with sickness and cowardice." Outerbridge believed that photographs should be composed, not "taken," and he reminds us that every element of his pictures, from the color to the composition, bears significance.

182 LISETTE MODEL
American (b. Austria), 1901–1983
Hubert's Freak Museum and Flea Circus, Forty-second Street, New York,
ca. 1945
Gelatin silver print
34.3 × 26.8 cm (13½ × 10%₆ in.)
84.XP.124.20

"I am not a visual person," Model once remarked enigmatically to a student, while to another she said: "Never take a picture of anything you are not passionately interested in." Inner conflict and outer contradiction were essential to Model, and it was her relentless probing of social realities—human foibles, peoples' senseless sufferings, and their profound eccentricities—that formed the affective ingredient in her art. Here two cross-dressed men are seen in the context of an amusement center in New York's tenderloin district, called "Hubert's Freak Museum and Flea Circus." Behavior that Freud had analyzed twenty years before was, in 1945, still generally considered as only appropriate for public display in a "Freak Museum."

REPORTERS AND POETS

In experimental photographs, the principle of the unhabitual tends to prevail, and we are brought into an understanding of the abstract by a contemplation of the concrete. Experimental photographers, within limits, have to make up their language as they go along by perpetually revising prevailing styles and materials. Just when we think we know what photography is, the unexpected appears, and we see something that we did not know existed, or see something familiar in an unexpected way, which is what makes photography such a dynamic art form.

Ever since the period of the discovery and invention of photography in the 1830s, photographers have taken sides on the issue of whether a photograph ought to be a highly objective reflection of the world or a vehicle for manifesting the photographer's innermost personal concerns. Does the best picture start with a purely visual perception or with an idea? The same questions are rephrased in each generation: Is photography essentially objective or is it subjective? Is it an art aimed at truth or at beauty? Is it an instrument of the reasoning mind or the intuitive heart? Is it brutal fact or lyric poetry?

For Alfred Stieglitz, the archetype of the poet-photographer, the photograph was a metaphor—or, as he put it, an equivalent—of his innermost feelings. Poet-photographers have persistently challenged the accepted truism that visual facts and surface appearance constitute objectivity by forcing every photograph to reflect a series of deliberate choices that express their innermost feelings.

By the late 1950s, journalist photographers had also become increasingly introspective and reflective; their work had become colored by their feelings and opinions as they addressed increasingly personal subjects. The decade of the 1960s witnessed the near abolition of distinctions between subjectivity and objectivity by photographers who appropriated the style and technique of documentary workers for purposes of self-expression. Their poetic photographs often resemble dreams made visible as they persistently explore the emotional side of human existence.

183 ANDRÉ KERTÉSZ
American (b. Hungary), 1894–1985
The Dancing Faun, 1919
Gelatin silver print
5.6 × 10 cm (2⁵⁄₁₆ × 3⅞₁₆ in.)
85.XM.259.18

André Kertész followed a pattern of progress from amateur to professional to artist, as did many of his contemporaries; however, the chief difference between him and most of the others who followed the same path is that Kertész took great pride in his amateur roots and conversely despised most of the photographs he was hired to make. He bought himself a camera about 1912 and by 1919 had mastered its use. His art was the product of a man who gives the impression of being perpetually on holiday, since his early pictures frequently represent his family and friends spending leisure time together. If we are to judge from the photographs alone, Kertész enjoyed a fairy-tale life in his native Hungary with his two brothers, Imre (1890–1957) and Eugenio (1897–?). "We were sportive, we three brothers . . . We went swimming, running, mountain climbing—everything," he remembered sixty years later. To create this picture, he cajoled his younger brother into doing a "faun dance." "He had the body of the good athlete that he was and a fine head for a faun," Kertész recalled.

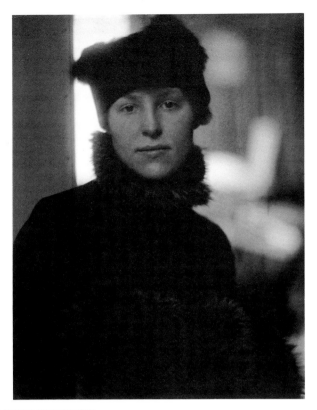

184 ALFRED STIEGLITZ
American, 1864–1946
Portrait of Marie Rapp, 1916
Platinum print
24.4 × 19.3 cm (9%₆ × 7%₆ in.)
84.XM.217.9

Stieglitz prided himself on never having made a photograph for hire, and from the beginning of his career he deliberately associated himself with the amateur photography movement. About 1910, he began to move closer to professional painters and sculptors. However, his portraits continued almost exclusively to represent family and friends, the classic terrain of amateur photography. His wife, Emmy, was a heavyset woman with somewhat mannish features, which may explain why he made relatively few portraits of her in comparison to the number of times he photographed peripheral family members and friends, like Marie Rapp, a young woman with the features and figure of the popular Gibson Girl. Dressed for winter in a fashionable fur-collared coat, she keeps her hands snuggled in a fur muff that is almost hidden in shadow. Her expression is remarkable for the profound serenity of her gaze; it seems to penetrate directly through the lens to Stieglitz. The portrait is a study in reciprocal adoration. More than any other photograph, this portrait represents a key precursor to Stieglitz's studies of Georgia O'Keeffe (pls. 156–57), which commenced a few months later. Stieglitz has ignored the stern and impersonal dogma of Modernism, allowing himself to be consumed by the emotion of the moment unfolding before him. We see here the triumph of his belief that the objective must serve the subjective, and that, in art, feeling should dominate design.

185 EDWARD WESTON
American, 1886–1958
Two Shells, 1927
Gelatin silver print
24 × 18.4 cm (9½ × 7¼ in.)
88.XM.56

Still-life arrangements on tabletops were a favorite subject for amateur photographers, but very few of them achieved the powerful form and masterful control of technique that Weston did here. Bored with portraiture, he began to experiment with the symbolic and formal potential of found objects. By nesting one chambered nautilus shell inside another, he created a powerful form not seen in nature. He also created a tough representational problem for himself. Viewing his subject close-up from below, with a camera designed for eight-by-ten-inch sheets of film, Weston was challenged to keep all of the visual elements in sharp focus. The polished surface presented another problem because of the way it reflected the light source, thus interrupting the sensual curve with piercing highlights. About the content of this photograph, Weston wrote: "It is this very combination of the physical and spiritual in a shell . . . which makes it such an important abstract of life." Central to the decade of the 1920s was this pursuit of the interaction between new form and content in art, and a balancing of tradition and innovation.

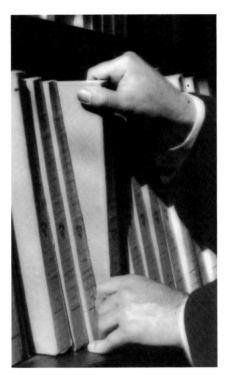

186 ANDRÉ KERTÉSZ
American (b. Hungary), 1894–1985
Hands and Books, 1927
Gelatin silver print
9.5 × 5.7 cm (3¾ × 2¼ in.)
86.XM.706.11

The year 1927 was an important period of transition for Kertész in Paris and for Weston in Los Angeles. Both made significant still-life compositions; both began to explore subjects that were invested with traditional content. Kertész was a lover of books, magazines, and newspapers all his life; he pictured books being read, discarded books, and authors at work. Here the subject is reduced to its essence— an ordinary soft-bound volume that he found in a bookshop on the Left Bank. It is neither a deluxe nor an antiquarian book, but Kertész presents it to us as an object deserving of precise and respectful handling. As with Weston's chambered nautilus, we see a tightly framed composition that starts with a found object that the photographer has very skillfully rearranged, thus creating a new artifact.

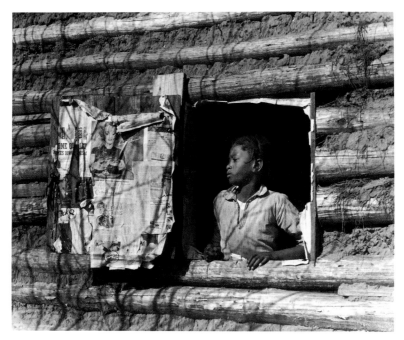

187 ARTHUR ROTHSTEIN
American, 1915–1987
Gee's Bend, Alabama (Artelia Bendolph), 1937
Gelatin silver print
40 × 49.7 cm (15¾ × 19%6 in.)
84.XP.686.21

188 HENRI CARTIER-BRESSON
French, b. 1908
The Coronation of George VI, 1937
Gelatin silver print
36.5 × 24.4 cm (14⅜ × 9⅝ in.)
85.XM.400.2

Neither Rothstein nor Cartier-Bresson would have objected to being classed as photojournalists; however, they had diametrically opposed approaches to the making of a picture. Rothstein believed words are essential companions to pictures, while Cartier-Bresson would be happiest if his work could exist without them. "Picture ideas are often achieved by knowing how to convert ideas from words into visual terms," Rothstein wrote. In order to achieve this study, he traveled to Gee's Bend, Alabama, under the auspices of the United States government, to illustrate the effects of the Bankhead-Jones Farm Tenancy Act of 1937. Rothstein had to exercise tact and diplomacy to win the confidence of Artelia Bendolph and to persuade her to pose; he had the directorial skill to elicit a sympathetic performance from his model. Rothstein was making the political point that cotton farmers and their families very much deserved the financial subsidies made possible by the Bankhead-Jones Act. His technique was simple yet extremely effective. In his words: "You see the girl—that's effect one. You see the ad [the blond woman]—that's effect number two. But the third effect is when you see both images together and recognize the irony."

The same year Rothstein was in Alabama, Cartier-Bresson traveled from Paris to London, where he was among the bystanders at an historical event. To achieve this photograph did not require a press pass or the skills of the diplomat or direc-

tor but rather those of the hunter, who silently stalks his quarry. Does it matter for us to know that this is the Coronation Day of George VI or that the event took place on May 12, 1937? Probably not, if the real story being told here concerns, not the pomp and ceremony of the coronation, but rather the ubiquity of newspapers, the universal pathos of human frailty, and the truth enshrined in the gaze of the small boy, namely, that no intrusion into privacy ever goes unnoticed.

189 ANDRÉ KERTÉSZ
French (b. Hungary), 1894–1985
Circus Performer, ca. 1920
Gelatin silver print
23.9 × 19 cm (9⁷⁄₁₆ × 7¹⁵⁄₃₂ in.)
86.XM.706.28

190 BRASSAÏ
French (b. Romania), 1899–1984
The Exotic Garden, Monaco, 1945
Gelatin silver print
29.7 × 23 cm (11¹¹⁄₁₆ × 9¹⁄₁₆ in.)
84.XM.1024.1

Kertész and Brassaï gloried in the power of photography to make possible a "Raphael without hands"— a concept proposed by the art historian Edgar Wind to express the frustration often felt by painters and poets at the lack of simultaneity between having a perception and recording it. The photographic image is connected to feeling by the very short time that elapses between the experience of an idea, perception, impulse, or emotion, and the reflex action that arrests it. This is what made photography such a revolutionary medium.

We see here how skillful camera artists can shape and give meaning to actualities as purely optical elements are fused with the visceral. Both photographs are built around networks of lines that we feel more clearly than we see. Kertész's line moves from right to left, generated by the line of sight from the observer in the background to the man doing a handstand on stacked chairs. Brassaï works with a chaotic network of lines established by the cactus and succulent forms that seem to reach out threateningly to the strolling nuns, whose habits reach upward and outward as though putting up a defense against an enemy of which the figures are totally oblivious. The scenario is, of course, a fiction created by the photographer's imagination working in tandem with the observer's.

191 W. EUGENE SMITH
American, 1918–1978
Dying Baby Found by an American
Soldier in Saipan, 1944
Gelatin silver print
22.1 × 17 cm (8¹¹⁄₁₆ × 6¹¹⁄₁₆ in.)
84.XM.1014.5

192 DMITRI BALTERMANTS
Russian, 1912–1990
Tchaikovsky, Germany, 1945
Gelatin silver print
59.7 × 46.4 cm (23½ × 18¼ in.)
84.XP.467.1

"There have always been romantics and realists, and they have snarled at each other since the beginning of history," said Roy Stryker, chief of the historical section of the Farm Security Administration, in the course of remarks on the nature of documentary photography. Romanticism and realism are not easy terms to define in photography, but these two photographs can serve as an effective beginning. Smith, an American who was a combat photographer assigned to the Pacific, shared with Baltermants, a Russian photographer six years his senior who was assigned to Sevastopol, Leningrad, and the German front, a respectful sensitivity for the incongruous situations that war breeds. Baltermants expresses the

ironic beauty of Russian soldiers gathered around a piano in the bombed-out parlor of a German house in the last days of World War II. Both photographers shared the Romantics' love of light and dark for dramatic effect and of strong subject matter that often addresses the larger human issues of mortality, depravity, and joy.

Since truth is the objective of the documentary photograph, it is in the quality of truth that documentary photography can be distinguished from its generally more exploitative cousin, photojournalism. Smith in particular was highly sensitive to this issue and focused attention on it in the title of his book *Let Truth Be the Prejudice*. He once declared to a group of students: "Humanity is worth more than a picture of humanity that serves no purpose other than exploitation." Yet Smith, like his Russian counterpart, seemed intent on making the truth look like art through the manipulation of photographic materials. Smith achieved brilliant highlights in his prints by the selective use of bleaching agents, and he worked hard to attain subtle tonal effects in the shadows. Baltermants often printed on high-contrast paper that gave to actuality a dreamy unreality.

193 BILL BRANDT
British, 1904–1983
The Isle of Skye, June 1947
Gelatin silver print
22.9 × 19.6 cm (9½ × 7¹¹⁄₁₆ in.)
86.XM.618.9

194 ANSEL ADAMS
American, 1902–1984
Mount Williamson from Manzanar, California, 1944
Gelatin silver print
19.1 × 23.9 cm (7½ × 9⅜ in.)
84.XP.208.160

"As the war moves to a climax, the only enduring things seem to be the aspect of Nature—and its reciprocal, the creative spirit," Adams wrote to Alfred Stieglitz on Christmas Day of 1944, the year in which this picture was made. Brandt and Adams incorporate the four parts of landscape composition that invite distinct treatment by the artist: foreground, middle ground, background, and sky. In a typical mountain landscape, the picturesque aspects of middle and background dominate, but here the focus has been deliberately, even perversely, inverted. The tools and methods used by the two photographers to achieve their results are nearly opposite. Adams found himself at the foot of Mount Williamson on the east side of California's Sierra Nevada mountains in the course of a project to document Japanese-American detainees at the Manzanar facility, and his equip-

ment consisted of a handcrafted wooden view camera with a telephoto lens. Brandt made his study of a waterfowl nest with a wooden camera fitted with a primitive, shutterless, pinhole aperture rather than a lens. In place of the standard ground-glass lens, Brandt used a metal shim pierced with a 1/32-inch-diameter hole that served as the "lens" and took in a very wide angle of view. Its optical structure exaggerated the size of foreground elements and sacrificed sharpness in the middle ground and beyond, just where Adams's picture had the greatest resolution. Even though their equipment and printing methods were so different, the two photographers created works that, visually, have much in common.

·

195 FREDERICK SOMMER
American (b. Italy), b. 1905
Max Ernst, 1946
Gelatin silver print
19.3 × 24.1 cm (7⅝ × 9½ in.)
86.XM.515

196 AARON SISKIND
American, 1903–1991
Arizona, 1949
Gelatin silver print
34.3 × 25 cm (13½ × 9⅞ in.)
84.XM.1012.122

Sommer's obsession is to reconcile antitheses, and to achieve this objective he reads books like a philosopher and behaves like an artist. His library contains volumes ranging from Aristotle and Plato to Wittgenstein, which may explain why his photographs simultaneously imitate nature and are idealizations of it. "Life is the most durable fiction that matter has yet come up with and art is the structure of matter as life's most durable fiction," Sommer has written. Decay is a theme that pervades his photographs. For example, his study of painter Max Ernst against a weathered wooden wall has been overprinted with a negative of a water-worn rock surface that seems to speak of mortality versus immortality, the predictable versus uncertainty. The random markings of nature from one eight-by-ten-inch negative, when superimposed upon the portrait on a master negative of the same size, almost miraculously complement one another. Siskind has described the act of making a photograph as "an emotional experience. It is utterly personal: no one else can see quite what you have seen." For Siskind and Sommer, photography is a totally subjective process in which the documentary and the subjective are perpetually intertwined. Siskind spent time just after the war traveling and working on self-assigned projects, including a period spent with Sommer at his home in Arizona, where this photograph of a severely deteriorating painted surface was made in the nearby abandoned mining town of Jerome.

197 BILL BRANDT
British, 1904–1983
August, 1951
Gelatin silver print
23 × 19.6 cm (9⅟₁₆ × 7²³⁄₃₂ in.)
84.XM.801.2

"It is essential for the photographer to know his lens. The lens is his eye and is responsible for the success or failure of the work," Brandt said to a visitor to his home in the last year of his life, without going on to explain that some of his very best work was made without the use of a lens. This and the image from the Isle of Skye (pl. 193) were made with a box camera fitted with a pinhole aperture, with infinity as its only focal point. Lacking ground-glass elements and a shutter, this pinhole aperture gathers light from an extremely wide field of vision and distorts the scale of foreground elements by enlarging them in relation to the background. Here the model's legs approach caricature in their extreme elongation, yet stay within the realm of high art through Brandt's masterful control of light and perspective. The foreground, made spare and unusual by the wash of light, is ingeniously complemented by the picture-within-a-picture, which is framed by the window across the room.

198 WEEGEE
American (b. Poland), 1899–1968
Entertainers at Sammy's-on-the-Bowery, ca. 1944–45
Gelatin silver print
33.4 × 26.8 cm (13⅛ × 10%6 in.)
84.XM.190.34

Weegee and Brandt may have had only two things in common: the tendency to push their art close to caricature and then pull back before going over the edge, and a necessary partnership with editors and publishers, who disseminated their work long before it was seen in museums and galleries. "When I started freelancing on spot news stories ten years ago, I was an awful flop," wrote Weegee in 1943. "After going to fires, murders, and auto accidents for some time and coming back with pictures which didn't sell—I made a discovery. Editors don't want photographs of burning buildings or wrecked automobiles, they want the *human element* and reaction." He continued with this advice to novice photographers: "So forget about filters and focusing and concentrate on the human emotions of the people before your lens." The winning smiles these ladies flash catch our hearts, while Weegee's cunning eye has focused on the details, in particular the wad of bills stuffed into a rolled-down stocking. In another print, he enlarged this portion of the negative as an independent composition that he inscribed with the title *Portrait of a Lady.* Unlike Weston (pls. 158, 185) and Adams (pl. 194), who very rarely printed only parts of their negatives, Weegee would manipulate his negatives in any manner required to achieve results that satisfied him.

199 HARRY CALLAHAN
American, b. 1912
Eleanor and Barbara, Chicago, 1954
Gelatin silver print
17.8 × 17.1 cm (7 × 6¾ in.)
88.XM.65.9

In conversation, Callahan readily tells how he met Eleanor Knapp on a blind
date in Detroit in 1933 and soon fell in love with her; she reciprocated, and they
were married in 1936. Until the early 1940s, Callahan was chiefly a photographer
of the landscape; then he began to concentrate on tender studies of Eleanor. We
are reminded of Stieglitz's approach to O'Keeffe (pls. 156–57) a generation
earlier, and of de Meyer's obsession with his wife, Olga (pl. 121). Light is the all-
important factor in each one of these photographs. Daylight filtered through
venetian blinds provides Callahan's illumination here. The backlighted scene
poses a technical problem: practically everything in the room is cast in shadows
that flatten the fictional space. This includes the forms of the two nude figures
that are the focus of the picture, which is composed exclusively of broad masses
embellished by linear elements skillfully drawn by light. The photographer did
not accidentally discover his three-year-old daughter, Barbara, draped over her
reclining mother's waist but worked with both mother and daughter as models,
placing them in various positions in different places in the room.

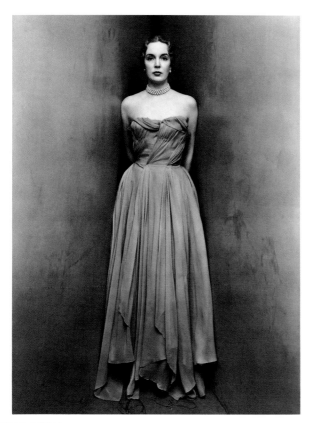

200 IRVING PENN
American, b. 1917
Mrs. William Rhinelander Stewart, 1948
Gelatin silver print
24.1 × 17.9 cm (9½ × 7½2 in.)
84.XP.983.52 [Gift of Samuel Wagstaff, Jr.]

Penn and Callahan are two photographers (like Brandt and Weegee) whose work can be compared even though they have little in common beyond their absolute devotion to a single woman and their dedication to using photographic materials in the purest way. Five years younger than Callahan, Penn earned his livelihood in New York from editorial illustration, advertising, photojournalism, and commissioned portraits, all areas of photography that Callahan rejected. Like Callahan, Penn often works in series oriented around a visual motif. Here, for example, the motif is the corner created by two portable background screens joined at an oblique angle, where he has posed this society woman attired in a ball gown. The soft light for this commissioned portrait, and numerous others created in the same environment, emanates from several artificial sources and is reflected off surfaces that are outside the field of vision. Carefully controlled light sculpts the figure and the folds of her garment, while the evenly lighted converging background planes create a physical space that embraces the model. The skillful interplay of line and volume excites the intellect; if the emotions are aroused, they are the emotions of the connoisseur responding to the language of photography—a delicious range of gray tones, pure blacks, and pristine whites—the same formal elements that Callahan used so effectively (pl. 199).

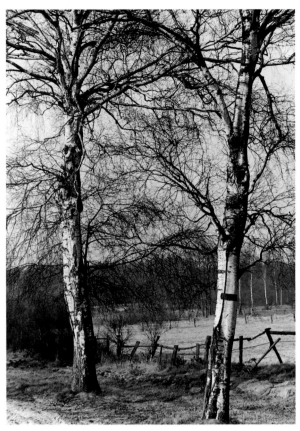

201 ALBERT RENGER-PATZSCH
German, 1897–1966
German Landscape with Birch Trees, 1956
Gelatin silver print
38.6 × 28.3 (15⁵⁄₁₆ × 11³⁄₁₆ in.)
90.XM.101.9

Light is the effective force at two distinct points in the creation of a photograph: once when the negative or transparency is exposed, then when the print is created. Perhaps the chief yardstick for measuring the quality of a photograph is the handling of light. Light can be soft or strong; it can come from one direction or bathe the subject from several sources; it can be manipulated at the time the negative is made, when the negative is printed, or both. In this landscape, Renger-Patzsch chose to control light at the time of exposure by choosing a hazy day with soft light. Teske (pl. 202) created an effect that he could only achieve once he had made the negative and was in the process of printing.

Renger-Patzsch's study of birch trees demonstrates a dramatic departure because it is so far removed from the objectivity that guided his industrial and plant studies of the 1920s and 1930s. The series reflects his serious appreciation of arboreal form and structure and represents one of the more extreme stylistic shifts in a single career in the history of photography. In his youth, Renger-Patzsch was one of the early adherents of the New Objectivity (Neue Sachlicheit), but he turned to the highly subjective interpretation of landscape in his later years.

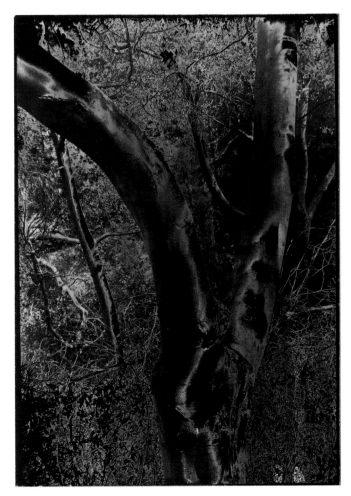

202 EDMUND TESKE
American, b. 1911
Olive Hill, Hollywood, negative, 1945; print, ca. 1960s
Gelatin silver print (duotone solarization)
35.2 × 25.2 cm (13⅞ × 9⅞ in.)
93.XM.5.10

Soon after he relocated from his birthplace, Chicago, to Los Angeles—which
has been his home for the last fifty years—Teske discovered Olive Hill, an estate
preserved by oil heiress Aline Barnsdall in the center of Hollywood. Like Renger-
Patzsch (pl. 201), he was attracted to trees by a reverence for nature, but the form
of his picture shows us a tree neither as the eye sees it nor as the camera recorded
it on the negative, but rather as a tree might be captured during a dream. What
we see is the result of Teske's skillful control of light. The reversed tones and
varied colors of brown and dark red were achieved by twice exposing the printing
paper to light: once with the negative (made twenty years before the print) in the
enlarger, when the underlying tree-image was transferred to the undeveloped
silver gelatin photographic paper; and a second time while the print was wet with
chemicals that reacted to the light and changed color from gray to russet, brown,
and reddish brown, in a process the artist calls *duotone solarization.*

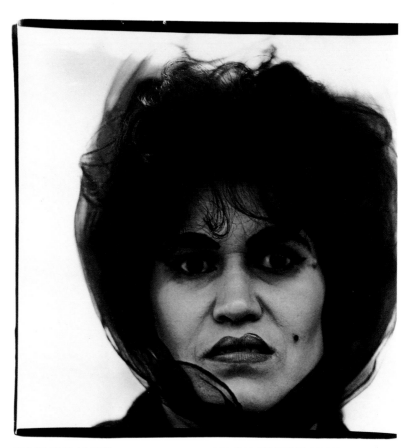

203 DIANE ARBUS
American, 1923–1971
Puerto Rican Woman with a Beauty Mark, 1965
Gelatin silver print
36.4 × 36.2 cm (14⅜ × 14¼₆ in.)
84.XM.796

204 GARRY WINOGRAND
American, 1928–1984
Untitled (Los Angeles International Airport), ca. 1964
Gelatin silver print
34.1 × 22.7 cm (13½ × 8¹⁵₆ in.)
84.XM.1023.25

"After ourselves, we are interested in other human beings—first our family; then our friends; lastly all others," wrote photographer Robert Disraeli in 1947, expressing the world view held by most photojournalists around the time Arbus and Winogrand began to work in photography. There is, however, one notable difference in attitude between Arbus and Winogrand and the average photographer: the two artists reversed the above priorities by preferring to concentrate on images of perfect strangers.

In the decade between the mid-1950s and the mid-1960s, Arbus and Winogrand devoted themselves to editorial photography, which entailed receiving assignments from magazines to create photographs to illustrate articles; however, in preparation for the assignments, a photographer was often required to confer with half-a-dozen people, including one or two senior editors, an art editor, and a writer. In reaction to these assignments, serious commercial photographers often made bodies of private work that were an adjunct to the work they did for hire.

Documentary photography, as practiced by these photographers, was far from

a mechanical process, because considerable selectivity—another word for subjectivity—was required to achieve memorable results. What distinguishes Arbus and Winogrand from documentary photographers of the generation before is that the latter gave themselves over to their subjects in a way best described by Margaret Bourke-White (pl. 172): "Temporarily the people being photographed are your people; their problems are yours; their joys and sorrows are shared." The situation was very different for Arbus and Winogrand, who, if they felt empathy for their subjects as individuals, failed to express it; neither did they express disdain.

205 WALKER EVANS
American, 1903–1975
Graffiti: Dead End, ca. 1973–75
Polaroid SX-70
7.9 × 7.8 cm (3⅛ × 3¹⁄₁₆ in.)
93.XM.15.2

Walker Evans, who is represented in the Getty collection by more than one thousand photographs, is best known for his documentation of rural America, created for the Resettlement Administration between 1935 and 1937 (pls. 160, 175). At that time he worked almost exclusively in black and white, using a tripod-mounted camera (although he also owned a hand-held Leica). When the Polaroid corporation issued its first self-advancing, fully automatic color camera, the SX-70, in 1972, Evans was among the first professional photographers to take it seriously. The potential for instantaneous color photographs caught his imagination; however, he saw a paradox in its very simplicity. "You have to have a lot of experience and training and discipline behind you [to use the camera effectively]," he told a friend. With the SX-70 Evans poetically recorded traces of vernacular Americana, such as signs, abandoned commercial and industrial sites, and everyday objects, such as fire hydrants. He also used it to portray his close friends in candid moments. "You photograph things you wouldn't think of photographing before," he remarked.

The Polaroid camera allowed Evans to respond instinctively rather than analytically to what he encountered. He had photographed in black and white dozens, if not hundreds, of walls with advertising signs, but few so allusive as this piece of graffiti. The sign's message anticipates the bleak cynicism that only the most avant-garde and experimental painters, sculptors, and musicians were exploring in the early 1970s, and that finally reached the mainstream in the 1980s. Made within a year of Evans's death, this image is both a haunting piece of autobiography and a social document.

ROSTER OF MAKERS

The following is a selected listing of makers of photographs whose work is represented in the collection of the J. Paul Getty Museum as of the date of this handbook.

The number to the left indicates how many single prints by an individual maker are in the collection. The numbers in square brackets after the maker's name represent works housed outside the main file because of their size or because of the special materials of which they are made.

The following abbreviations have been used throughout: AB—album and/or book; CC—cabinet card; CDV—carte-de-visite; DAG—daguerreotype; ST—stereograph; TT—tintype.

1 A. G.	1 Amedor
1 A. L.	1 Amouroux, J.
4 A. N.	84 Anderson, James [Isaac Atkinson]
1 Aalborg	1 Anderson, John A. [1 CC]
32 Abbott, Berenice [2 AB]	2 Andrée
5 Abdullah Frères [Kevork and	0 Andrieu, J. [71 ST; 1 CDV]
Wichen Biraderler] [8 CDV; 8 ST;	2 Angelo
2 AB]	0 Angerer, Ludwig [10 CDV]
2 Abel, Mione	5 Annan, James Craig [27 AB]
2 Adam-Salomon, Antoine-Samuel	14 Annan, Thomas [4 CDV; 9 AB]
[7 AB]	1 Anschutz, Thomas
39 Adams, Ansel [3 AB]	0 Anson, Rufus [7 DAG; 1 CDV]
1 Adams, Marcus	0 Anthony, Edward [115 ST; 7 CDV]
0 Adams, S. F. [22 ST]	1 Anthony, Edward and Henry T., and
34 Adamson, John [3 AB]	Co. [1,001 ST; 13 CDV]
1 Adamson, Prescott	9 Anthony, Mark [1 ST; 1 AB]]
1 Adamson, Robert	3 Antonelli, Severo
1 Adcock, J.	1 Antony, Maurice
3 Agha, Mehemed Fehmy	1 Apeda Studio
14 Aguado, Comte Olympe	2 Appert, Eugène [5 CDV; 4 AB]
1 Aichinger, Franz J.	1 Appleton, J. M. [3 AB]
4 Albers, Josef	2 Aragozzini, Vincenzo
1 Albert, T.	1 Aram
1 Albin-Guillot, Laure [4 AB]	1 Arambourou, Charles
26 Albok, John	1 Arbus, Diane
1 Alexander, Kenneth	5 Archer, Frederick Scott [1 AB]
2 Alexander, Richard	3 Armoni, Raffaelli
1 Alfred Brothers	4 Armstead, G.
161 Alinari, Fratelli [7 ST; 7 CDV]	3 Armstrong, Will
7 Allen, Charles	2 Arndt, Gertrud
0 Allen, Edward L. [19 ST]	17 Arnold, Bill
2 Allen, Frances and Mary [1 AB]	1 Arnold, Charles Dudley [2 AB]
1 Allen, Ted	1 Arual (?)
5 Alliot, E. A.	0 Atelier Héliographique [1 DAG]
6 Altobelli and Molins	275 Atget, Eugène [1 AB]
1 Altobelli, Gioacchino [1 AB]	8 Atkins, Anna [2 AB]
1 Alvarez Bravo, Lola	1 Atwell, Harry A.
70 Alvarez Bravo, Manuel	1 Aubert, François

17 Aubry, Charles
12 Auerbach, Ellen
1 Austin, I.
1 Autrey, Max Mun
2 Avedon, Richard
79 Azari, Fédèle [2 AB]
3 B. C.
13 Bachrach
3 Bachrach, Ernest A. [1 AB]
1 Bachrach, Fabian
2 Bachrach, Louis Fabian [1 AB]
1 Backhouse, Alfred
1 Bahelfer, Moses
2 Bailey, Henry
1 Baker and Record
1 Baker Studio
2 Balazs
2 Baldi
1 Baldi and Wurthle [7 ST]
0 Baldwin, George W. [34 ST]
0 Baldwin, Schuyler C. [18 ST]
125 Baldus, Édouard-Denis [11 AB]
6 Ball, Russell
5 Ballmer, Theo
1 Baltermans, Dmitri
4 Baltz, Lewis
1 Balzar
1 Balzer, Gerd
1 Bangs
15 Bangs, R. Jay
4 Bankhart, George [8 AB]
1 Barchan, P.
1 Bardou, A.
29 Barker, George [155 ST; 7 AB; 3 CC]
80 Barnard, George N. [87 ST; 5 AB]
1 Barney
0 Barnum, Deloss [343 ST]
11 Baron, Richard
1 Barraud, Herbert
1 Barrie, G., and Son
4 Barron, Susan
1 Bartholdi, Frédéric-Auguste
2 Bartholomew, Ralph
8 Bartlett
2 Bassano, Alexander [14 CDV; 1 AB; 2 CC]
20 Basso, Richard
0 Bates, Joseph L. [27 ST]
15 Batz, Eugen
12 Bauer, James
6 Bayard and Reynard
5 Bayard, Émile [4 AB]

13 Bayard, Hippolyte [2 AB]
0 Bayard, Hippolyte, and Félicien Bertall [24 CDV]
23 Bayer, Herbert [2 AB]
7 Bayer-Hecht, Irene
2 Beals, Jessie Tarbox
1 Beaman, E. O. [49 ST; 1 AB]
Beard, Richard [5 DAG; 7 AB]
19 Beato, Antonio [3 AB]
100 Beato, Felice [1 ST; 17 AB]
5 Beaton, Cecil [6 AB]
3 Beauchy, E.
9 Bechard, Henri [1 AB]
125 Becher, Bernd and Hilla
1 Beckmann, Hannes
48 Bedford, Francis [47 ST; 127 CDV; 16 AB]
1 Bedford-Lemere, Henry [1 AB]
0 Beer, S. [22 ST]
4 Beese, Lotte
1 Behles, Edmondo [27 ST]
4 Bell, Charles M. [3 AB; 1 CC]
1 Bell, Curtis [2 AB]
0 Bell, Francis H., and Brother [54 ST]
24 Bell, William Abraham [1 AB]
18 Bell, William H. [143 ST; 53 CDV; 6 AB]
30 Bellmer, Hans [2 AB]
1 Bellon, Denise
0 Bemis, Samuel [4 DAG]
2 Ben-Yusuf, Zaida [4 AB]
2 Benecke, Robert [2 ST; 2 AB]
1 Benjamin
6 Bennett, Henry Hamilton [113 ST; 1 AB]
2 Bennett, Jeanne E. [3 AB]
2 Benson, Richard
1 Bentley
1 Berger, Otti
1 Bergheim, P. [1 AB]
11 Bergmann-Michel, Ella
2 Bergon, Paul [10 AB]
1 Bernard, J.
2 Bernhoeft, C.
0 Bernoud, Alphonse [25 ST; 2 AB]
1 Bertall, Charles-Albert (Vicomte d'Arnoux)
4 Berthaud, M. [3 AB]
3 Berthier, Paul-Marcellin
1 Bertolf, Hannes
12 Bertsch and Arnaud
0 Bierstadt, Charles [202 ST; 1 AB]

0 Bierstadt, Edward [123 ST]
1 Bierstadt, Edward and Charles
 [2 CDV]
0 Biewend, C. E. H. [1 DAG]
2 Bing, Ilse
1 Bingham, Hiram
6 Bingham, Robert Jefferson [10 CDV;
 1 AB]
7 Binnemann, Rudolphe
1 Bischoff and Spencer
80 Bisson Frères [Louis-Auguste and
 Auguste-Rosalie Bisson] [11 -CDV;
 6 AB]
2 Bisson, Auguste-Rosalie (Bisson *jeune*)
 [14 ST]
1 Bizek, Karel
18 Black, James Wallace [8 ST; 3 CDV;
 3 AB]
1 Blackford Studio
1 Blaise, Gabriel [4 CDV]
1 Blakemore's Studio
1 Blanc, G.
0 Blanchard, Valentine [41 ST; 6 CDV;
 1 AB]
46 Blanquart-Evrard, Louis-Désiré
 [11 AB]
0 Blessing, Samuel T. [28 ST]
2 Blight, Richard
3 Bliss Brothers
1 Blos, S.
12 Blossfeldt, Karl
2 Blot, Julien
4 Blowers, John
14 Blumenfeld, Erwin [2 AB]
1 Bly
1 Bodine, A. Aubry
1 Bodmer, C.
0 Boehl, Emil, and Lorenz H. Koenig
 [60 ST]
3 Bogardus, Abraham [1 DAG; 7 CDV;
 3 AB; 3 CC]
2 Boiffard, Jacques-André
1 Boissonnas and Detaille [1 CC]
1 Boissonnas and Eggler
8 Boissonnas, Frédéric [7 AB]
6 Bondonneau, Émile
126 Bonfils, Félix [13 ST; 10 AB]
0 Bonine, R. K. [20 ST]
1 Bonney
1 Bool, Alfred and John
3 Borri, Vicente [1 AB]
1 Both, Katt

1 Boubat, Édouard
3 Boucher, Pierre [3 AB]
10 Bouell, Charles von
11 Boughton, Alice [1 AB]
1 Boulle, E.
2 Bourke-White, Margaret [3 AB]
12 Bourne, Samuel [17 AB]
7 Boussenot, Tony
1 Bousseton, Auguste A.
1 Bovier, Léon
2 Boyce, G. P.
8 Boysen, J. T.
1 Boyé, Otto H.
1 Braden Brothers
2 Bradford, William
0 Bradley, Bryant [21 ST]
2 Bradley and Rulofson [Henry W.
 Bradley and William Herman Rulof-
 son] [1CDV; 5 AB; 10 CC]
44 Brady, Mathew B. [34 ST; 2 DAG;
 42 CDV; 5 AB; 1 CC]
0 Brady, Mathew B., and Co. [19 ST;
 25 CDV]
14 Bragaglia, Anton Giulio
1 Brahm, S.
2 Brancusi, Constantin [1 AB]
23 Brandt, Bill [3 AB]
3 Brandt, Marianne
8 Braquehais, Bruno
39 Brassaï [Gyula Halász] [2 AB]
59 Braun, Adolphe [437 ST; 43 CDV;
 17 AB; 2 CC]
5 Braun, Adolphe, and Co. [1 AB; 1 CC]
1 Breitwish
1 Breslauer, Marianne
1 Bresolin, Domenico
2 Breton, André
2 Breuer, H.
0 Bricknell, T. J., and Cudding [16 ST]
2 Bridges, George
2 Bridges, George, and Calvert Richard
 Jones
5 Brigman, Anne W. [9 AB]
0 Brinkley, F. [18 AB]
1 Briquet, A. [2 ST; 3 AB]
2 Brockmann, F.
3 Brockmann, F. and O. [6 AB; 3 CC]
1 Brodsky, M.
34 Brogi, Giacomo [10 ST; 7 CDV;
 6 AB; 4 CC]
2 Broise, Albert
7 Brooks, Ellen

1 Brooks Studio
0 Brooks, William [11 ST]
5 Brown Brothers
1 Brown, Fedora E. D.
0 Brown, J. M., and A. F. Wheeler
 [18 CDV]
0 Brown, William Henry [23 ST]
32 Browne, John Coates [1 AB]
72 Browning, Benjamin
0 Brubaker, Christian B. [18 ST]
62 Bruguière, Francis
12 Bruning, W. P.
11 Brusa, Giovanni Battista [3 AB]
1 Buck, Ken Robert
1 Buckham, Alfred G. [1 AB]
1 Buckland, David
1 Buckle, Samuel [1 AB]
2 Buehrmann, Elizabeth
2 Buisson, Victor de
1 Buisson, Victor de (fils) [3 CC]
15 Bull, Clarence Sinclair
87 Bulla, K. K.
13 Bullock, John G. [61 ST; 3 AB]
1 Bullock, Wynn
6 Burchard, Jerry
1 Burchartz, Max
1 Burgert Brothers
1 Burke, John [3 AB]
0 Burns, Archibald [10 ST; 1 AB]
2 Burrows, Robert
0 Burton Brothers [Alfred Henry and
 Walter John Burton] [65 ST; 1 AB]
0 Burton, James Davis [14 ST]
1 Bushnell, James E.
2 Butterfield, D. W.
0 Byerly, Jacob [534 DAG; 2 CDV;
 34 TT]
2 Byron, Joseph
0 Ch. D. [5 ST]
2 C. N.
1 C. N. and Co.
1 Caithness, Earl of [James Sinclair], and
 William Bambridge
14 Calavas, A. [1 AB]
1 Caldesi and Montecchi
31 Callahan, Harry
1 Callis, Jo Ann
5 Cameron, Henry Herschel Hay
 [1 AB]
122 Cameron, Julia Margaret [11 AB;
 4 CC]
5 Camino

29 Cammas, Henry [1 AB]
1 Camnitzer, L. G. A.
1 Campbell, Alfred S. [18 ST; 1 AB]
9 Caneva, Giacomo
15 Capel-Cure, Alfred [1 AB]
0 Carbutt, John [114 ST; 1 AB]
12 Carjat, Étienne [9 CDV; 14 AB]
1 Carlet Studio
1 Carpenter, William Benjamin
7 Carrick, William [43 CDV; 1 AB]
13 Carroll, Lewis [Charles Lutwidge
 Dodgson]
0 Carter, Charles William [54 ST;
 1 CDV]
1 Carter, Sidney Robert [2 AB]
66 Cartier-Bresson, Henri [1 AB]
3 Castagneri, Mario [1 AB]
0 Caswell and Davy [17 ST]
1 Cayatte
1 Cecil, Hugh [2 AB]
0 Centennial Photographic Co.
 [Edward L. Wilson and W. Irving
 Adams] [14ST; 1 CDV]
1 Chadwick, Arthur W.
1 Chalot, I. [1 AB; 2 CC]
0 Chamberlain, William Gunnison
 [52 ST; 6 CDV; 1 AB]
1 Chambon, F.
1 Champlouis, Victor Nau de
1 Chanoine, G.
0 Chardon, Alfred (jeune) [15 CDV]
1 Charles [1 CDV]
4 Charnaux, F. [20 ST; 5 CDV; 2 AB;
 4 CC]
8 Charnay, Claude-Joseph-Désiré
 [2 AB]
1 Chartran
0 Chase, William M. [106 ST]
2 Chatenay
3 Check, K.
5 Chernewski, Anita
2 Cherrill, Nelson King [1 AB]
1 Chesley Brothers
9 Child, Thomas [1 AB]
0 Childs, Brainard F. [25 ST; 1 CDV]
7 Chochola, Vaclav
0 Churchill, Remmett E., and
 D. Denison [3 ST; 27 CDV; 1 AB]
3 Citroen, Paul
2 Civiale, Aimé [26 ST; 8 AB]
1 Civirani
2 Civis, Euro [Livio Tanzi]

7 Clark, Larry
0 Claudet, Antonie-François-Jean
[17 ST; 26 DAG; 6 CDV; 1 AB]
1 Clesinger
27 Clifford, Charles [1 CDV; 8 AB]
2 Clifford, D. A. [35 ST]
0 Clough, Amos F., and Howard A.
Kimball [64 ST]
1 Clough, Charles
21 Coburn, Alvin Langdon [27 AB]
0 Coghill, John Joscelyn [10 AB]
100 Collard, A. (Albert?)
12 Collein, Edmund
25 Collemant, Paul
3 Colliau, Eugène [1 CDV]
1 Collier, Joseph [Charles Harrington]
[124 ST; 1 CDV; 5 AB]
1 Collin
1 Collins, John F.
1 Colls, Lebben [1 AB]
1 Colonial Studio
1 Colquhoun, Charles Fergus
1 Columbia Medallions Co.
1 Combier, Charles
4 Comeriner, Erich
1 Commercial Photograph Co.
1 Connell, Will [1 AB]
0 Conrad, Giorgio [2 ST; 10 CDV]
4 Consemüller, Erich
2 Constant, Eugène
16 Constantin, Dmitri
2 Cook
1 Cook, Wright
1 Coonley, J. F.
6 Cooper, A. C.
9 Cooper, Thomas Joshua
1 Coplans, John
1 Coppola, Horacio
0 Cotton, W. S. [124 ST]
7 Courtéoux
1 Couturier, J.
1 Cox, George Collins [1 AB]
1 Cox, Howard
0 Cramb, John [11 ST]
61 Cramer, Konrad
3 Crane, Barbara Bachmann
158 Crawford, Ralston
3 Cremer, James [166 ST; 1 CDV;
1 AB]
2 Cremière, Léon [3 CDV]
0 Cremière, Léon et Cie. [45 CDV]
1 Crespon, A. [1 CDV; 1 AB]

1 Croce, Gianni
1 Cronenweth, W. E.
1 Crow, S. M.
3 Croy, Otto R.
1 Crupi, Giovanni
0 Crum, R. D. [36 ST]
29 Cuccioni, Tommaso [6 AB]
0 Culver, William W. [10 ST]
1 Cundall and Howlett
51 Cunningham, Imogen [3 AB]
8 Currey, Francis Edmond [7 AB]
0 Currier, Frank F. [12 ST]
101 Curtis, Edward S. [20 AB]
0 Curtis, George E. [105 ST; 2 AB]
0 Cushing, W. H. [34 ST]
4 Cuvelier, Eugene
4 Daguerre, Louis-Jacques-Mandé
[13 AB]
2 Daguerre Studio
14 Dahl-Wolfe, Louise
1 D'Alessandri, Paolo Francesco
2 Dalí and Halsman [Salvador Dalí and
Philippe Halsman]
2 D'Allemagne
0 Dana, C. E. [1 CDV; 4 AB; 7 CC]
1 Dansey, George
1 Dapprich, Fred R. [1 AB]
3 Dassonville, W. E. [2 AB]
17 Davanne, Louis-Alphonse [2 AB]
1 Davidson, George
3 Davidson, Isaac Grundy
5 Davies, George Christopher [1 AB]
1 Davis
0 Davis Brothers [22 ST; 1 CDV]
1 Davis, Dwight A. [2 AB]
0 Davis, Guy B. [11 ST]
1 Davis, Lynn
5 Day, F. Holland [10 AB]
13 Dayal, Lala Deen [2 AB]
1 Deal, Joe
0 Dean, William P. [23 ST]
1 Debitte and Hervé [12 ST; 3 CDV;
6 CC]
2 de Bray, W. [1 AB]
7 Degas, Edgar
2 De Gaston
1 de Glibovskaia, Xenia
2 Degoix, Celestino [1 ST; 37 CDV]
1 De Jaeger, Stefan
13 Delamotte, Philip Henry [8 ST;
1 DAG; 9 AB]
3 De la Rue, Warren [6 ST; 1 AB]

1 Delisby, F.
9 dell'Emilia Fotographia
2 Delmaet and Durandelle
3 Delton, Louis-Jean [1 AB; 1 CC]
7 Demachy, Robert [33 AB]
0 Demay, L. [37 CDV]
37 de Meyer, Adolph
1 Deming, W. M.
2 Dempsie, C. M.
7 Deroche and Heyland
2 Desplanques, E.
1 Detroit Diesel Photographic
3 Detroit Photographic Co. [1 AB]
9 Detroit Publishing Co.
1 Deutsch, H. E. [1 AB]
0 Devanne, A., and Miguel Aléo
　[6 ST; 15 CDV]
68 Devéria, Achille and/or Théodule
　[1 AB]
1 Devoy, Carl
1 De Youngh
1 Dexel, Walter
2 Diamond, Harry
4 Diamond, Hugh Welch [3 AB]
1 Diem
8 Dingus, Rick
39 Disdéri, André-Adolphe-Eugène
　[13 ST; 127 CDV; 10 AB]
0 Disdéri et Cie [144 CDV; 2 AB]
1 Distin, William L.
3 Dittrich Studio
1 Dix, Victor
7 Dixon, Anne
1 Dixon, T. J. [1 AB]
1 Dobelman, Ph.
1 Dodd, Jeremy
1 Dodge, Clarence
3 Dohmen, Leo
1 Doisneau, Robert
1 d'Olivier, Louis-Camille
14 Doolittle, James
1 Doremus, J. P. [11 ST; 1 CDV]
1 Dovizielli, Pietro [3 AB]
2 Dow, Arthur
1 Downey, William
1 Downey, William and Daniel
　[11 CDV; 2 AB; 5 CC]
0 Draffin, J. [10 ST]
1 Dremin, Ivan E.
2 Dreyer, Louis H.
5 Drtikol, Frantisek [4 AB]
9 Druet, Émile [3 AB]
6 Dubois de Nehaut

2 Dubreuil, Pierre [13 AB]
12 Du Camp, Maxime [7 AB]
0 Duchochois, P. C. [18 ST; 1 AB]
0 Duchochois, P. C., and William
　Klauser [18 CDV]
2 Dührkoop, Minya
3 Dührkoop, Rudolf [8 AB]
1 Dunlop, Dan [4 AB]
1 Dunmore and Critcherson
2 Dupont, Aimé [1 AB]
17 Durand [3 CDV]
2 Durand-Brager, Jean-Baptiste-Henri
40 Durandelle, Louis-Émile [2 AB]
1 Durheim, Carl
11 Durieu, Eugène
1 Durst, André [1 AB]
4 Dusacq
3 Dyar, Otto
0 Eagles, Joseph Dunlap [23 ST]
121 Eakins, Thomas
0 Earl, Francis Charles [5 ST; 7 CDV]
1 Eaton, Robert
4 Ebert, H. A.
1 Eberth
1 Eckert, G. M.
8 Eder, Wolfram
9 Edgerton, Harold E. [2 AB]
0 Edmond [10 CDV]
1 Edwards
1 Edwards and Son
2 Edwards, Jay Dearborn
1 Edwards, John Paul
3 Eggleston, William
11 Ehm, Josef
7 Ehrhardt, Alfred
1 Ehrlich and Loew
3 Ehrlich, Franz
10 Eickemeyer, Rudolph, Jr. [26 AB]
2 Eidenbenz, Willi
1 Elder
3 Elliott and Fry [Clarence Edmund
　Elliott and Joseph John Fry]
　[29 CDV; 1 AB; 2 CC]
0 Elliott, James [19 ST]
0 Elliott, Joseph John [23 ST]
1 Ellis and Walery
1 Ellis, Edmund L.
0 Ellisson, William, and Co. [14 ST]
18 Emanuel, Charles H. L. [6 AB]
2 Emden, H.
2 Emerson, P. H. [21 AB]
4 Emonds, P.
1 Empire View Co.

0 England, William [185 ST; 4 AB]
1 English, Don
5 Enos, Chris
1 Epler and Arnold
6 Erfurth, Hugo [5 AB]
2 Erno, Vadas
1 Ernsberger
1 Estimson, J.
7 Eugene, Frank [18 AB]
1 Evans, Evan D.
106 Evans, Frederick H. [8 AB]
2 Evans, Tom
1,192 Evans, Walker [6 AB]
0 Eynard-Lullin, Jean-Gabriel [3 ST; 1 DAG]
0 Eynard-Lullin, Jean-Gabriel, and Jean Rion [92 DAG]
1 Fafournoux, C.
0 Fagersteen, Gustavus A. F. [10 ST]
3 Fairchild, Charlotte
0 Falk, Benjamin J. [5 AB; 22 CC]
7 Famin, Charles
4 Fardon, G. R. [2 CC]
2 Farnsworth, Emma J. [7 AB]
5 Farrand Studio, The [S. B. Johnson]
2 Fassett, Samuel Montague [12 ST; 5 CDV]
1 Faucheux, A.
1 Faurer, Louis
2 Feiler, Jo Alison
13 Feininger, Andreas [3 AB]
55 Feininger, T. Lux [1 AB]
1 Feist, Werner David
7 Fenn, Otto
2 Fennemore, James H. [17 ST; 1 AB]
324 Fenton, Roger [12 ST; 15 AB]
11 Fernique, Albert
13 Ferrez, Marc [2 AB]
4 Ferrier, Claude-Marie [18 ST; 9 AB]
1 Ferrier, Claude-Marie, and Hugh Owen
30 Ferrier, Jacques-Alexandre
11 Ferroli, Amadeo
1 Fetzer, J.
1 Feuerstein, J.
1 Fidanza, Francesco
2 Fillon, A., and Heuse
1 Finch Studio
12 Finsler, Hans
1 Fischer, Emil
3 Fisher, K. A.
22 Fiske, George [2 ST; 4 AB]

2 Fitch, Steve
2 Fizeau, Armand-Hippolyte-Louis [2 DAG; 1 AB]
1 Flach, Hannes Maria
15 Flacheron, Frédéric (Count)
2,793 Fleckenstein, Louis [10 AB]
10 Fleischmann, Trude [1 AB]
5 Flett, B. E. [Flett Studio]
0 Florida Club, The [Charles Seaver, Jr., and George Pierron] [35 -ST]
1 Folberg, Neil
4 Foncelle, A.
1 Fontaine, G. [1 CDV; 2 AB]
18 Fortier, Francois-Alphonse
9 Foster, J. R.
2 Foulard, Charles
0 Fraget and Viret [27 ST]
2 Fraker, William A.
4 Franck [François-Marie-Louis Alexandre Gobinet de Villecholles] [38 CDV; 7AB]
7 Frank, Robert
1 Frankel
1 Frankenstein, von
1 Fratelli D'Alessandri
3 Frazer, Jim
25 Fredricks, Charles DeForest [2 CDV; 2 AB]
0 Fredricks, Charles DeForest, and Co. [13 ST; 50 CDV]
0 Freeman, J. [19 ST; 1 AB]
1 French, J. A. [67 ST]
0 French, J. A., and Charles H. Sawyer [15 ST]
1 Frick, A. H.
188 Frith, Francis [342 ST; 3 CDV; 45 AB]
2 Frith, Francis, and Co. [2 AB]
5 Froissart, Louis-Antoine
3 Fryer, Elmer
1 Fuchs, Waldemar
47 Fuhrmann, Ernst [1 AB]
1 Funkat, Walter
107 Funke, Jaromír [2 AB]
0 Furne Fils [11 ST]
1 Furne Fils, and Henri Tournier [21 ST]
1 Fusterz, Petre
0 G. A. F. [33 ST]
1 G. D.
3 G. H. [4 AB]
1 G. J. [3 AB]

5 Gaillard, Paul
0 Gage, Franklin Benjamin [27 ST]
1 Gal, Serge
2 Gale, Joseph
4 Gallo, Paolo
6 García, Hector
0 Garcin, A. [12 ST; 20 CDV; 2 CC]
92 Gardner, Alexander [15 ST; 11 CDV; 7 AB; 1 CC]
1 Gardner, James [2 AB]
1 Gardner, Walter
9 Garnett, William A.
1 Garrett
3 Gaston and Mathieu
0 Gates, George F. [80 ST]
3 Gates, Jeff
0 Gates, Willis D. [21 ST]
2 Gearo
8 Géniava, Paul
53 Genthe, Arnold [8 AB]
1 Georg, Victor
0 Gerard, Charles [C. G. or Ch. G.] [26 ST]
6 Gerlach, von, and Schenk
1 Gerschel Frères
13 Gerson, Lotte
0 Ghemar Fréres [24 CDV]
1 Giacomelli, Mario
0 Gibbard, Christopher Smith [10 ST]
5 Gibson, James F.
1 Gibson, Sykes, and Fowler
0 Gill, William L. [13 ST]
15 Gilpin, Laura [5 AB]
1 Giovara e Figli
1 Giraud
12 Giroux, André
4 Gleason, Herbert W. [6 AB]
16 Gledhill, Carolyn, and Edwin
3 Glimette
40 Gloeden, Baron Wilhelm von [14 AB]
1 Glossner, M.
1 Godefroy, H. C. [9 AB]
33 Godet [6 AB]
4 Goell, Jonathan
13 Good, Frank M. [184 ST; 23 CDV; 3 AB]
0 Goodman, Claudius E. [13 ST]
1 Goodman, Michael
1 Gordon, N. L.
1 Gordon, Richard
3 Gottscho, Samuel

1 Goubier, E.
1 Gouchenheim and Forest
23 Goupil et Cie [35 CDV; 21 AB]
1 Gramaglia, Maggiorino
10 Graubner, Gotthard
0 Graves, Carleton H. [166 ST]
0 Graves, Jesse A. [26 ST; 2 AB]
1 Gray, B. C.
1 Graybill
1 Green, Lionel
43 Greene, John B.
1 Grill, K.
1 Grimes, W. M.
0 Griffith and Griffith [26 ST]
1 Grolleron, P.
1 Grooteclaes, Hubert
0 Groves, W. B. [116 ST]
2 Gruber, Terry de Roy
0 Grundy, William Morris [72 ST]
1 Guarnieri, Giuseppe
0 Guérard, Baptiste [28 CDV]
2 Guichard, E.
2 Guillot, Bernard
1 Gurney, Jeremiah, and Son [27 ST; 15 DAG; 32 CDV; 2 AB; 2 CC]
0 Gurnsey, Bryon H. [68 ST]
12 Gutch, J. W. G. [2 AB]
11 Gutekunst, Frederick [5 ST; 7 CDV; 11 AB; 1 CC]
1 Gutschow, Arvid
1 Guttmann, E.
1 H. D.
82 Haas and Peale [1 AB]
0 Haes, Frank [20 ST; 2 CDV]
1 Hacker, F.
3 Hagemeyer, Johan [2 AB]
2 Haines and Wickes
0 Haines, Eugene S. M. [79 ST]
1 Hak, Miroslav
1 Hale, Frank L.
6 Hall
3 Halloran, Sue
1 Halpern, Julius
1 Halsman, Philippe [2 AB]
43 Hammerschmidt, W. [1 ST; 15 CDV; 3 AB]
8 Handy, Levin C.
2 Hanfstaengel, Erwin
1 Hanfstaengl, Franz [7 AB; 3 CC]
0 Hanriot [15 ST]
41 Harlingue, A.
1 Harmelin

1 Harris and Ewing
1 Harris, Joe
1 Harrison
10 Harrison, W. H.
0 Hart, Alfred A. [68 ST]
38 Hart, E. H.
3 Hartsook
1 Hass, Kevin
3 Hausmann, Raoul [1 AB]
0 Havens, O. Pierre [44 ST]
6 Haviland, Paul B. [5 AB]
3 Havinden, John [6 AB]
3 Havrah
1 Hawarden, Lady Clementina
49 Haynes, F. Jay [61 ST; 4 AB]]
0 Hayward, E. J., and H. W. Muzzall [27 ST]
1 Hazard, John Bevan
0 Hazeltine, Martin Mason [21 ST]
1 Hedderly, James
1 Heidelsberger, Heinrich
1 Heilmann, J. J. [1 AB]
2 Heizer, R.
4 Hellé, E.
1 Hellman, Elma
1 Hemingway, Ernest
1 Hemphill, William Despard [5 AB]
1 Henderson, Alexander [1 AB]
0 Hendricks, Francis [18 ST]
4 Henle, Fritz [1 AB]
0 Hennah, T. H., and Kent [16 ST]
1 Henneberg, Hugo [13 AB]
4 Henneman, Nikolaas [4 AB]
1 Henneman, Nikolaas, and Thomas Malone [1 AB]
25 Hennig, Albert
21 Henri, Florence [3 AB]
0 Hensel, Loudolph [21 ST]
1 Herschel Family
2 Herschel, Sir John [1 AB]
1 Herter, D.
1 Hervey, Antoinette B. [1 AB]
2 Hester, Wilhelm
2 Hewitt, George W.
0 Heywood, John B. [137 ST; 1 AB]
15 Hibbard, C. P.
1 Higginbotham
1 Higgins, J. C.
1 Hill, David Octavius [14 AB]
120 Hill, David Octavius, and Robert Adamson [8 AB]
7 Hill, Ira L.
1 Hill, John T.

38 Hillers, John K. [214 ST; 3 AB]
1 Hills and Saunders [23 CDV; 4 AB]
4 Hilscher, Albert
1 Himmelsbach, Emil
105 Hine, Lewis W. [6 AB]
1 Hinton, A. Horsley [14 AB]
2 Hirsh, Hy
3 Histed, E. W.
0 Hobbs, William N. [13 ST]
2 Hoch, Hanna
12 Hockney, David
18 Hoffman, Heinrich
2 Hoffman, Irene
3 Hoffman, Julius
16 Holcombe, James W.
1 Hollinger
22 Hollyer, Frederick [1 CDV; 4 AB]
1 Holman, G. P.
1 Holmes, Silas A.
3 Hommel, George P.
1 Homolka, Florence
1 Honh, Ivan G.
1 Hood, P. H.
3 Hook, William E.
7 Hooper, William Willoughby [3 AB]
1 Hoover, L. F.
2 Hope, James Douglas [79 ST]
1 Hopkins, Thurston
9 Hoppé, E. O. [7 AB]
7 Horst, Horst P. [3 AB]
4 Houdoit, J.
17 Houseworth, Thomas [1 ST; 3 AB; 2 CC]
0 Houseworth, Thomas, and Co. [159 ST]
3 Howell, William T. [1 AB]
5 Howlett, Robert [3 ST; 5 AB]
8 Hoyningen-Huene, George [3 AB]
1 Huard, E.
0 Hubbard, William A., and Alonzo L. Mix [23 ST]
4 Hubbuch, Hilde
0 Hudson, John [22 ST; 7 CDV; 1 AB]
1 Hudson, W. A.
18 Huffman, L. A. [5 ST]
1 Hugo, Charles-Victor [1 AB]
2 Hugo, Leopold
1 Hujar, Peter
1 Humbert de Molard, Louis-Adolphe
1 Hunt, C. L. [1 AB]
1 Hurd and Smith [P. Hurd and William O. Smith] [27 ST]
30 Hurrell, George

1 Huynet
1 Hyde, John George [3 AB]
1 Hyde, Scott
2 I. C. C. ,
0 Illingworth, William H. [49 ST]
33 Incandela, Gerald
2 Incorpora, Giuseppe
0 Ingersoll, Truman Ward [21 ST]
1 Innes, William T.
0 Inskip, John [3 ST; 28 CDV]
0 Irving, James E. [13 ST]
1 Isler, A. F.
1 Israel and Riddle
1 Itting, Gotthardt
1 Izis [Israel Bidermanas]
1 J. A. C.
2 J. D. [1 AB]
1 J. G. [1 CDV]
0 Jackson Brothers [William Henry
 Jackson, Ed Jackson, and Ira Johnson]
 [30 ST]
117 Jackson, William Henry [159 ST;
 20 AB; 12 CC]
0 Jackson, William Henry, and Co.
 [51 ST; 2 CC]
1 Jacobi Eliot, C.
6 Jacobi, Lotte [3 AB]
1 Jacquet, Eugène
2 Jaeger, Joh
1 Jahan, Pierre
0 James, C. H. [11 ST]
2 James, Christopher
0 James, William E. [28 ST]
0 Jarvis, John F. [49 ST; 4 CC]
1 Jeanrenaud, A.
1 Jennings, Payne [1 ST; 1 AB]
1 Jeuffrain, Paul
1 Jicinsy, Karel
9 Johnson, Harry
1 Johnson, J. A.
8 Johnston, Frances Benjamin [8 AB]
9 Jones, Calvert Richard
9 Jones, Ray
2 Josephson, Kenneth
0 Jouvin, Hippolyte [23 ST]
1 Juley, Peter A.
1 Kahan, Roger
4 Kahn, Steve
144 Kales, Arthur F. [1 AB]
2 Kaminsky, Walter
11 Kar, Ida
60 Käsebier, Gertrude [27 AB]

1 Kato, Kiyashi
10 Kean, Kirby
14 Kearton, Cherry [1 AB]
2 Keighley, Alexander [17 AB]
25 Keiley, Joseph T. [13 AB]
16 Keith, John Frank
3 Keith, Thomas
1 Kelham, Augustus
2 Kellon (?)
9 Kemmler, Florence
1 Ken, Alexandre [8 CDV]
1 Kennan, George
65 Kennedy, Clarence [2 AB]
1 Kennerell
1 Kepes, Gyorgy
1 Kerfoot, John B. [1 AB]
164 Kertész, André [7 AB]
4 Kesting, Edmund [1 AB]
0 Ketner, George [11 ST]
2 Keyes, Donald Biddle
3 Keystone View Co. [52 ST]
0 Kilburn, Benjamin West [955 ST;
 2 CC]
0 Kimball, Howard A. [11 ST]
1 Kimball, W. G. C. [53 ST]
1 Kimbei, Kusakabe
1 Kindergraph
0 King, Horatio B. [1 DAG]
0 King, Marquis Fayette [10 ST]
35 Kinsey, Darius Reynold
7 Kira, Hiromu [2 AB]
1 Kirkland, George C.
6 Kjeldgard, Marinus Jacob
0 Kleckner, M. A. [73 ST]
1 Klein, William
1 Klucis [Gustav Gustavovich]
0 Knecht, J. R. [20 ST]
1 Knight, Tom
2 Knowlton
0 Knowlton Brothers [Franklin S. and
 Wilbur F. Knowlton] [13 ST]
2 Knudsen, Knud [2 AB]
2 Koblic, Premysel
6 Koch, Frederick
26 Koch, Max
3 Kolb Brothers [2 AB]
1 Kolb, E. C. [1 AB]
22 Korth, Fred G. [3 AB]
3 Koslowsky, J.
2 Kramer, Oscar [3 ST; 11 CDV]
91 Krampf, Gunther
2 Kröhn, B.

17 Krull, Germaine [7 AB]
3 Krupka, Jaroslav
7 Krupy, Alex J.
16 Kuehn, Heinrich [13 AB]
0 Kühn, B. [B. K.] [83 ST]
0 Kuhns [56 ST]
3 Kuhr, Fritz
1 Kulagina-Klucis, Valentina
112 Kuniyoshi, Yasuo
3 Küss, von
0 L. B. [11 ST]
5 L. M.
22 L. P. [4 AB]
1 Lacan, Ernst
1 Lafayette
0 Laforge, P. [11 ST]
1 Lais, Paul
1 L'Aisne, Victor
4 Lamazouere
0 Lamy, E. [E. L.] [138 ST; 2 CDV]
3 Lampue
1 Landau, Ergy [5 AB]
10 Langdon-Davies, F. H.
8 Lange, Dorothea [1 AB]
13 Langenheim Brothers [Frederick and
 William Langenheim] [17 ST;
 1 DAG]
0 Langenheim, Frederick David [20 ST;
 5 DAG; 2 AB]
0 Langenheim, Loud, and Co. [46 ST]
1 Langill, C. C.
1 Laredo, Victor
1 Larrain, Sergio
1 Larson, William
6 Lartigue, Jacques-Henri
1 Lassimonne
4 Laughlin, Clarence John [2 AB]
1 Laurent, H. [1 CDV]
18 Laurent, Juan [2 ST; 13 CDV; 6 AB]
2 Lauschmann, Jan [2 AB]
3 Laussedet, Ed.
5 Lavenson, Alma R. [2 AB]
4 Laviosa, Vicenzo
2 Lawrence, Roswell B.
0 Lawrence, George S., and Thomas
 Houseworth [210 ST; 37 CDV]
0 Lawrence, William Mervyn [12 ST]
7 Lawton, Ernest
1 Lazergues
1 Lazergues and D'Allemagne
1 Leavitt, Helen
4 Lebe, David

0 Le Begue, René [10 AB]
5 Leblanc, C. L.
3 Lecchi, S.
0 Lecocq-Frêné [10 ST; 1 CDV]
29 Le Deley, E.
0 Ledot [12 ST]
1 Lees, H. J.
44 Le Folcalvez, Henri
2 Lefrancq, Marcel G.
65 Le Gray, Gustave [2 ST; 2 CDV; 5 AB]
0 Lehmann, H., and Co. [10 CDV]
0 Le Jeune, A. [20 CDV; 2 AB; 4 CC]
65 Lekegian, G. [3 AB]
7 Lemercier, Lerebours, and Bareswill
5 Lemoine, René
16 Lendvai-Dircksen, Erna
0 Léon, Moïsé, and Issac Lévy [26 ST;
 [198 CDV; 2 AB]
2 Lerebours, Noël-Marie-Paymal
 [2 DAG; 10 AB]
2 Lermoyer
7 Leroux, A. [5 AB]
1 Leroy, J.
15 Le Secq, Henri [1 AB]
2 Lester, Gene
1 Levin, Larry
0 Levitsky, Sergei Luvovich [33 CDV]
1 Levitt, Helen
1 Levy, J. W.
2 Levy, L. [J. L.] [5 ST]
0 Lewis, Thomas [16 -ST]
13 Liebert, Alphonse J. [1 ST; 3 CDV]
5 Liebling, Jerome
2 Lincoln, F. S.
12 Lindahl, Axel [1 AB]
0 Linde, E., and Co. [50 CDV]
16 Lindsay, Coutts
0 Lindsay, D. J. [52 ST]
0 Linn, J. Birney [16 ST]
2 Linn, Judy
13 Lipnitski, Bernard
3 Lippman, Irving
1 Lissitzky, El
1 List, Herbert
1 Lithotype Printing Co. (Gardner,
 Mass.)
6 Llewelyn, John Dillwyn [5 AB]
1 Lloyd, A.
5 Lloyd, John
13 Lockwood, Frank
0 Loeffler, John [28 ST; 3 AB]
0 Loeffler and Petsch [12 ST; 3 AB]

11 Loew, W. M. Heinz
2 Lohse, Remie
4 Lombardi, Paolo [5 AB]
15 London Stereoscopic Co. [340 ST;
 51 CDV; 10 AB; 7 -CC]
1 Longworth, Bert
1 Lopez
6 Lorens, A. [4 ST; 6 CDV]
0 Loubère, P. [11 ST]
1 Loughton, Alfred J.
5 Louise, Ruth Harriet
1 Louvre Studio
0 Lovejoy, Edward and Foster [30 ST;
 1 AB]
1 Lowy, Joseph [1 ST]
1 Lucas-Pritchard
0 Lucas, Richard Cooke [60 CDV]
3 Ludwig, Karel
1 Lukas, Jan
18 Lumen, Charles
0 Lumière, Auguste and Louis [10 ST]
143 Lummis, Charles F. [1 AB]
2 Luswergh, Angelo
399 Lynch, Warren
4 Lynes, George Platt [3 AB]
1 Lyon, Danny
16 Lyte, Farnham Maxwell
1 M. H.
1 Maar, Dora [2 AB]
1 Macaskill, Wallace R.
6 McBride, Will
6 McDonald, James M. [8 AB]
2 McDonough, P. A.
0 McGlashon, Alexander [11 ST]
1 McGraw, R. F.
0 Macintosh, H. P. [14 ST]
1 McLachlan, L.
1 McLeish, Donald
1 McMurtry, Edward
38 Macpherson, Robert [4 AB]
31 Magritte, René
1 Magron, Henri
1 Maisclark, Peter
1 Makanna, Phillip
1 Mally, Michael
226 Man Ray [Emmanuel Radnitsky]
 [11 AB]
23 Man, Felix H. [Hans Felix Siegismund
 Baumann]
0 Manchester Brothers [Henry Niles and
 Edwin Hartwell Manchester]
 [31 ST; 12CDV]

0 Manchester Photographic Co.
 [10 CDV]
1 Mandel, Julien [1 AB]
0 Mang, Michele [1 AB; 15 CC]
0 Mang, Michele, and Co. [14 ST]
1 Mannes, Henri
32 Mantz, Werner
1 Manuel Frères
1 Mapplethorpe, Robert
1 Maraini, Fosco
1 Marceau
1 Marceau, Theodore C.
1 Marconi, Guglielmo
1 Marden
6 Marey, Étienne-Jules [4 AB]
2 Margaritis, Philippos [12 DAG]
3 Marie, Jules
3 Marien, Marcel
1 Mariette-Bey, Auguste [4 AB]
1 Mario, J.
1 Mark, Mary Ellen
2 Marotte, Léon
2 Marr, Thomas E. [1 AB]
4 Marsden, Simon N. L.
1 Marshall, Nancy
0 Marshall, William I. [25 ST]
1 Martin, Charles
1 Martin, Étienne-Simon
9 Martin, Ira W. [3 AB]
7 Martin, Paul [1 AB]
2 Martinet (Maison) [18 ST; 5 CDV;
 3 AB]
1 Marumo, Shinicho
100 Marville, Charles [6 AB]
1 Massari, Alejandro
4 Masse, Victor
2 Masson, Louis-Léon [16 ST]
12 Mather, Margrethe
1 Maugans, J. C.
2 Maull and Fox [1 AB]
41 Maull and Polyblank [11 CDV; 1 AB]
0 Maull, Henry, and Co. [16 CDV]
2 Maunier, V. G.
0 Maunoury, Eugenio [11 CDV; 1 AB]
39 Maurer, Oscar [11 AB]
7 Mauri, Achille [5 AB]
1 Maurice, E.
0 Maurisset, Théodore [1 lithograph]
1 Mayall, John Jabez Edwin [1 ST;
 4 DAG; 31 CDV; 6 AB]
3 Mayer and Pierson [4 ST; 1 DAG;
 29 CDV; 2 AB]

1 Mayer, Émile
1 Mayer, Otto
4 Mayes, Elaine
1 Maynard, Florence
1 Meade Brothers [2 DAG; 2 AB]
0 Meade, Charles R. [2 DAG]
6 Meder, L. [14 ST]
11 Meili (Photographic Studio)
0 Melander, Louis Magnus, and Brother
 [23 ST]
1 Melandri [1 CC]
1 Melbourne Studios
1 Mellen, George E.
7 Menanteau
4 Mestral, O.
1 Meurisse
3 Meyer, Hannes
2 Meyers, A. Lincoln [1 TT]
1 Michals, Duane
0 Michaud, Julio [81 ST]
0 Michaud, Julio, and Son [14 ST]
2 Michiels, J. F.
0 Miethke and Wawra [12 ST; 1 CDV]
5 Mieusement, Médéric [1 CDV; 2 AB;
 4 CC]
1 Miley, M., and Son
1 Millea, Tom
3 Miller
5 Miller, Charles Harry [1 AB]
1 Miller, George C.
1 Miller, Lee [2 AB]
0 Miller, Milton M. [14 ST]
1 Mills, Kelly S.
1 Minick, Roger
3 Mishkin Studio
1 Mitchell
1 Mitchell, Charles L.
0 Mitchell, J. S., and Charles N.
 De Waal [19 ST]
86 Model, Lisette [3 AB]
10 Modotti, Tina [2 AB]
10 Moffett Studio
10 Moholy, Lucia
104 Moholy-Nagy, László [4 AB]
3 Mole and Thomas [Arthur S. Mole and
 John D. Thomas]
10 Molinier, Pierre
1 Möller, H.
4 Molzahn, Johannes
3 Monroe, Robert
3 Monsen, Frederick I.
19 Moon, Karl E. [2 AB]

3 Moore, Henry
29 Moore, Henry P. [18 ST]
0 Moore, John Robert [36 ST; 8 CDV]
11 Moore, R. P.
1 Mora, José María [5 CDV; 1 AB;
 14 CC]
11 Moraites, Petros
19 Moran, John [70 ST; 2 AB]
0 Moran, John, and J. Storey [17 ST]
4 Morgan and Kenyon
1 Morgan, Barbara
1 Morgan, Rodney McCay
0 Morgan, Rufus [21 ST]
1 Morrison, C. H.
0 Morris, S. Hall [20 ST]
0 Morrow, Stanley, J. [10 ST]
5 Morse, George Daniels [1 CDV]
2 Mortensen, William [3 AB]
9 Moscioni, Romualdo [6 AB]
0 Moser, Senior [19 ST]
2 Moulin, F. Jacques [1 DAG; 2 AB]
2 Moulin, F. Jacques, and Achille Quinet
5 Moulton, Henry DeWitt
0 Moulton, J. C. [26 ST; 1 CC]
0 Moulton, John S. [49 ST]
0 Moulton, Joshua W. and John S.
 [66 ST]
1 Mrozovskaia, Elena
8 Mucha, Alphonse
1 Muche, Georg
1 Mudd, James
1 Muffley, Richard
0 Mugnier, Georges-François [4 ST;
 19 CC]
118 Muhr, Adolph F.
1 Muky
1 Muller
2 Mulnier, Ferdinand J. [3 CDV;
 14 AB]
0 Mumler, William H. [39 CDV]
1 Munari, Bruno
36 Munkacsi, Martin [5 AB]
3 Muray, Nickolas
1 Murray, Colin
2 Murray, John
188 Muybridge, Eadweard J. [279 ST;
 1 DAG; 15 AB]
13 Muzet, V. [1 CDV; 1 AB]
5 Myers, Eveleen W. H.
2 NASA
0 N. C. [49 ST]
31 N. D. [Neurdein] [13 AB; 2 CC]

2 N. Y. Photogravure Co.

0 N. Z. [25 ST]

433 Nadar [Gaspard-Félix Tournachon] [1 ST; 40 CDV; 45 AB; 24 CC]

55 Nadar, Paul [Paul Tournachon] [3 CDV; 45 AB; 42 CC]

34 Naya, Carlo [89 ST; 1 CDV; 2 AB]

10 Neame, S. Edwin

49 Nègre, Charles [1 DAG; 8 AB]

0 Negretti, Henry, and Joseph Zambra [1 ST; 1 DAG; 112 CDV; 1 AB]

1 Nenen

1 Nesbitt, J. H. More

5 Nessi, Antonio [2 CDV; 4 AB]

10 Neurdein Frères [1 AB]

9 Neurdein, Étienne [24 ST; 18 CDV; 4 AB; 2 CC]

0 Newell, Robert [5 ST]

0 Newell, Robert, and Son [Robert and Henry Newell] [12 ST]

1 Newhall, Beaumont

1 Newman, Arnold

0 New York Stereoscopic Co. [142 ST]

0 Nichol, Alexander [27 CDV; 1 AB]

0 Nickerson, G. H. [27 ST; 1 CC]

3 Nielson, H. F.

1 Ninci, Giuseppe

4 Nizzoli, Marcello

11 Noack, Alfredo [1 ST; 4 AB]

8 Norman, Dorothy

5 Normand, Alfred-Nicolas

1 Normand, Charles

1 Noskowiak, Sonya [1 AB]

1 Notman and Barker

17 Notman, William [56 ST; 3 CDV; 20 AB]

15 Nougé, Paul

1 Novelty Studio

1 Novák, Karel

12 Noyer, A. [1 AB]

0 Numa Fils

13 Nutting, Wallace

4 Ochsner, B. J.

14 Officer, Robert [1 AB]

12 Ogawa, Kazumasa

1 Okamota, Hisao

1 Oliver Studio

1 Oliviera, A.

2 Ollman, Arthur

1 Ongania, Ferdinando

1 Orlowski, M.

9 Ortiz-Echagüe, José

1 Ostheim, O. Von

84 O'Sullivan, Timothy H. [270 ST; 6 AB]

7 Otsup, Iosif

1 Otto [2 AB]

1 Oulif, Casimir

15 Outerbridge, Paul [2 AB]

8 Ovenden, Graham

1 Owen, Hugh [9 AB]

10 P. Z. [4 AB]

0 Pach, Gustavus W. [27 ST; 1 CDV; 3 AB; 4 CC]

6 Pach Brothers [1 ST; 7 AB; 3 CC]

1 Pakay, Sedat

0 Palmer, J. A. [25 ST]

0 Palmer, William [14 ST; 2 CDV; 1 AB]

3 Pap, Gyula

5 Parisio, Giulio [1 AB]

1 Park, Bertram [2 AB]

9 Parker, Harold A. [2 AB]

0 Parker, Joseph C. [20 ST]

1 Parker, William E.

0 Parks, J. G. [79 ST]

4 Parr, Martin

3 Parry, Roger M. [2 AB]

1 Parsons, S. F.

2 Parsons, S. H.

1 Partridge, Roi

1 Pavia Frères

1 Peabody, Henry G. [2 AB]

0 Pease, Nathan W. [77 ST]

1 Peavey, L.

15 Pec, Émile [Émile Pecquerel]

2 Pedo, Gaetano

0 Peeters, Charles [10 ST]

1 Peigne, C.

4 Peissachowitz, Nelly A.

3 Penn, Irving

1 Perez, Ricardo Jonas

24 Perier, Charles-Fortunat-Paul-Casimir

3 Perini, Antonio [1 ST; 1 CDV; 2 AB]

2 Perkis, Philip

0 Perraud, Philibert [12 DAG]

1 Persus

0 Pesme [23 CDV]

5 Peterhans, Walter

1 Peters, Christian

1 Petersen, P.

1 Petit and Trinquart [4 CDV; 2 AB]
8 Petit, Pierre [39 CDV; 8 AB]
1 Petroussov, Gueorgui
0 Petschler, H. [18 ST; 2 CDV]
0 Petschler, H., and Co. [16 ST;
 11 CDV]
6 Petschow, Robert
8 Petzold, Adolph [2 AB]
2 Peyser and Patzig
5 Philp and Solomon [1 CDV]
1 Philpot, J. B.
5 Photoglob (Edition) [1 AB]
4 Photoreflex
1 Phyfe, Hal
1 Piallat
1 Pierrefitte
1 Pierson, Pierre-Louis [21 CDV; 3 AB]
93 Pirrone, Luigi
0 Plaut, Henri [14 CDV]
0 Plumbe, John, Jr. [10 DAG]
1 Pluschow, Guglielmo von [1 AB]
0 Pointer, Henry [25 CDV]
10 Poitevin, Louis-Alphonse [7 DAG]
39 Polke, Sigmar
0 Pollock, Henry Alexander Radclyffe
 [H. P.] [13 ST]
1 Polozzi, C.
0 Pond, C. L. [28 ST]
61 Ponti, Carlo [27 ST; 3 CDV; 1 AB;
 1 CC]
6 Ponting, Herbert G. [1 AB]
18 Popovsky, A. F.
2 Popper, Grete
1 Poppi, Pietro
1 Porett, Thomas
1 Porter, Eliot [1 AB]
3 Post, William B. [9 AB]
1 Pottier, Philippe [1 AB]
1 Pouncey, John [1 CDV]
3 Pousette-Dart, Richard
2 Powell
0 Powers Frères [Longworth and Hiram
 Powers] [11 ST; 1 CDV]
1 Powers, George T.
1 Pozzi, Pompeo
9 Pratt, Ernest M. [2 AB]
1 Premi, Andrea
0 Prescott and White [10 ST]
1 Preslit
18 Pretsch, Paul
9 Price, William Lake [1 ST; 2 AB]
0 Proctor, G. K. [16 ST]

1 Protheroe
2 Prouveur, Jean-Marc
2 Puig, J. E.
2 Pulham, Peter Rose
2 Pullis, Pierre P.
4 Pumphrey, William
0 Purviance, William T. [69 ST;
 1 CDV]
10 Puyo, Emile Joachim Constant
 [22 AB]
0 Quéval, J. [13 ST; 5 CDV]
10 Quigley, Edward W. [2 AB]
16 Quinet, Achille [13 ST; 2 AB]
4 Quinsac, André [1 AB]
1 R. C. and Co.
2 Raghatt, Lloyd
1 Rahm, K. O.
0 Rainforth, S. I. [127 ST]
3 Rand, H. M.
4 Rasmus, David
6 Rau, Carl [1 AB]
20 Rau, William H. [34 ST; 4 AB]
12 Rautert, Tim
5 Raymond, Lilo
0 Read, J. Wilbur [39 ST]
1 Reading, J. T.
1 Records, Bill
1 Redaway
3 Redfield, Robert S. [6 AB]
0 Reed, Selwin C. [23 ST]
1 Reekie, John [1 AB]
8 Regnault, Henri-Victor
9 Reid, Charles
1 Reid, Charles (Studio)
0 Reilly, John James [84 ST; 1 AB]
0 Reilly, John James, and Co. [16 ST]
0 Reilly, John James, and John Pitcher
 Spooner [28 ST]
3 Reinhard
6 Reisner, Georg
1 Reisz, André
25 Rejlander, Oscar Gustave [9 CDV;
 3 AB]
1 Relang, Regina
4 Renard, François-Auguste
1 René-Jacques [René Giton]
204 Renger-Patzsch, Albert [4 AB]
1 Renger-Patzsch, Sabine
3 Reutlinger, Charles [25 CDV; 8 AB;
 1 CC]
7 Rey, Guido [17 AB]
1 Rice, Chester P.

2 Richards and Betts [2 AB]
6 Richards, Albert G.
4 Richards, Frederick Debourg
31 Richebourg, A.
6 Richee, Eugene Robert
1 Rinaldini, Augusto
119 Rinehart, Frank A. [2 AB]
3 Ringl and Pit [Ellen Auerbach and
 Grete Stern] [1 AB]
11 Rive, Roberto [2 AB]
0 Robbins, Frank [13 ST]
0 Robbins, William S., and Co. [14 ST]
6 Robert, Louis-Rémy
2 Robert, Paul
18 Robertson, James [9 AB]
9 Robertson, James, and Felice Beato
1 Robinson and Cherrill [Henry Peach
 Robinson and Nelson King Cherrill]
 [1CDV; 1 AB]
1 Robinson, David
0 Robinson, G. W. [31 ST]
0 Robinson, H. N. [50 ST]
11 Robinson, Henry Peach [1 CDV;
 17 AB]
0 Roche, Thomas C. [219 ST]
2 Rockwood, George Gardner [3 CDV;
 7 AB; 2 CC]
6 Rodan, Don
82 Rodchenko, Alexander
3 Röder, C. G.
1 Rodger, Thomas [9 CDV; 1 AB]
18 Roger-Viollet, H.
2 Rogers and Newing
3 Rogers, Gertrude
44 Roh, Franz [1 AB]
16 Rohde, Werner
5 Rol, M. [1 AB]
2 Roman, Dominique
2 Römmler and Jonas [3 CC]
2 Römmler, E.
0 Ropes, H., and Co. [28 ST]
3 Rose, Hajo
1 Rosenblum, Walter
1 Rosenfeld, A.
0 Rosier, M. [94 ST]
2 Rosling, Alfred [3 AB]
3 Ross, Horatio
6 Rossetti, Dante Gabriel [1 AB]
13 Rossignol, Marie
1 Rossiter, Alison
36 Rössler, Jaroslav
2 Roth, Jean

6 Rothstein, Arthur
1 Roubier, Jean
4 Rousset, Ildefonse [7 AB]
1 Roux, Christine
4 Royal Atelier
4 Rubinstein, Naftali
2 Rudolph, Charlotte
2 Rudolphy, Hugo
12 Rudomine, Albert
67 Russell, A. J. [40 ST; 4 AB]
1 Ruzicka, D. J. [2 AB]
0 Sabatier
5 Saché, Alfred
1 Saglio and Peter [1 AB]
2 Salaün, A.
30 Salomon, Erich [1 AB]
4 Salviati, Paolo
1 Salvin, Osbert
34 Salzmann, Auguste [3 AB]
12 Samaras, Lucas
1 Samuel, Ford E.
1,235 Sander, August [1 AB]
1 Sander, Gunther
2 Sands, C.
1 Sanford, D. S.
4 Santos
1 Sarkar, Benoy
6 Sarony, Napoléon [4 ST; 13 CDV;
 18 AB; 70 CC]
0 Sarony, Olivier-François-Xavier
 [20 CDV]
0 Sarony and Co. [Napoléon Sarony and
 Alfred S. Campbell] [31 CDV;
 2 AB; 2CC]
4 Saudek, Jan
0 Saunders, Irving [32 ST]
4 Saunders, W. [1 AB]
12 Savage, C. R. [97 ST; 5 AB; 1 CC]
0 Savage, C. R., and George Martin
 Ottinger [16 ST; 1 CDV]
1 Savitry, Émile-Dupont
8 Schad, Christian
1 Schafer
1 Schall, Roger
1 Schauer, Gustav
2 Schawinsky, Xanti
1 Schenk, Charles [1 AB]
1 Schenker, Karl
1 Scherdel
3 Schlemmer, Oskar
1 Schmidt, Ferdinand
7 Schmidt, Joost

2 Schmidt, Otto [1 CDV]
36 Schneeberger, Adolf
4 Schneider, Roland
1 Scholl, Aemilian
2 Schramm, Louis B.
3 Schreiber, George Francis
0 Schreiber, George Francis, and Sons [19 ST]
4 Schroeder
20 Schürmann, Herbert
11 Schürmamm, Wilhelm
1 Schwartz
0 Schwarzschild, F. [20 CDV]
2 Schwitters, Kurt
1 Sciutto, Giovanni Battista [1 AB]
6 Scott Orr, H.
1 Scowen, C. [2 AB]
0 Scripture, George H. [25 ST]
3 Seabrook
0 Seaver, Charles, Jr. [36 ST]
3 Sears, Sarah C. [2 AB]
6 Sébah and Joaillier [1 AB]
30 Sébah, Pascal [1 ST; 2 CDV; 3 AB]
0 Sedgfield, William Russell [66 ST; 2 AB]
0 Seeley, Alfred V. and Edward [12 CDV]
9 Seeley, George H. [1 ST; 10 AB]
2 Seely Studio
1 Segal, Adrien
2 Seiberling, Christopher
1 Seidenstücker, Friedrich
8 Señan and Gonzalez [1 AB]
2 Severance, F. J.
3 Shahn, Ben [1 AB]
2 Shaw, Lauren
11 Sheeler, Charles [4 AB]
0 Sherman, William H. [13 ST]
1 Shinn, Walter Scott
25 Shiraoka, Jun
14 Shore, Stephen
14 Shteinberg, Iakob
0 Shute, Charles H., and Son [23 ST]
0 Silvester, Alfred [15 ST]
5 Silvy, Camille [55 CDV; 4 AB]
1 Simmons, L. D.
4 Simon, Stella
0 Singley, Benjamin L. [74 ST]
8 Sinsabaugh, Art
6 Sipprell, Clara E. [3 AB]
137 Siskind, Aaron [1 AB]
1 Skeen, W. L. H.
3 Skoff, Gail

3 Skoien
4 Smith, B. J.
1 Smith, David
1 Smith, Erwin E.
1 Smith, Harry
2 Smith, Lewis
30 Smith, W. Eugene
2 Smythe, S. A.
1 Snare, John
1 Snelling, Henry H., and L. E. Walker
0 Snelling, Henry H. [17 AB]
1 Soame, James
2 Société Royale Belge de Photographie
1 Soler, F.
2 Sommer, Frederick
18 Sommer, Giorgio, and Edmondo Behles [64 ST; 91 CDV]
112 Sommer, Giorgio [56 ST; 9 CDV; 11 AB; 1 CC]
1 Sotiropoulos, P.
1 Soule, John P. [437 ST; 12 CDV; 5 AB]
51 Soule, W. S. [1 ST]
12 Soulier, Charles [1 AB]
0 Southwell, William [12 CDV]
1 Southworth and Hawes [9 DAG]
1 Spink
0 Spithover, Joseph (Giuseppe) [15 ST; 25 CDV; 2 AB]
8 Spitz, Charles
3 Spohr, Barbara
0 Spreat, William [21 ST; 9 CDV]
1 Spurr, Melbourne
0 Stacy, George [26 ST]
1 Stafford
4 Staley
1 Staller, Eric
2 Stanbery, Katherine S.
2 Stanbery, Mary R. [2 AB]
1 Stanley, J. C.
1 Stebinger, Loraine
41 Steichen, Edward [37 AB]
1 Steinberg, J. and M.
1 Steincmann, E.
2 Steiner, André [1 AB]
3 Steiner, Ralph
1 Steinert, Otto
1 Stephens, A. B.
1 Stephens, C.
4 Stern, Grete
2 Stevens, Roy
1 Stevenson, Hilde
13 Stewart, John

3 Stickney Studio
181 Stieglitz, Alfred [95 AB]
1 Stillman, William J. [2 CDV; 4 AB]
1 Stocks, B.
20 Stoddard, S. R. [109 ST; 4 CDV;
11 AB; 11 CC]
1 Stoiber, A. H. [12 AB]
5 Stone, John Benjamin [12 AB]
1 Stone, Joseph A.
2 Stone, Sasha [3 AB]
1 Story Maskelyne, M. H. Nevil
147 Strand, Paul [2 AB]
1 Straub, Karl
0 Strohmeyer, Henry A., and Henry
Wyman [45 ST]
2 Strumper
103 Struss, Karl F. [4 AB]
10 Strüwe, Carl
4 Stück, Franz von
0 Stuart, John [3 ST; 10 CDV; 1 AB]
0 Styles, Adin French [21 ST]
71 Sudek, Josef [4 AB]
1 Sultan, Larry
1 Sunami, Soichi
1 Super, Gary Lee
25 Sutcliffe, Frank M. [8 AB]
1 Sutton, Thomas [5 ST; 4 AB]
3 Tabard, Maurice [6 AB]
16 Taber, I. W. [11 AB; 2 CC]
0 Taft, Preston William [12 ST]
69 Talbot, William Henry Fox [12 AB]
1 Tashiera, George
15 Tato [Guglielmo Sansoni]
2 Taunt, Henry [4 AB]
9 Taupin, A.
1 Taylor, F. J. [1 AB]
4 Taylor, Harold A. [3 AB]
0 Taylor, John C., and Huntington
[21 ST]
21 Telberg, Val
2 Tenison, E. K.
2 Terris
35 Teske, Edmund
7 Teynard, Félix [3 AB]
24 Thalemann, Else
6 Thayaht [Ernesto Michahelles]
0 Thiebault, E. [2 ST; 13 CDV; 1 AB]
4 Thiollier, Félix
3 Thiry, Georges
1 Thomas
6 Thompson, Charles Thurston [2 AB]
1 Thompson, Fred

2 Thompson, Jerry L.
2 Thompson, Paul
0 Thompson, Stephen [11 ST; 3 AB]
2 Thompson, Ted
52 Thomson, John [46 AB]
0 Thorne, George W. [11 ST]
1 Thorne-Thomsen, Ruth
0 Thurlow, James T. [16 ST]
3 Tiffany, Louis Comfort
0 Tipton, William H. [15 ST; 1 CDV;
1 AB]
6 Tilli
2 Topley, W. J.
29 Tournachon, Adrien [3 AB]
4 Tourtin, J. [2 AB]
0 Towle, Simon [19 ST]
6 Trémaux, Pierre
23 Tripe, Linneaus [6 AB]
7 Tritschler, Alfred [1 AB]
3 Trois Empereurs, Des
2 Trojna, K.
1 Troth, Henry [12 AB]
1 Trump, George
2 Trülzsch, Holger
3 Tunny, J. G. [3 CDV; 2 AB]
5 Turner, B. B. [2 AB]
0 Tuthill, T. T. [13 ST]
2 Ubac, Raoul
6 Ueda, Shoji
169 Ulmann, Doris [4 AB]
2 Umbo [Otto Umbehr] [1 AB]
2 Underhill, Irving
15 Underwood and Underwood
[130 ST; 2 AB]
2,733 Unknown maker [1,061 ST;
873 DAG; 395 CDV; 471 AB;
112 TT; 64 CC]
2 Unknown maker (African)
655 Unknown maker (American)
[1,106 ST; 73 DAG; 310 CDV; 1 AB;
30 TT; 65 CC]
3 Unknown maker (Austrian) [4 ST]
10 Unknown maker (Belgian) [7 CDV;
1 AB; 5 CC]
116 Unknown maker (British) [629 ST;
6 DAG; 405 CDV; 2 AB; 2 CC]
0 Unknown maker (Canadian) [56 ST]
3 Unknown maker (Dutch)
106 Unknown maker (French) [500 ST;
25 DAG; 264 CDV; 2 AB; 29 CC]
52 Unknown maker (German) [73 ST;
42 CDV; 6 CC]

4 Unknown maker (Greek)
27 Unknown maker (Indian)
105 Unknown maker (Italian) [193 ST;
 4 DAG; 63 CDV; 11 CC]
1 Unknown maker (Japanese) [6 CDV]
1 Unknown maker (Mexican)
1 Unknown maker (North African)
10 Unknown maker (Norwegian)
 [1 CDV]
2 Unknown maker (Panamanian)
43 Unknown maker (Russian) [4 CDV]
22 Unknown maker (Spanish) [8 ST;
 2 CDV]
13 Unknown maker (Swiss) [1 DAG;
 2 CDV]
3 Unknown maker (Turkish)
13 Unnevehr, J. G.
0 Upton, Benjamin Franklin [29 ST]
3 Valentine, George D.
13 Valentine, James [35 ST; 1 DAG;
 2 CDV; 24 AB]
0 Vallee, Louis Parent [103 ST]
15 Vallou de Villeneuve, Julien
0 Vance, Robert H. [10 DAG]
2 Vandamm
2 Van der Poll, Willem
1 Van der Weyde, Henry
3 Van der Zee, James
4 Vandyk, C.
0 Van Lint, Enrico [21 ST; 10 CDV;
 2 AB]
4 Vannerson, Julian
4 Van Riel, Frans
2 Van Sant, F. A.
2 Van Vechten, Carl
1 Varia [Gjon Mili]
1 Vasari, A.
1 Vaux, George B.
1 Vaux, Mary M.
1 Vaux, William S.
1 Ventnor Photo Service
1 Verger, Pierre
1 Vergnol, A.
10 Vidal, Léon [1 AB]
16 Vigier, Joseph
1 Vignon, Jacques
21 Vobecky, Frantisek
3 Vogt, Christian
12 Volkov, Pëtr Ivanovich
4 Vollhardt, Hans
1 von Eggloffstein, Frederick

33 Vroman, A. C. [3 AB]
2 Wagner, C. D.
1 Waintrob, Abraham L.
2 Wakely, George D. [34 ST; 1 AB]
0 Waldack, Charles [17 ST; 1 CDV]
3 Walery [Stanislaw Ostrorog] [3 AB]
4 Walker, L. E. [42 ST; 1 AB]
1 Walker, Margaret
2 Walker, Samuel A. [1 CDV]
6 Walling, William
2 Walmsley Brothers
1 Ward, Dewitt C.
1 Warhol, Andy
1 Warnod
8 Warren, George K. [14 CDV; 4 AB;
 1 CC]
1 Wasmuth, Ernst
1 Wasserman, Dmitri
6 Waters, R. J.
318 Watkins, Carleton E. [817 ST;
 1 CDV; 9 AB; 2 CC]
4 Watkins, Herbert [2 CDV]
8 Watson-Schütze, Eva [13 AB]
0 Weaver, P. S. [27 CDV]
2 Webb, Todd
1 Webb, William
0 Webster and Albee [23 ST]
1 Weck Frères
15 Weed, C. L. [22 ST; 1 CDV; 1 AB]
75 Weegee [Arthur Fellig]
5 Wehrli, A. G.
1 Weil, Mathilde [3 AB]
0 Weil, Peter F. [45 ST]
1 Weinstein and Levin
1 Weiss, W. M.
0 Weller, Franklin G. [134 ST]
0 Wendt Brothers [Julius M. and Francis
 Frank Wendt] [15 ST]
0 Wendt, Julius M. [78 ST]
2 Wenger, Jane B.
11 Weston, Brett [3 AB]
215 Weston, Edward [12 AB]
3 Whipple, J. A. [1 ST; 3 DAG;
 3 CDV; 7 AB]
32 Whistler, John [1 AB]
6 White
3 White Studio [1 AB]
19 White, Clarence H. [30 AB]
1 White, G. F.
3 White, Harvey
0 White, Hawley C., and Co. [39 ST]

11 White, Henry [1 AB]
2 White, Minor
1 Whitehurst Gallery
2 Whitehurst, Jesse H. [1 AB]
0 Whitney, Charles Emmons, and
 Charles A. Zimmerman [10 ST]
1 Whitney, H. H.
0 Whitney, Joel Emmons [20 ST;
 2 CDV]
1 Wiggins, Myra A. [5 AB]
3 Wilding, Dorothy [3 AB]
4 Wilkinson, C. S.
0 Williams, Joshua Appleby [45 ST;
 3 CDV; 1 AB]
0 Williams, Thomas Richard [29 ST;
 11 DAG; 4 CDV]
1 Williamson, C. H. [4 DAG; 1 CDV]
4 Willis, Edith L.
1 Wills and Vreeland
0 Wilson, Alexander [10 ST; 1 CDV;
 2 AB]
8 Wilson, George Washington [249 ST;
 106 CDV; 26 AB]
1 Wilson, J. C.
0 Wilson, Jerome Nelson [49 ST;
 1 CDV]
0 Wilson, Jerome Nelson, and Pierre O.
 Havens [12 ST]
1 Winder, J. W.
43 Winogrand, Garry
33 Wiskovsky, Eugen
6 Witkin, Joel-Peter
2 Wittick, Ben [1 AB]
9 Wolcott, Marion Post
1 Wolf, Reinhart
242 Wolff, Paul [5 AB]
1 Wolonish, J. E. or [J. C.]
209 Wols [Alfred Otto Wolfgang Schultze]
1 Wonderly, M. A.
1 Wong, Lewis L.

1 Wood, S. Frederick R.
1 Woodbury, D. B. [1 AB]
16 Woodbury, Walter B. [8 ST; 8 AB]
1 Woodhead, B.
8 Woods, Edmund L.
5 Woods, Gary
0 Woodward, Charles Warren [73 ST]
1 Worth, Don
11 Wortley, Stuart [3 AB]
2 Wright, E. A.
1 Wright, Frank Lloyd
21 Wurts Brothers [Lionel and Norman
 Wurts]
7 Wynfield, David Wilkie
16 Wynkoop, Hallenbeck, Crawford, Co.
13 Wynn, Dan
19 X. [10 AB]
1 Yamazaki, Hiroshi
20 Yavno, Max
1 Yeo, H.
3 Ylla [Kamilla Koffler] [2 AB]
5 Yoder, Janica
0 York, Frederick [20 ST]
2 Yost, Lloyd
2 Young, Andrew [1 AB]
0 Young, R. Y. [13 ST]
2 Young, Sol
1 Yva [Else Simon] [1 AB]
16 Zangaki [6 AB]
1 Zecha, Simon
2 Zerbe, W. H.
7 Zetterstrom, Tom
2 Ziégler, E. [3 ST; 2 AB; 2 CC]
32 Zielke, Willy [4 AB]
1 Zimmer, George F.
0 Zimmerman, Charles A. [37 ST;
 3 AB; 1 CC]
1 Zimmermann, Werner [3 AB]
1 Zuber, René [4 AB]
75 Zwart, Piet [1 AB]

INDEX

References are to plate numbers.